Helen Lewis is a writer, editor and researcher who was born in England and moved to Australia when she was twenty-one. She wrote her PhD thesis on her father's experiences as a combat cameraman and has presented conference papers in Australia and overseas on the ethics and aesthetics of disseminating images of atrocity. In 2012 she was a research associate at the Imperial War Museum, London. She lives in the hinterland of Eden, New South Wales, where she indulges her love of gardening.

HELEN LEWIS

The Dead Still Cry Out

The Story of a Combat Cameraman

t

TEXT PUBLISHING MELBOURNE AUSTRALIA

textpublishing.com.au

The Text Publishing Company
Swann House
22 William Street
Melbourne Victoria 3000
Australia

Copyright © Helen Lewis, 2018

The moral right of Helen Lewis to be identified as the author of this work has been asserted.

All rights reserved. Without limiting the rights under copyright above, no part of this publication shall be reproduced, stored in or introduced into a retrieval system, or transmitted in any form or by any means (electronic, mechanical, photocopying, recording or otherwise), without the prior permission of both the copyright owner and the publisher of this book.

Published by The Text Publishing Company, 2018

Book design by Imogen Stubbs
Cover photograph by No. 9 AFPU
Maps by Ian Faulkner
Typeset by J&M Typesetting

Printed and bound in Australia by Griffin Press, an accredited ISO/NZS 14001:2004 Environmental Management System printer

ISBN: 9781925603620 (paperback)
ISBN: 9781925626667 (ebook)

A catalogue record for this book is available from the National Library of Australia

This book is printed on paper certified against the Forest Stewardship Council® Standards. Griffin Press holds FSC chain-of-custody certification SGS-COC-005088. FSC promotes environmentally responsible, socially beneficial and economically viable management of the world's forests.

*Dedicated to the men of the
British Army Film and Photographic Unit*

We had wanted to show you truth, but truth photographs badly.
We had wanted to show you hope, but we could not find it.

HARRY BROWN, *POEMS*, 1945

Contents

Author's note	xi
Five photographs	1
Yiddisher Vikings	3
Waking the past	12
Opening the suitcase	22
An absent family	39
After Cable Street	57
Waiting for war	66
Blue wings	75
Goodbye to England	86
First blood	96
Blooding	113
Red Devils	126
Soldiers with cameras	150
Film as a weapon	167
A cameraman in Arnhem	180
Cameramen under siege	201
Facing terror	231
Seeing Bergen-Belsen	253
Reading horror	271
Liberation	296
Constant witness	308
Acknowledgments	315
Images	318
Sources	319

Author's note

In reconstructing my father's story I have, for the most part, used only those photographs he chose to keep, reflecting what was important to him about his war experiences.

Of the many photographs in this book, eleven cover the liberation of Bergen-Belsen concentration camp and are graphic evidence of the atrocities committed there.

The reproduction of these images and others like them over the years since the Second World War has provoked much discussion and controversy, and there are those who would argue that we should not view them at all.

I am not one of them, but neither do I advocate for the widespread dissemination of these images. For me, context is the key, and I feel their reproduction in the framework of this story is appropriate. I hope readers will understand why by the time they finish this book.

I am aware of the profound distress that these images and details of the narrative may cause, but I think that sometimes we need to be disturbed.

—Helen Lewis

Five photographs

I am playing in a small cupboard under the incline of the stairs, a place where the bric-a-brac of family life is kept and the place of my imagining games. Today I am Lucy in *The Lion, the Witch and the Wardrobe*, looking for a door to a magic land. I open a battered grey and blue metal suitcase, rifling through the layers of papers and documents. I pull out a brown foolscap envelope and break the seal; five huge black and white photographs spill out. I stare at each photograph for some moments and then return them to the envelope, resealing the flap and replacing the envelope among the layers in the suitcase. I shut the lid, click the catch shut and sit on the suitcase, hands pressed beside me. I make no sound, and my face remains a mask. I tell no one what I have seen.

 Did I really sit like that on the suitcase, or did I kneel in front of it, palms flat on the lid, as if holding it shut? I am uncertain now. How do I know my face was a mask? I remember the monstrous images, and a nameless something churning my stomach, and guilt that I had seen what was not meant for me. Sometimes when I recall this moment it seems like it happened to some other child.

Yiddisher Vikings

In a sense our parents are born to us out of our earliest memories of them. My father appears to me as a tall man in a dark suit already thickening into middle age; hard to imagine that he was an elite paratrooper during the war. When I was very young, I asked him what he would do if his parachute did not open.

'I'd go back and get another one,' he said.

'And what did you do when you landed?'

'I shot off all my ammunition at once so that I could run faster.'

I did not believe him, but the flippancy of his responses somehow barred further conversation.

Old memories have been surfacing lately, things I have not thought of for years: about the war, my parents, and our family. They play again sporadically like sequences from an old family movie, unsettling me.

My brother Jeff is lifting me up and sitting me on top of a rough stone wall to watch him play. I must have been about three. The wall is in front of the house where I was born, a semi-detached in a place called Chadwell Heath, in east London. I sit there uncomfortably, the sharp edges of the stonework digging into my bare

legs and through my shorts. I would like to get down but it is a long way to the ground and I am not quite sure how to do this. Also, I am enjoying being part of his game, if only indirectly. He is five years older than me and my sister Caroline is three years older than him. I am always running after them trying to keep up and am baffled as to why I cannot do the things that they can. My sister is an amazing being to me, she can read and write and paint. I try to copy her.

My sister is teaching me to skate on the back terrace of our house. I am holding on precariously behind her, being towed. Then we fall backwards, she on top, knocking the breath out of me. Later, I am lying tucked up on the couch and the doctor has been, just in case. My mother is worried because I have not said a word since the accident and my father, who has been away for months filming in Canada and the US, is coming home today, and there is much anticipatory excitement. In time I will come to feel this too, and look forward, as my sister and brother do, to the wonderful presents that he brings for us, and his stories, but this time when he arrives I feel shy. He pinches a toe sticking out from under the covers. I know he is my father, but he has been away so long that he is unfamiliar.

I was a little over four when our family moved to a brand-new house in the hamlet of Little End in country Essex. My father named it 'The Old Well' because the builders discovered an ancient well under a flagstone when they demolished the old farmhouse that had stood there. It was a large house; my parents wanted us each to have a room of our own and space to run around in the fresh air. They probably had in mind the

terrible smogs that choked and killed Londoners in the fifties.

Most of the time my parents presented a united front to us children, but I knew quite early that my mother did not like my father teasing us. I think she thought it unkind, especially when we were too young to retaliate. He reserved an especially humiliating strategy for when we were shopping together. Regardless of what the shop sold, when he was asked, 'And is there anything else, sir?' he would reply, 'Yes, do you have one of those things for taking stones out of horses' hooves?' Clearly he thought this very amusing. I would hide my face in his leg with deep embarrassment as the shop assistant feigned laughter, looked confused or simply tried to ignore the remark. Sometimes before walking into a shop I would plead with him not to ask the question. When I got older I would move away and inspect something in another part of the shop.

His silliness could be frustrating too when I wanted straight answers to my important questions about the world. Once, in answer to my plea for seriousness, he asked a little miffed, pouting like a child, 'Do you really want me to be a serious dad, just like all the other dads?' That set me back, because I had to admit that, on balance, I really did not want a serious father—and besides, there were moods that came upon him sometimes, as if a light went out inside him, leaving a dark presence that would chase away the playful child-man. Then he would become intolerant of anything that disturbed his peace and might burst out angrily at one of us children. At times I would spot a kind of tension building in his neck and jaw before the mood came upon him, and although there was often no obvious connection to anything I had done, I

somehow felt implicated. No, it was better that he was a silly dad.

Stories about my father's early years and the war were scant. He told me a little about volunteering for the newly formed parachute regiment, becoming an army combat cameraman, filming the battle for Arnhem, and the enthusiastic and vociferous welcome given to the Allies by the Danes. He told me how, in Denmark, he was invited to a party by a young man who turned out to be the boyfriend of the girl who caught his eye—a girl more beautiful than Ingrid Bergman. In the absence of a shared language, they held hands. After two weeks he had to leave with his unit but arranged to have a red rose sent to her each day until his letters reached her. My mother said he came back, was it a year later? I suppose my father thought we children were too young to be told much about the war, and perhaps, later, he did not want to look back.

My mother was much more forthcoming, telling me stories about her childhood growing up in Denmark, showing me photographs of family and friends. Her tales of living under German occupation evoked the heroic glamour of the film *Casablanca*. She sang in a swing band like the Andrews Sisters, went to 'curfew parties' that lasted all night and was taken by her boyfriend to watch an explosion he had engineered at a German fuel dump. In Copenhagen, where she lived, King Christian rode his horse through the streets to bolster the morale of his people, and when the Nazi occupiers ordered the Danish Jews to wear a Star of David armband, he put one on in solidarity, or so she said. Certainly she felt proud that Denmark had saved nearly all of the more than seven thousand Danish citizens who were Jewish. She also told

me about meeting my father at a liberation party organised by her boyfriend. Bad luck for the boyfriend.

My parents did not speak much about their early years living with my father's family in London's Stamford Hill, but I came to understand from the little they did say that Granny had treated my mother very poorly and my father was still aggrieved by this. As I got older, my mother explained how lonely and lost she had felt in those first few years in England, as an outsider with little English in a Jewish family and community. She told me Granny would curse her, or at least that was how she interpreted the little patterns of sticks Rosa left outside the door to their rooms.

One day my father came home to find her crying because of an incident in the local kosher butcher's shop. Rationing was still in force and there was not much choice, so my mother took the parcel of meat she was given, but when she unwrapped it at home, she found it was mostly gristle. She had returned to the shop and asked the butcher to exchange the gristle for an edible cut, but he refused. The shop was full of women talking, either waiting their turn or dawdling afterwards to chat and gossip. The butcher made sure he announced his refusal to the whole of this congregation. Feeling humiliated, my mother ran out of the shop.

When my father heard the story he was enraged, and immediately went to confront the butcher, leaving my mother behind. The rest of the story was relayed to my mother by Granny, who was present in the shop when he arrived. According to Rosa, my father burst into the butcher's shop in a fury, pushed his way to the counter and then leaned across and grabbed the butcher by his apron. Hauling the astonished man halfway across the counter,

he looked into his face and said, 'I'll hang you from one of your hooks if you ever treat my wife that way again.' At which Granny interjected, 'My boy fought in the war.' She was proud of her son, even though he was defending a 'shiksa'.

They lived with my father's parents for seven years, and then, just after my brother was born, they moved to Chadwell Heath. My father hardly ever went to see his parents that I can remember. His sisters came to us on a few occasions, but there were often falling-outs with one or the other, though I never really knew what these disagreements were about. My mother did not want my father to be estranged from his family, but he was stubborn.

School opened me to the fact that we were not like other families, with their extended clans of uncles, aunts, cousins and close friends. We rarely saw our parents' families and had few family friends. As I grew older, I came to realise that my father had a way of discouraging visitors. The niceties of polite society were ignored, and much to my mother's discomfiture he would on occasions recline his chair, put his newspaper over his face and go to sleep while visitors were still present. When not engaged in the busy life of a roving news cameraman, he preferred to be reclusive. I think I have inherited this trait.

School also opened up the question of religion, which had not figured in my life thus far. My parents had agreed that we should not be inducted into any religion. My father was a forceful atheist who blamed the religions of the world for inflicting centuries of pain and suffering upon ordinary people, and it was not until the last weeks of her life that my mother told me she believed in a god.

As a child it took me a while to realise that the biblical stories read to us at school were not just stories to other people. The rituals of religion settled over me gradually, through the experience of prayers and hymn-singing during the morning school assembly and visits to the local church for services at Easter and Christmas. I enjoyed the ritual and the singing and was a soloist in the choir, and my parents never tried to dissuade me from going to the church services.

But in spite of taking part in all this, I knew I was an outsider. Though I cannot really pinpoint when I became conscious of it, somehow I came to know that other children did not have a Danish mother or a Jewish father, that other children had been christened and confirmed. I had already decided that a lot of what was claimed to be fact by religions was highly implausible—as likely to be true as the trove of myths and legends I had discovered in my local library and voraciously read my way through. I recognised repeated themes in these myths, themes that were echoed in the biblical stories. By the time I was a teenager I chose to opt out of school assemblies altogether.

My father had his own twenty-four-hour news service long before they were imagined. Always rising early, he would make tea and read the morning paper and then listen to the first edition of the morning news on the radio. If he had no specific assignment, he would travel into Alexandra Palace, which housed the BBC in the early days of television. After work he would read the evening paper, then watch the news and later a current affairs program or documentary, if there was one. If he had a news item going to air, he would critique its editing and presentation, many times

complaining that what went to air was not the story he had filmed.

His preoccupation with the news exposed me to the often disturbing nature of world events at a very young age, and sometimes I found the whole thing overwhelming and rather worrying. I was seven when the Cuban missile crisis occurred, but I still remember it distinctly, the terrible knowledge that we could annihilate ourselves with nuclear weapons, or at least that the world left after their use would not be a place we would like to live in. There was talk of the doomsday clock too, of how the crisis would move the clock closer toward midnight when the great disaster would occur. I knew that the clock was not real, yet I could not help but fear it, because there were only a few minutes left, and clocks only went forward, not backwards.

Eating together was a time for talking in our family and, as we grew older, debate: history, literature, religion, politics, the news my father had covered that day. Nothing was really off limits, though when I think back we did not discuss the war much, surprisingly. Both my parents took part in these discussions, with my mother usually playing moderator. My father did not like to lose an argument, something that started to happen as we children grew older and became better informed and more articulate. If my father felt cornered, he would throw arbitrary argumentative ordnance into the discussion to confuse and distract, sometimes even changing the course of the discussion entirely with a dizzying array of non sequiturs. I suppose it taught us conversational robustness and agility.

Parents are a matter of fact to children—unquestionable, I think, until we reach the age where we understand and recognise

them as individuals with their own wants and needs. I can see now that my parents' mixed marriage was testing, not least of their fundamental beliefs in tolerance and the inalienable right of human beings to be treated fairly and without prejudice. We were a product of that belief.

Yiddisher Vikings, my father called us wryly.

'The only Yiddisher Vikings in the whole of Stamford Hill,' he would singsong and laugh. Indeed, we were an isolated little tribe, a nuclear family in a very real sense, separated from my father's family by antipathy and my mother's by geography.

Waking the past

I went backpacking with a friend in Europe the year before I left England. We had made a pact to travel to South America together when she finished her studies, but suddenly I could not wait. I was driven by a growing sense of unease with the country of my birth—a sense that I did not fit or belong, and a contrary fear that if I did not go soon, I would never leave.

My sister had settled in Australia, in Canberra, so I decided a long working holiday there would occupy me until my friend was free. I turned twenty-one the day after I arrived in Canberra, and my life seemed to begin, finally. I did not go back to England again except for visits, and my friend and I never did the trip to South America. I fell in love with Australia's vast and aged geography, its strange, tangled trees and bush, its eclectic mix of cultures still in flux. 'Still on my working holiday,' I joke now to my friends.

Five years after I left England, I went back to visit my parents. They had retired to a lovely property near St Lawrence on the Isle of Wight. It looked out across the busy shipping lanes to France. A large orchard had inspired my mother to try her hand at cider and

elderberry wine, and they were pretty good. It was a wonderful holiday of hikes along the cliff tops, horseriding through the lush countryside, and afternoon tea watching the yachts at Cowes. One evening they took me to a party with other retirees, and though they had warned me what to expect, I was still astonished by the reaction of one of the guests when I told him that I would not be returning to live in England. He paused, bemused, and then protested as if he might persuade me: 'But England is the centre of the civilised world.' I hope I did not stay too long with my mouth open. 'Ex-colonials!' my mother said later when I told her, as if that explained everything.

As the ferry pulled away from the seaside town of Ryde toward the mainland, I watched my parents growing smaller on the quayside and felt melancholic. I wondered when I would see them again, suspecting it would be a long time—but after my visit, they decided to move to Australia, and a year or so later they did, leaving only my brother in England. Canberra became their home too.

'My third country,' my mother said, as if she was an old hand now at changing countries. I suppose she was.

They seemed to enjoy their new life. My mother did some work for a local tutoring service and my father did some volunteer work broadcasting for the local community radio station, 2XX. As I lived close by, it became my habit to drop in for a cup of tea, which my father was invariably brewing. During the summers when the air was scorching, we would meet to swim lengths at the Olympic pool in Civic. Afterwards, we would sit under the shade trees and my father would serve coffee from a thermos and

buttered honey cake, which was a favourite of my mother's.

I had hoped to coax my father out of retirement to make documentaries, but he just laughed it off.

'I don't want to go back to work.'

Thirty years with the BBC news service had entirely erased any excitement in the business for my father, and the discovery of a heart condition put it out of the question. He had to have bypass surgery. After he recovered, he agreed to write down some of the stories of his exploits in the field, stories that he had told and retold us over the years. I read them over the months as each was completed, reminding him of things he had forgotten and the episodes left to tell. One day when I arrived for tea, he told me that he had finished the stories. I can still remember the falling-lift lurch I felt at his words.

'Surely there are always more stories to tell?' I countered. But he was adamant.

He died quite suddenly a week later of a heart attack, age sixty-nine. When I heard, I felt the falling sensation again, but this time it was bottomless. I always wondered if he felt it coming, if saying he had finished his stories was his way of letting me know. He had spent just five years in Australia.

My mother, who was eight years younger than him, stayed on in Canberra and married again. I married too and moved north with my husband. We bought a small property in a place called Burringbar in northern New South Wales, up near the Queensland border, and together we created a magnificent garden around a large lake. My mother lived on long enough to see the start of it, and I nursed her there after she was diagnosed with cancer.

My mother and I tried to be brave and forthright with each other during the five months it took for the cancer to run its course. Eventually she told me that she would die quite soon, and that I should let my brother and sister know. It was a relief when they finally arrived and I could have time off from caring to be a daughter again. It was a long time since we three had been together like that and with our mother. We entered a golden limbo in which it seemed that our impossibly emaciated mother became free of pain and might actually go on living, a fact which seemed to disconcert her.

'So how do I go about it?' she said to me a week after my brother and sister had arrived. She was sitting in a recliner chair on the verandah where she could be part of things and see the garden.

'Go about what?'

'Dying,' she said. 'I mean, I don't want to keep everybody waiting.'

I burst out laughing at this polite absurdity, and she did too as she realised the dark humour of what she had said. We laughed until we were in tears, and then we laughed some more. I knew I would miss her horribly. 'I don't think anyone's in a hurry,' I managed to say.

There is a photograph of her on one of her last days, a hollow-eyed stick figure smiling as she is helped along from her room to the verandah.

During those last months, I asked her if she still had any of my father's film and photographs, and what he had given away. I wrote notes as she talked. I had an odd feeling of desperation

about the task and suddenly realised that I was writing to avoid a second sense of loss that I would feel when my mother died—when I would lose him ... them ... finally, when he would slip even further away.

When my mother died on her seventieth birthday, the old grey and blue metal suitcase passed to me. I slipped the notes I had made into the suitcase with the rest of my father's things, but I did not return to examine what was there.

•

I am travelling back from Canberra, where I have been working for a week or so, and wonder if it is being there again that is bringing up the past so vividly. Maybe *I* am dying, I think—reviewing the chronicle of my life. Else why would I be thinking all this now, after so much time has passed? Maybe it is not Canberra, though, but the book I started reading as I flew down. There was a passage that made me cry, strangely—I had not expected that.

I have always avoided books about the Second World War and the Holocaust, but *History on Trial* somehow got past my defences. It is an account of scholar Deborah Lipstadt's battle to defend a libel suit brought by the historian David Irving. In an earlier book, *Denying the Holocaust*, Lipstadt had described him as one of the most dangerous spokespersons of the Holocaust denial movement, so he sued her and her publisher.

Perhaps the fact that this book seemed to be about a trial, not about the Holocaust itself, made it less confronting—safer. Of course Irving lost. *How could he not?* is what I thought when I first read about Lipstadt's book in the literary pages, but

reviewer David Marr's comments sent a wave of apprehension through me.

'The work of deniers is oddly easy. They don't have to prove much. All they have to do is cast doubt. But this requires they have public reputations as scholars.'

It took me a while to find a copy; a local bookseller tracked it down and I picked it up just in time to bring with me on my trip to Canberra. The idea of historical truth being tested in a court of law was intriguing and I was not disappointed. It was an astonishing story and Lipstadt an engaging writer. I hardly noticed the flight until I glanced out of the window to see a silver flash of Lake Burley Griffin signalling our descent. I turned back to finish the page.

Lipstadt was describing the end of her first day in court. A media scrum had collected outside, and an elderly woman pushed her way through the crowd to Lipstadt:

> She had a heavily wrinkled face and very sad eyes. Dressed quite sensibly for a January day in London, she was wearing a plain light blue wool sweater, dark wool skirt and sturdy shoes. Her knitted hat was pulled tight over her grey hair. Ignoring reporters, she thrust her arm in front of me, rolled her sleeve up to her elbow, and emphatically pointed at the number tattooed on her forearm. 'You are fighting for us. You are our witness.'

Fat tears welled instantly and spilled down my nose. I had felt embarrassed and blotted them discreetly, hoping no one would notice. I was surprised and confused. Lipstadt's description was

touchingly rendered, but it did not seem possible that it had caused me to cry. I closed the book as if this might stop the flow and pushed it into my briefcase. We readied for arrival. The tears were gone by the time we landed, but I felt perturbed inside, and later during my stay, I cannot pinpoint exactly when, unsettling recollections began to rise.

•

I step out of the aircraft to be enveloped in the moisture-laden air of the Gold Coast. It is soft and steamy after a week in Canberra's desiccated climate. Fragments of the past are still running interference in the present and I am barely aware of the drive home with my husband. The usual questions about how my work went and which friends I caught up with are an unwelcome distraction, and I know I seem terse. In some respects our tree change has been a success, with our garden gaining a few awards and opening to the public. But our relationship has been slipping slowly into antipathy through a constant chafing between us.

We are preparing for a spring opening, and there is still a lot to be done. At home we go for a walk together to take stock of the work still left to do. We wind our way along well-known paths under the palms and through plantings of bromeliads, orchids, coleuses, hippeastrums and salvias—a riotous profusion of foliage and flowers in the gaudy tropical way—but my usual pleasure in this exercise is disrupted by a sense of some counterfeit here. I watch my husband as he bends over to pull a giant palm leaf out of the garden bed; a familiar act in a familiar place but there is something badly wrong. Then it comes to me, with a visceral

shock, that I am seeing a stranger. There is a changeling here. I want to ask him: 'Do you know who I am?' But I cannot explain what I have seen or felt and perhaps I already know the answer; the changeling is me.

•

'It's not fair,' I can hear one or other of us saying as children when my father had refused us some request.

'That's because it's Saturday,' my father would reply. 'And Saturday's the day for not being fair.'

He had established this simple rule when we were very young. Looking back, I see its logic. Life falling, generally, into the pattern of school days and weekends meant it was likely that Saturday would be the day we wanted something. As a refusal could legitimately ensue, the granting of a request was made special. When later we began to argue that the Saturday rule was inherently unfair, my father argued back that it was valid because it taught us the inherent unfairness of life.

At least this memory makes me smile—but where does it come from, this steady drip of recall? I have been home a week now, and we are counting down the days to our open garden. I stand up from my work to throw another bundle of prunings onto the pile on the lawn, stretching my back and then stepping gently between the plants to the next section. Eastern spinebills feeding on the nectar of the tropical salvias scatter and flutter around my head like demented garden fairies before settling again. I am dripping with sweat. A satisfying line of weeds and clippings are waiting on the lawn to be cleared, and the heavy physical work has helped

to push my preoccupations into the background. The humidity is soaring, and the air is heavy with rain. It will come soon. I go to the swing seat on the jetty to sit and rock slowly, letting the cool air from the lake fan me.

The book is here. I touch its dust jacket.

'I don't feel myself,' I have heard other people say and wondered what that meant, but now I think it describes how I am feeling: out of body, out of place. At least my body is in one place, here, now, while my mind inhabits some other space where the past lives.

Rain patters on the jetty roof as I pick up the book and find my place, but something makes me pause and then leaf back through the pages to Lipstadt's description of the elderly woman pushing through the crowd. As I start to read, I see her clearly—pushing through the crowd of friends, spectators and media, rolling up her sleeve and showing her tattoo to Lipstadt—and then I see myself too.

I am a child, ducking into the cupboard under the stairs. I take a brown envelope from the suitcase and slide my finger under the flap to open it. Five huge photographs slide out in front of me. I look at each one for some moments and then return them to the envelope, pressing the flap shut and burying it under layers in the suitcase. I close the lid and click the catch shut. And then what happens? Do I sit on the suitcase? Do I kneel in front of it? I cannot see this, but I remember something else now. For the first time, I remember the feeling deep in the pit of my stomach—a palpitating and uncomprehending dread.

Across the lake, light bounces and flashes off the chop of

water, and I put down the book and sob until my breath comes in shudders. The turtles drift in, hopeful of some bread, and the eels too. An alarmed grebe chides noisily, rushing away to gather tiny specks of chicks onto its back, and a light breeze ripples across the water, cooling my face.

Opening the suitcase

The next morning I slide the old grey and blue metal suitcase out of the angle of the roof in the loft. It is fuzzy with fine cobwebs. I have not been back to the suitcase since I put the notes I made there. I hardly know why I am here now. I snap open the catch. The suitcase seems a small container for the relics of one life in the same way an urn seems too small to hold the body's physical remains. I see a manila folder on top labelled *Holocaust Address* in my father's rough scrawl. It is eerie to see his handwriting again; comforting too, like an afterglow of his living presence. I pick up the folder and glance at the speech inside. He typed it up and made handwritten corrections and annotations. I am not sure of the speech's original purpose, but I do remember it being used after he died. It was at the 1995 tribute to survivors of the camps organised by the Sydney Jewish Museum. An actor read the piece.

I start to lift folders out of the suitcase, one by one, checking their contents. They are densely packed, and this surprises me. I had never thought of my father as a big collector or keeper of things; he always seemed unsentimental in this way. More surprising is

the fact that most of the material is about his war years; there is little about his thirty years with the BBC.

There are many things I have never seen before—sketches of his comrades, press clippings and mementos—along with written recollections, contributions to books, and correspondence with the Imperial War Museum in London about the oral history recordings he made with them. Then I pull out a rather phallic lump of black rubber that I recognise as the rubber bullet he brought me back from Northern Ireland, where he did regular tours of duty for the BBC during the Troubles.

I remember him giving it to me. We had been discussing the use of rubber bullets there by the British troops before he left. I suppose he could see that I did not understand how damaging a rubber bullet could be, that being hit by one fired from a gun was not the same as trading test tube bungs during chemistry class. The bullet was large, heavy and dense; it was obvious to me at once that a rubber bullet was not benign.

The next thing I pull out of the suitcase is a blue, hard-covered binder of war photographs—an album, the photographs in it pasted down together with typed captions. I skim the pages. The photographs begin in North Africa and end in Denmark.

What was it my father said about crossing into Denmark?

'It was like the sun had come out ... people smiling, welcoming ... whole buildings.'

Denmark had escaped being a battleground, and the people greeted the Allies as liberators, heroes. The photographs show it: they exhale joy. People line the streets smiling, waving flags, throwing flowers, and girls jump up to kiss soldiers. I look for a

photograph of the girl 'more beautiful than Ingrid Bergman', but she is not there. Perhaps she did not belong to the end of war but the beginning of peace.

As I lift out the next few items I feel something slip from a folder and look down. Several outsized black and white photographs have fallen face-up on the floor. I fan them out. There are five of them, and I recognise them immediately. For a moment I cannot seem to breathe, and a burning sensation chases over my skin. Desolation leaches from the images. I reach for a folder to contain them, but they are too big and the edges protrude. I hold the folder to me, clasped in my arms, wondering what I should do with it … with them. Then I stack it on top of the blue binder of photographs and a file of newspaper clippings and, clutching the bundle to me, go downstairs to my office.

I arrange the files and the blue binder on the floor and sit back in my chair, staring at them and the protruding edges of the five photographs; the flush of heat is fading from my body. It must be forty-five years since I first saw those images.

I cannot really remember how I came to know about Belsen and my father's work there, or even when. Had I overheard my parents talk about it before I found the photographs? Was finding the photographs the beginning, and if so, how did my learning about Belsen go on from there? Thinking back, it seems as if I always knew; that I knew enough, or so I convinced myself. Why have these photographs come back to me now?

•

Our open garden is only a few days away and everything is coming together ... except me. A confusion of thoughts and memories flood my waking hours, and my sleep is broken, filled with unpleasant dreams and bouts of sweating—yet I feel a preternatural alertness. I cannot talk about what I feel because it has no real coherence. I just have a sense that I have failed or been caught out in some way, like a soldier who has fallen asleep on watch and allowed the enemy to infiltrate.

In my office the floor is filling up with folders as I bring more down from the loft. I kneel among them. It is midafternoon, and I have time to take another look at the files before my neighbours arrive for drinks, at least that is what I think, but I am soon lost in the memories that this activity provokes. I pick up a folder of newspaper clippings of interviews that my father gave in 1984. It was the year that the Imperial War Museum screened a documentary at the Berlin film festival about the Allied discovery of the concentration and extermination camps. *Memory of the Camps* was put together in the last months of the war but never completed. Its release in Berlin created a flurry of interest because of its subject matter and also because of some famous names involved in its production, notably Sidney Bernstein and Alfred Hitchcock. Somehow the story got around that Hitchcock had directed it, but in fact he was the treatment adviser—the reality was that there was little opportunity to direct cameramen operating independently at the front.

I remember my father receiving a barrage of requests for interviews from around the world. I suppose it was his connection with the Imperial War Museum that helped the media find him in

Canberra. A letter from Kay Gladstone, who conducted the interviews, seems to confirm this. I leaf through the clippings. Beneath them are a series of publicity photographs of my father, obviously taken for use with the articles. One in particular checks my skimming and delivers a pang because it reminds me of how he looked when I called in to see him after the last of the interviews.

He looked worn out, and his eyes were watery. His mouth was resignedly fixed, as if trying to hold something back, and he kept dabbing at his nose with a handkerchief. I was surprised to find him in such a state. I had not realised until then that it caused him pain to speak of these things. I am mortified to realise now how dreadfully superficial was my understanding of the emotional cost of doing those interviews, of the emotional cost of remembering. As we sat together quietly, he suddenly asked me, 'Why do I have to keep telling this over and over again? Isn't it enough I took the film?'

I tried to say something soothing about the importance of eyewitness accounts and historic events, but it fell rather awkwardly into the silence that followed. Did I agree with him that the images said enough, that they said it all? I think perhaps I did. Naively, ignorantly, I believed the evidence was clear and incontrovertible, that no sane person could argue against it.

He told me that a producer had approached him with an idea for a documentary involving him seeing *Memory of the Camps* and visiting Bergen-Belsen again. He rejected the idea emphatically, telling me, 'I don't need to see the film again—I don't need to be reminded, and I don't want to go back. I wish I could forget. I *wish* I could forget.' I felt so helpless in the face of his distress.

I know my father was aware that there were people who denied what happened in the camps. But I wonder if he realised how far these ideas would travel with the passage of time? How down the years, when the grass had grown over the grave mounds, and the numbers of those who survived and who witnessed had dwindled; how then it would be possible to deny what had happened and gain for that denial a measure of acceptance?

It is difficult for me to comprehend too when I have lived, subliminally, with the proof all my life. I once met a young man of German descent who was a 'denier'. It was in the late 1980s, in Canberra. I cannot recall how we fell into conversation about these matters, but what I do remember is my astonishment at his views. I never challenged his ideas at the time; it did not seem worth the effort. It was, after all, just a crackpot view held by a few fringe extremists, or so I thought. Would it have made any difference if I had? I wonder now if not speaking

out was a form of cowardice. Was there a split second in which I considered the consequences before I let his remarks pass unchallenged?

In her book, Lipstadt says that Holocaust deniers are not the 'other side', and while there are many questions that can be, and are, asked about the events of the Holocaust, she does not debate 'the very fact of it'. Would showing this young man the photographs have convinced him? Could I—should I—have said something before walking away? I am beginning to understand now why Lipstadt's book has touched me so deeply and wonder what my father would have made of *Irving versus Lipstadt*. I wish I *had* been a soldier caught out asleep on watch—at least it would mean I was aware there was something to protect, but I have been a lotus-eater, living to forget.

As I slip the photograph back into the folder, another catches my restless attention. It is recognisably my father, but not as I have ever known him. He is in uniform, lying on the ground, propped on his elbows in an oblique profile against a backdrop of barbed wire. He holds his camera, an odd-looking box, in both hands in front of him and gazes intently to the left of the frame, eyes cast slightly upwards. It must be a staged shot, because he looks spit-polished and relaxed. Even the wisps of grass seem carefully arranged so as not to intrude upon his face and the body of the camera he is holding.

The image has an archetypal quality. It is as if he was preparing his publicity shot for posterity. He is smooth-cheeked and handsome, and his sergeant stripes, beret and Parachute Regiment cap badge are clearly visible. He must be about twenty-four or

twenty-five, and I realise for the first time how young my father was when he went to war, when he filmed Belsen.

I wonder who he is, this young man—the man who became my father, who became the tall man in the dark suit of my early memories. He looks so serious, so intent. I wonder where and when this photograph was taken, and by whom, but there is no information written on the back. In a sudden inspiration, I take it to my desk and go online to look for it on the Imperial War Museum's website, but when I open the site, the museum's catalogue proves to be overwhelmingly vast and I am pessimistic. The search could take me hours, and the photograph might not even be there.

I remember going on a school excursion to the Imperial War Museum when I was about twelve. It had an imposing facade of

columns topped by a cupola. I bought a reproduction of a First World War recruitment poster with a man in a peaked military cap, Lord Kitchener, I think, pointing his finger at the viewer, and emblazoned with the words: *Your Country Needs You*. I did not connect the museum with my father, or perhaps I did not connect my father with history. I am sure I did not know then that the film and photographs he took during the war were archived there. Now, all these years later, I am revisiting the museum online, from half a world away.

I am pleasantly surprised when, after a very short time, I find the photograph, but the information provided is disappointing. There is no specific attribution. The caption says:

> Cameramen in uniform: Sergeant Mike Lewis of the Army Film Unit posing with a De Vry, the camera most widely used by British combat cameramen. Mike Lewis transferred from the Parachute Brigade to the AFU, and filmed Arnhem and the liberation of Belsen.

Below this photograph in the catalogue is another credited to my father—actually a still from his Belsen footage. It is of women waving from behind barbed wire. The caption says:

> Women inmates of the German concentration camp at Bergen-Belsen wave through the wire to liberating British soldiers (including the cameraman Mike Lewis). The group includes Mania Salinger, the central figure in the group closest to the wire.

Then it comes back to me, my father talking about his first contact with the inmates at Belsen. He said they were peering through the wire in wonder. 'Eating us up with their eyes' was how he described it. My father tried to speak to them in a mixture of Yiddish and German, neither of which he knew that well. But they understood that their deliverance had come, and their wonder turned to awe. 'You are a Jew, and you are free!' they cried in disbelief.

Is this photograph of that moment? I could have asked him, if I had ever thought to. There are so many lost conversations, conversations we could have had if I had been more inquisitive and he more forthcoming. I could have asked about these women, and whether he remembered the moment they waved to him through the wire and asked him if he was Jewish. They look so full of life, healthy, not at all like the pitiful figures in the photographs from

the suitcase. They must be some of the lucky ones, perhaps recently arrived, who had not yet succumbed to starvation and the noxious conditions at Belsen—but of course you cannot see what is behind them. You cannot see what the next frames of film might reveal if the camera moved between and behind the waving women. You cannot see those too emaciated and weak to stand, or the corpses strewn everywhere. But my father could have told you that beyond these women there was hell, and that even without seeing it you could smell it.

As I browse the Imperial War Museum's website, it occurs to me that there is a correlation between the material housed in the old Victorian building in London and the piles spread across my office floor. They are both archives, both cover the same events, but the personal archive is like a key to the larger, public one, borrowing from it, referencing it and pointing to sources.

I swivel round on my chair and bend to pick up the blue binder. Or perhaps it is an album? I have not made my mind up what it is yet. A Tunisie franc hangs from a thread inside the front cover. Pages can be added or removed by pressing the front and back covers together to open the spine. The pages are a thick, coarse paper, which shows the grain. Sugar paper, I think, like we used for our scrapbooks as children.

The pasted photographs with their captions are postcards from the past, telling of long-forgotten occasions, like my father's encounter with a famous general.

Gen. Eisenhower in N. Africa. He paused for a moment while getting into his car to enable me to get this picture. He asked if it was "O.K." and I said it was.

I think my father joined the Army Film and Photographic Unit, the AFPU, after the North African campaign was over. Eisenhower's visit could have been one of his first assignments.

There are other items pasted in the blue binder too, such as cartoons, a Christmas Day menu from Algiers dated 1943 and photographs clipped from newspapers. One shows my father and two other cameramen just returned to England from Arnhem, a small town in the Netherlands where a momentous battle had taken place.

The clipping is not dated, but the three of them look dishevelled, as if they might be newly arrived home. I find a copy of the original image on the Imperial War Museum's website. The caption says that it was taken by Lieutenant Barker at the AFPU Centre, Pinewood Studios, on the day they arrived back, 28 September 1944. The online image is uncropped and has a square format. It is not yellowed or faded with age like the newspaper clipping, and its freshness seems to bring that moment closer. I can see the building behind them and my father's pistol in its holster.

Back in England are the men who recorded the Arnhem epic—three sergeant cameramen, whose magnificent battle pictures were yesterday printed in "The Daily Sketch." Left to right: Sergt. D. M. Smith, of Manchester, who is 24, and was wounded in the shoulder; Sergt. G. Walker, of Bute, aged 28 and a veteran of five years' camera work on the battlefield, and 26-year-old Sergt. C. M. Lewis, a Londoner, who has made 18 parachute descents.

The catalogue caption says, 'The three Army Film and Photographic Unit photographers who recorded the 1st Airborne Division's epic fight at Arnhem.' I wonder if it was the army's publicity unit who labelled the battle 'epic', and if this description of it was picked up by the newspaper. My father called the battle at Arnhem a 'planned blunder', I remember. As I read a little about what happened there, I think his description might be a bit of an understatement—'monumental failure' or 'disaster' might be better. The battle for Arnhem lasted for nine days, from 17 to 25 September 1944. Ten thousand British troops went in by parachute and glider, and about two thousand managed to escape. My father and his fellow sergeant cameramen were some of the lucky ones—they made it home, bringing their film and photographs with them.

The blue binder has many pages devoted to Arnhem, and I see now that the whole thing is ordered chronologically. It is more

diary than album; a visual diary of my father's war. It is not obvious when it was created, but the whole thing has the look and patina of age and reads as if it were assembled between assignments.

The images at the heart of this diary are a mixture of sizes; some may even be stills taken from film. I had always believed that my father took film only, but the Eisenhower photograph tells me he took stills too, and now I wonder if he took all the images in the diary apart from those he features in. I suspect there may be copies of these images in the Imperial War Museum's collection, but I can only find a few. I realise I have been lucky to find the ones I have so easily.

I puzzle over how the military authorities would have viewed the keeping of photographs by its sergeant cameramen. Then, quite by accident, the answer appears before me: I find an image of a travelling exhibition of AFPU photographs in North Africa dated February 1943. The caption says that the photographs could be purchased at the time; souvenirs were apparently encouraged. I feel an unexpected glow of satisfaction at the discovery of this small fact.

I am surprised to hear the sound of my neighbours arriving and look out to see that the light is fading quickly. A whole afternoon has passed as if in an instant. I feel slightly dazed by the intensity of my musings. Sitting among the files, papers, photographs and objects, I wonder what I am doing with it all anyway. *Sorting it out* is what I tell myself. *Trying to make sense of it.* The piles spread across the floor are like a map of my father and his war, if only I could read it. He was not the type to go to reunions or remembrance days, but it is clear that he often

thought about the war. Suddenly I have so many questions.

Strange that this war which seemed so long ago when I was a child is now disquietingly close, and stranger still that its black and white images are now tinged with some quintessence of my father. There is so much I do not know about his youth and the war, but maybe he can talk to me through what he left behind. Perhaps, in a sense, his archive anticipated a moment like this. There are traces of him here and in that old Victorian building in London, traces of the events that helped shaped him, traces of him from before I was born.

•

My neighbours have left now, and I am back in my office. It is late, but it is too difficult to go to our shared bed this evening, and I am not tired yet. The gathering was awkward, and tensions that before might have been suppressed in company spilled over. The sense of estrangement that I felt in the garden has persisted, and I am sure my husband senses this distance. My preoccupation with my father's archive seems to irritate him, but I do not care. Something is driving me recklessly along, as if the past has become more important than the present.

I sit swivelling back and forth in my office chair, trying to decide what to look at next. This is the last opportunity I will have for the next few days until the open garden is over. I bend down to pick up a copy of a document with the title *Secret Dope Sheet*. It is the shot-list my father wrote for Arnhem and gives captions for each reel of film.

> Arnhem Holland: On Sunday 17.9.44 at 11.25 am. My plane with scores of others took off from an English airfield. The planes were Douglas C 47 and piloted by Yankees. At approximately 1.55 pm I baled out west of Arnhem ... The importance of this operation is that it means outflanking the Siegfried Line and the main entry via the Rhine to Germany. The day was bright and clear. There was no opposition on the dropping zone. The Dutch were glad to see us.

I look for the corresponding film on the Imperial War Museum's website and make an astonishing discovery when I locate it and read the accompanying description of the film sequence:

> 1st Airborne Division flies into battle in Southern Holland. The opening sequences are shot from the cockpit of a No 46 Group RAF Dakota as it flies over East Anglia (?) towards southern Holland on September 17th [1944]. During the flight, an anonymous cameraman takes over briefly to film Sergeant Lewis (who gestures at the camera while sorting out his kit) ...

He is there, the young man who became my father, caught on a few frames of film, on his way to Arnhem. The unspecified gesture intrigues me. I can only guess at what it is, but knowing that I could track down the film and see it—could see him—is rather thrilling.

It is strange to see my father catalogued as if he were an artefact or exhibit of sorts. I suppose he is, but he is something else

too—a chronicler, a recorder of history—and I want to hear what he has to say. Before shutting down my computer, I order a digital recording and transcript of his oral history from the museum.

It is two in the morning, and I push back from my desk. The moon is very bright, and I go outside to sit down on the stone steps in the rockery. The night is still and warm; only the occasional nasal call of a wood duck intrudes upon the silence. Soft light illuminates the lake, and the shadows of the palms intersect the lawn, flowing across the white market umbrellas set up for our open day. I feel fired with curiosity: about the war; about my father; about his role in filming the war; about Arnhem, and Belsen. It is like an intoxication, an extra aliveness that skips across the surface of my skin and makes me want to know more, to see him gesturing to the cameraman on his way to Arnhem. In that moment it becomes inexorable: I will go to London to see for myself what he saw.

I start to laugh quietly at my allegorical opening of the trunk in the attic. I could be Pandora, or her sister Eve, that other insatiably curious woman. I laugh at my years of hiding the past from myself, and I laugh with relief that I do not have to hold it so tightly inside me anymore. I want to write my father's story down. I have this sense that if I do, I might ease his burden of remembering—of witnessing.

An absent family

On my sixteenth birthday, my father gave me polaroid copies of two photographs: one was of my grandmother Rosa Englischer, age sixteen; the other of him as a baby with his sisters, Edith and Nancy.

'You look just like her,' he said when he handed me the photograph of Rosa.

It was true: my resemblance to my young grandmother was uncanny and strangely disturbing. It was as if I were looking at myself dressed for a costume drama that I had forgotten I went to. The photograph he took of me then 'for comparison' is lost now, but I remember I had a pageboy haircut, popular at the time. Now I am old enough to be young Rosa's grandmother, and as I look at her photograph I am struck by a moment of recognition of myself, a younger self, which Rosa reflects. Sometimes when I catch a fleeting reflection of my face in the right light, I still see a trace of her.

I hold the faded photographs in my hand, the only tangible connection between me and my father's family and who they were, who he was. I have copies of a few official documents: birth certificates for my father and his sisters, a marriage certificate for my grandparents, a census extract identifying Rosa's father, and a few old school reports that my father kept. My grandparents and aunts are long gone now, and there are no cousins or other relatives to fill the gaps.

Almost a year has passed since I found the war diary and the photographs, and I have been to London and back. I was away two months, most of the time in England doing research and visiting my brother. There was not enough time in my itinerary for the things I had planned to do, and no time at all for the things it became obvious I should. The more I researched, the more questions I seemed to have. Ten days at the Imperial War Museum raced by. I went in early and left late, viewing my father's film in long sessions with few breaks. The days I spent there took on a surreal quality as I struggled to cram in all the information I

could, taking notes, copying documents and reading.

I went to the Museum of the Parachute Regiment and Airborne Forces, then housed at Browning Barracks near Aldershot, where I found out that sergeant cameraman Harry Oakes, who was with my father at Belsen, was still alive. My brother Jeff and I went to visit him at his home. We drank tea while I asked questions and Harry Oakes talked. His eyes opened wider and his voice became husky as he described their arrival at Belsen. He seemed to look straight through me, as if the dreadful scenes were in front of him again. He brought out a bundle of black and white photographs, copies of the ones he took at Belsen. After we left, my brother told me that he had found the suitcase under the stairs too, and seen the photographs, much like I had, though he was not so young. He asked why anyone, including our father, would want to keep such awful reminders. I thought about that question a lot during the sleepless nights and drenching sweats that menopause visited upon me.

I went to the National Archives at Kew to look at the official war diaries of the AFPU. I rushed from place to place, hopping on and off the London Underground at stations that had been familiar in my youth but were now barely recognisable all these years later. I would have liked to see the streets where my father walked as a young man; to see Pinewood Studios, where the AFPU was based; I wanted to go to Arnhem to meet a contact I had made there, too—but I ran out of time.

I had stilted long-distance phone calls with my husband, as if everything between us was normal. We were trying to arrange to meet up in Macedonia, where he had gone to visit family. When

I eventually got there, it was not a happy reunion. In Macedonia I came down with a virulent flu that left me thinner, depleted and shaky. We returned to Australia separately. I remember travelling home to Burringbar alone and not wanting to be there when he arrived. I stayed only long enough to gather a few personal items and my father's archive and then left, crying and waving to my friends, who were looking after the garden and our dog, Lily. I had the curious impression that I had, by starting to unpack my father's life, unravelled my own. I lived nomadically for the first six months, eventually coming to rest in Canberra, where I unpacked my few things and started trying to make sense of my life and my research.

In my new home, the sun stripes through the blinds onto a trestle table of open books piled one on another, documents with coloured flags and fanned-out photographs. More books, articles and DVDs are piled on the floor and on bookshelves. My research in London did not reveal as much of my father's story as I had hoped it would, nor did listening to his oral history interview. Though it covered the period from his early childhood to just after the war and joining the BBC, his interview proved vague on the specifics of time and place, perhaps understandably, since it was made so many years after the events he was describing. There was an eeriness in hearing his voice again, and in watching him in the *Images of War* documentary, but it was comforting too.

I look at the photograph of Rosa again, trying to read her expression. It is perverse that the desire to know more comes when there is no one left to tell me. I cannot draw on family folklore either. There is no trove of anecdotes passed down by relatives or

siblings, because by the time I was really aware of the situation, my father was virtually estranged from his family and we rarely saw them.

In the photograph, Rosa's eyes are directed to the left of the frame and slightly up, as if she is trying to ignore something unpleasant; maybe having her photograph taken. I remember feeling that way when my father captured my moment of likeness with her. I wonder if this is portrait as keepsake or portrait as travel document. Is she shy or worried? What is the history hinted at in her face? I have a sense that sharing a family likeness with Rosa gives me some sort of right to say I know her, as if an essence of her is incarnated in me that allows me to divine her story.

If my father was correct in saying that Rosa is sixteen in this photograph, then it must have been taken in 1903, just before she left for England or just after she arrived, most likely fleeing a wave of pogroms that swept through the Pale of Settlement, a region of imperial Russia where Jews had been permitted to live. The pogroms began in the 1870s and continued until the early 1900s. Perhaps her look is one of stupefaction at her loss and at being uprooted.

The second photograph my father gave me, of himself and his two sisters, has a very different quality. It is a photograph of a photograph: I suspect my father propped the original against a wall so that he could make the polaroid copy, as you can see the wallpaper or tiles behind the torn corner of the original print. The image is so faded with age and iteration that the children look like apparitions, especially my father and Nancy, who are dressed in light colours. I scan the image and digitally enhance it to bring

out more detail, but still they persist as wraiths. The framing of the photograph is awkward. Part of it might have been cropped in the reproduction. Nancy, or 'Nellie' as her birth certificate says, seems crowded out; one shoulder is cut off, and she seems to look down and to the right of the frame, as does my father. Only Edith appears to be looking at the photographer. Perhaps she is being told to make sure Mike sits still, because her hands are behind him and could be holding or supporting him as he sits on the low stool. He looks to be about eighteen months old, which would make it 1919 or 1920; Edith would be nearly eleven and Nancy almost nine. One thing stands out, though: my father's position in the centre foreground makes him the focal point of this family portrait.

All I remember of Nancy and Edie is Nancy's explosive and unpredictable temper that seemed in keeping with the flaming henna-red of her hair and Edie's musty, mothball smell and her 'So, what's the news?' on the rare occasions that she visited, as if she suspected my father created the news rather than filming it.

There was one story that did get passed on to me from Nancy that now seems imbued with greater significance. I can still see her standing there making a tube of her left fist and holding it up to her eye while making winding motions with the other hand. She was demonstrating how my father pretended to be operating a camera while he directed his sisters in his imaginary films; it was one of his favourite games with them when he could persuade them to play, which was often, as the young Nancy fancied herself a film star. I remember being amused by the idea that you had to turn a handle to make the camera run. I think by this time my father was using a large battery-operated colour camera for his work with the BBC—an Arriflex, I think.

I look at the image of Rosa again; she is family, but only in a biological sense. I did not really know her, can hardly remember her. My father told me that she made exceptional golden chicken soup with kreplach (dumplings), mandatory for a Jewish mother, and that her cholent (a slow-cooked casserole usually prepared for the Sabbath) was rich and melting with flavour. There was one occasion when he took me to see her. It is a wisp of memory. I was very young, maybe four. We bought a box of food from a Jewish delicatessen, I think. I was given small sweet cakes with poppy seeds and currants from that box. I had the impression that my father took her food because she was poor. My memory of her is

like a faded photograph. She is a small, hunched figure dressed in black, wearing a headscarf tied peasant-style. She sits backlit against a tiny window, and nothing exists outside her dark silhouette and its halo of light. A feeling of uneasiness attaches to that memory. Was it just that I did not know her, or was I channelling my father's ambivalence? I suppose that Rosa's world was in some ways small, bounded by an orthodoxy in religion and in life, an orthodoxy that had been transplanted with her. I do not think she ever reconciled herself to my father marrying 'out'. Her husband, my grandfather, I barely remember at all—did he wear glasses and dress in brown slacks and a brown cardigan?

I rummage through a box of jumbled family photographs, looking for any other images of my father and his family. The different formats—black and white prints, colour prints, slides and even some polaroids—are like some technological and cultural shadow box of a postwar family. The album I remember from childhood with its neat photographic corners holding the black and white images in position has been replaced by a newer one with sticky plastic cover sheets. Although it holds some of our earliest family photographs, the chronology is confused and some prewar images of my father and mother intermingle with later family ones. There are also a few other wartime photographs of my father, and I wonder why they are not in the war diary. What is most striking about this incomplete and disorderly family album is the absence of my father's family. By contrast there are many images of my mother's side—Mormor and Morfar, my grandparents; Tante Else and Onkel Mogens, my aunt and uncle; my cousins, Per and Jan, and others too, some unknown.

This absence of images is odd for a man who became so immersed in the visual. Of course there may not have been many family photographs taken when he was young, but after the war, when he and my mother lived with his parents and when my sister and brother were born, there must have been plenty of opportunity. Maybe the absence of images is like the tearing of a photograph in two to remove the offending party. He had cut off his family—they were dead to him. Giving me those two photographs was an aberration, or perhaps a late attempt to remedy an omission that he came to regret, seeing my likeness to his mother, and having reached an age (he must have been about fifty-four) when his feelings had mellowed. As my father grew older, I realised that he was less absolute in his feelings, and there seemed to be a reconciliation with the self, with his Jewishness. My mother gave him a gold Star of David as a birthday present—I suppose he must have been sixty-three or sixty-four—and to my absolute surprise, he accepted it and wore it for the rest of his life.

It was probably not long after my father gave me the two photographs that Rosa died and they found that she had money hidden—money she had put by, it was supposed, as insurance against a time when she might have to flee again. It must have been quite a bit, because I also remember hearing that my grandfather married again, a younger woman, who in a few years put him in a nursing home and kept the money. When I heard about the hidden money I thought it terribly sad, because my grandmother had lived so frugally to save it, and because she never felt safe, even after all that time. Knowing all this, knowing only this, what does the bequeathing of this likeness from my

father mean? What else do we share, Rosa and I?

Besides the few documents and photographs, I have also found a copy of Hans Christian Andersen's *The Ugly Duckling and Other Fairy Tales*, a prize my father won from the Senrab Street primary school he attended in Stepney. I found it among the books that I inherited from my mother when she died. Odd to think it has been in my library so long without me realising it. Senrab Street School is still there, but it has changed its name to Marion Richardson Primary School now. I look at it and the surrounding streets online, taking a virtual tour of the area.

Solomon Englischer, Rosa's father, appears on the 1911 census, but there is no Mrs Englischer—he is a widower. What happened to Rosa's mother? My father said that Rosa had a brother too, but he went to Canada. More absences, dead ends. Rosa came from Warsaw, and her future husband, Leo Wizenberg, from Lodz, a city to the south-west of Warsaw. They were married at the East London Synagogue on 9 August 1908. He is listed as a purse maker and she as a curtain maker. Rosa has made an 'x' in lieu of her signature on my father's birth certificate. I wonder if this is an indication of her lack of schooling or just that she was not competent in English. My father was her third child and only boy, born 6 February 1918 in a maternity hospital in Vallance Road, Whitechapel; they called him Colman Michael—Colman was Leo's father's name—and his surname on the birth certificate was spelt Weisenberg. He was the only one of Rosa's three children to be born in hospital. Perhaps complications were anticipated, or maybe she had been ill.

I tax my memory and the meagre artefacts of his family and

early life. My father told me that he was a sickly baby—perhaps the photograph of him and his sisters was taken after fears for his survival were past. I know that Rosa remained over-protective of her 'boychick'. My father said that she wanted to keep him 'in cottonwool' and tried to stop him playing football in the street with other boys. I have this notion that he started school late, at age eight, because of her fears, and it seems to be borne out by the earliest school report I have for him, which is dated 1926. It puts him bottom of the class and says *Very backward but now improving.*

By 1928, he is fourteenth out of forty-two and has topped the class in reading. By the end of his schooling, he has excelled in recitation, drawing, reading, poetry and geography. The school reports speak of a pedagogy of a different era, with its reading, arithmetic, mental arithmetic, composition, dictation, recitation and handwriting, and assessments of fair, good and very good.

The last report, dated 23 March 1932, is written by the headmaster as a letter of reference, obviously with future employers in mind. Michael Weisenberg is described as 'trustworthy' with 'good powers of conversation', 'gentlemanly in his manner' and 'a lad of outstanding merit in the direction of artwork, especially in pen and ink sketching'. The headmaster hopes that he will be able to use this 'undoubted gift' in his work. A letter comes offering him a place at art school, but Rosa gets the letter first and hides it from him. He finds it later, tucked away in a drawer. He is just fourteen.

I remember him telling me that story once, and he talked about it in his oral history interview, too, but he did not say how he came to be offered the place—whether one of his teachers recommended him, or he applied. When I first heard that story from

my father I thought it a dreadful betrayal on Rosa's part. I would have hated her if she had done that to me. But my father made it clear that he bore her no ill will. It was the 1930s, the time of the Great Depression, and although London had not suffered as much as other parts of England, times were still tough, especially in the East End, where they lived. He knew there was not enough money coming into the house, and he knew too that the hardness of her own youth and life meant she could not see how art would be of benefit to him. I suppose many bright, gifted young people had to leave school early to help their families in the 1930s.

There is a photograph of young Michael Weisenberg on his way to his first job at a printery. I remember my father showing it to me when I was in my teens, maybe when he gave me that photograph of Rosa. He told me he was fourteen, but when I turn it over, I find he has written the date on the back, 17 October 1933—which means he was fifteen and a half.

The photograph is in a postcard format made popular by Kodak. Maybe a street photographer snapped him, or a friend? He looks toward the camera with a serious expression, nervous, perhaps, about his first day at work. His jacket looks shabby, and the sleeves are too short, as if he has grown out of it. His tie is skewed under his shirt collar, and he is drawing his jacket together as if he is cold, or maybe it is an act of self-consciousness in the face of the photographer. The shop windows reflect the scene across the road, and what looks like a postman with a bag over his shoulder walks in the background.

There is barely a sign of the combat cameraman in this young face, and nothing of my father it seems, but then I think that he is not my father, he is not even Mike Lewis yet, and he is not Sergeant C. M. Lewis the British Army combat cameraman. It is as if I have peeled away the mask of my father and am seeing just a young Jewish boy from the East End, lucky to be walking to his first job in a time of mass unemployment, perhaps wondering what else his life might hold.

After he left school, he tried to pursue his love of art and attended night school at the Hornsey School of Art until he found the long hours of study on top of work too much. The 1930s working day was generally eight to six, Monday to Friday, and

Saturday mornings. Not much time for other pursuits. I wonder if Hornsey School of Art was the same institution that offered him a place. It was an old institution even then, established in 1880, and considered to be a model of innovation and experimentation in art education. It must have been an incredibly exciting place to be, and Michael was very disappointed when he had to give up his studies. He stayed long enough to learn the rudiments of composition and graphic design, and to feel he had discovered his talent. He also stayed long enough to discover something else, something profoundly satisfying and sustaining: a world of new ideas that expanded his horizons, and teachers who engendered ideas and thoughts in him in a way that no one ever had before.

And there were a lot of new ideas and ideologies fomenting on the street corners of the East End in the 1930s. Christians, communists, socialists, fascists and trade unionists—all spruiked their causes and handed out pamphlets. A current of radicalism ran through the place, fuelled by a history of poverty, poor living conditions and the fallout of the Great Depression. There was another volatile element in this mix too—refugees. The East End had long been a magnet for people seeking sanctuary. Many dispossessed had disembarked at the docks, carrying their few belongings, before making their way through the fog along cobbled streets to overfilled, grimy tenements and sweated labour shops. French Huguenots, Irish weavers and Eastern European Jews—all who came brought with them their culture, customs, traditions and religion.

Though Rosa might have been a displaced person, she would have found much that was recognisable to her in the East End.

Almost forty years of Jewish migration had left its mark. Yiddish was spoken on the streets, and there were signs in Hebrew; the aroma of freshly baked challah, bagels and cheesecake came from the Jewish bakeries; kosher butchers catered to those for whom religious observance was important; and synagogues were dotted through the cityscape. The refugees changed their new country and were changed by it, especially their children.

Though he could not continue his studies, young Michael did not stop learning, and as he started to understand the social choreography of his world, he began to reinvent himself, changing his name from Michael Weisenberg to Mike Lewis to make it easier to find work. Shedding the baggage of his obligations to his religion and culture and daring to embrace a more secular self; discarding his Cockney accent, too, for one that did not mark him. Having heard him speak all my life with the unmistakable accent and cadence of the British broadcasters of his time, I find it hard to believe he ever sounded differently. It was as if he had made a list of all the things he needed to change to transform himself and his life—and remarkably, he did just that.

But there was one thing he could not get away from completely, no matter how much he changed, and that was anti-Semitism. When the subject was touched upon in his oral history interview, my father said that it completely puzzled him when he was young, and confused and bewildered him in his teens; that it was not something he cared to speak about even now, because the experience of it was so painful.

His naive belief that English fairness, justice and integrity were real and would prevail gave way to his lived experience. I suppose

you could change your appearance if you were one of those Jews who wore a black hat and had side locks. You could don a flat cap, and work on Saturday—but it did not matter. You would never fit in as far as some were concerned. You would always be an interloper.

I think of the hurt of it, of being abused and maltreated just for who you are, but then I realise I am wrong—that is not how it works. The recipients of this kind of odium are not hated for *who* they are but what they represent—the other—and the other can be anything you want it to be: a Christ killer, a usurer, a plotter, too stupid, too clever. Prejudice is a malleable type of hatred.

The Haskalah, the Jewish Enlightenment of earlier centuries, may have encouraged Jews to believe that secularisation would help them gain acceptance and the same rights afforded to their neighbours, but rights could be revoked, as German Jews would soon find out. At the Nuremberg Rally of 1935, discriminatory laws were introduced that denied citizenship to Jews, and a later decree defined who was Jewish on the basis of parentage. All of these changes signalled an accelerating circumscription of Jewish life and a de facto sanctioning of hate crimes against Jewish people. Romania, Slovakia and Hungary followed with similar laws. The tide of anti-Semitism was rising, and it was explicit, strident and widespread. England was not immune. Sir Oswald Mosley, leader of the British Union of Fascists (BUF), was openly encouraging anti-Semitic sentiment on the streets of London and especially in the East End. The BUF had a paramilitary wing called the Blackshirts who kept hecklers at bay at meetings, leading to some violent clashes.

In October 1936, Mosley tried to lead a march of about three thousand of his followers through the East End of London which had a large Jewish population. A petition to prevent the march had been rejected and protesters gathered to block the way. Estimates say six to seven thousand police, many on horseback, were sent to clear the way for the marchers. Instead, the 'Battle of Cable Street', as it became known, saw a hundred thousand protesters, including Jews, communists, trade union members, Labour Party members and Irish Catholics, stop the march by sheer force of numbers. I find a fascinating piece of newsreel footage on YouTube showing the crowd clashing with police on horseback.

My father says he did not go to the Cable Street blockade but did go to a meeting at the local town hall later that day. A *Guardian* newspaper report said that the communists and fascists both held meetings after the blockade, the communists at Shoreditch Town Hall and the fascists close by in Pitt Street. It seems likely that the Shoreditch meeting is the one my father went to.

•

Midsummer. A veil of smoke is drifting in from a fire out west, transforming the sun into a wan orange disc. The grass on Mount Majura, where I like to walk and think, is crisp underfoot, the bush silent, except for the almost sub-aural static of cicadas—the sound of the incendiary heat. I open my office blinds a little and peer out across the street. The scene wobbles in and out of focus in the heat haze. Resettling in Canberra has been unsettling, and at times it is unclear which decade of my life I inhabit, like a Billy Pilgrim fading in and out of the past. I feel a surge of protective

feeling toward the young Mike Lewis as he struggles with being an outsider, as if I have now become the parent and he the child.

As the months pass, Mike is emerging slowly out of memories, stories, interviews, film and photographs, caption sheets, and the mementos he chose to keep. I triangulate what I am learning with published histories that describe the events he was involved in, and with the testimony of others who were present at those events, sometimes with him. Pictures and scenes are developing in my mind like photographs in a darkroom as I reconstruct what happened and begin to write it down.

After Cable Street

Mike and his friend Harry are making their way home from a meeting at Shoreditch Town Hall. It was a lively affair, and the sense of passionate defiance that gripped Cable Street earlier is evident in the crowd as it pours from the hall and Hoxton Square, where the overflow of people was accommodated. The loudspeakers set up so those in the square could hear the proceedings are being taken down. There is an infectious sense of victory in the dispersing crowd. Earlier that day Sir Oswald Mosley's British Union of Fascists was stopped from marching down Cable Street. In a remarkable show of unity, Irish Catholics rubbed shoulders with Jews, and business owners with trade unionists, all declaring *No pasarán*—they shall not pass—a slogan borrowed from the civil war in Spain, which broke out a few months earlier.

A short distance away at an open-air rally in Pitfield Street, the routed Blackshirts and their supporters are also dispersing from a meeting. But there is no sense of defeat here; instead there is a righteous indignation that they were prevented from exercising their right to march along a route approved by the police. It just shows that what Mosley has been saying about the Jews and the

communists is right. A heavy police presence surrounded both meetings and is maintained as they break up. Emotions are still running high on both sides, and the police do not want a repeat of the afternoon's riot.

Even though they were not at the Cable Street blockade, Mike and Harry share the sense of excitement that pervades the evening and had listened enthralled as the various speakers recounted the events of that afternoon. Estimates about how many had turned out for the blockade vary. Some say 150,000 people, others 250,000. Some say there were five thousand police, others seven thousand. But all are agreed that the protesters filled the street, resisting all attempts to clear a path for the marchers. Barricades were thrown up and there were violent running battles between police and demonstrators. Women pelted the police from upstairs windows with rubbish and rotten vegetables and flung the contents of chamber pots at them for good measure. Word on the street is that the police were particularly brutal. Many were injured on both sides and there have been arrests too. But in the end the fascists were stopped. By direct action, the citizenry has put to rights what a petition of thousands of signatures could not—and whatever the Jewish Board of Deputies counsels, sometimes you have to take a stand.

It has been a cold start to October, and Mike and Harry turn up their collars and hurry home. They are headed for Stamford Hill, where they live. As they turn into a narrow street, Mike notices some youths up ahead. He cannot make out how many; they are out of the arc of the sporadically spaced streetlights. He nudges Harry in the ribs. He knows instantly that this is going to

get ugly. One of the group spots them and points a finger. 'Yids!'

The rest turn to look, following his finger.

Mike and Harry exchange a momentary glance of understanding before they leap past the men and run. About a quarter of a mile ahead—if they can make it that far—there is a junction where police are usually on duty. Adrenaline gives Mike and Harry an eruption of speed, and the youths are temporarily wrong-footed by their sudden flight, but they soon regain their senses and run after them.

'Get 'em! Dirty Jews! Commie bastards!' and other abuse shout down their flight.

It is a long and desperate sprint, and the sound of so many feet getting closer and closer is terrifying, but Mike thinks they can make it. He can see the old school up ahead, and that means they are almost at the junction. He feels no chill now and streams with sweat, part exertion and part fear. The junction appears out of the gloom as a light at the end of a tunnel, but as Mike lunges toward it, he realises that Harry is no longer with him.

Mike turns to see Harry, just behind him, slumping against the school wall as the mob rain blows on him. The junction is in sight, but Mike is transfixed by the image of Harry, head bowed against the raining blows. Having caught Harry, the mob seems oblivious to Mike. Something ignites in him, and without a plan he turns and rushes them, fists blurring. The fury of his attack makes them fall back from Harry, who lifts his bloodied face and, seeing Mike, puts up his fists defiantly. Afterward, when they talked about it they can never remember quite how they managed it—but somehow, they get away.

It is 4 October 1936, and Mike is eighteen. Abuse, racist graffiti, vandalism and beatings such as the one he and Harry have just experienced have all been on the increase in the lead-up to Cable Street. The success of the blockade does not bring an end to this behaviour, or the fear, or the taunting.

'The Yids, the Yids. We gotta get rid of the Yids.'

•

Rosa and Leo are worried about what is happening in Europe, and after Mike and Harry come home with bloodied faces and raw knuckles, their fears move closer to home. Already, Jewish shops are being attacked, their windows broken and their owners terrorised. Poor Rosa—she thought she had left that all behind.

She and Leo talk a lot about what is happening, and about Germany too, how Hitler is getting away with things. He sent troops into the Rhineland earlier in the year, in breach of the Treaty of Versailles, and no one tried to stop him. At the Games of the XI Olympiad, held in Berlin, he excluded German Jews from competing with barely an objection raised. Many Jews made stateless by the Nuremberg laws have sought refuge in England, and they brought with them frightening stories.

For Mike, his parents' fears do not seem real, in spite of his own experiences. He cannot accept that what is happening in Germany could happen in England, and he believes in the League of Nations. In his mind it is a shining, utopian organisation that will put everything to rights. There is also the siren call of new ideas like socialism and communism that promise a cure for all these ills. Things are changing, and in the future people will not

be judged anymore by their race or religion or class.

He feels his parents' dread, but he does not really get it. He wonders if their fears are a kind of race memory of all the terrible things that have happened to the Jewish people, transmitted from generation to generation through memory, or perhaps even genetically, though it does not occur to him that it might apply to himself. In the 1930s this is a strange notion, though many years later it will start to be accepted.

As 1936 draws to a close, there are reports about Stalin's purges and Germany's bombing raids in support of Franco's Nationalist faction in Spain. Rosa and Leo are convinced there will be war. On 12 March 1938, German troops march into Austria, marking its annexation. Many more Jews lose their citizenship and flee. The Évian Conference, convened by the United States to discuss the growing Jewish refugee problem, is a failure. The attending nations declare themselves sympathetic to the plight of the displaced Jews but will not make any commitment to take them in, saying that an influx of large numbers of migrants might import racial problems into their own countries.

Hitler seems bent on taking those territories he considers rightfully German. In September, the Munich Agreement between Germany, Great Britain, France and Italy allows Germany to annex the Sudetenland, part of Czechoslovakia. Britain and France hope it will appease Hitler and avert war. But this does not satisfy him either, because really he wants *Lebensraum*, living space, in eastern Europe.

In November, the assassination of a German diplomat in Paris unleashes a pogrom across Germany that becomes known as

'Kristallnacht' (night of the broken glass). The police are pulled back to allow an unfettered spree of terror, and in the aftermath Hitler orders the arrest of twenty to thirty thousand Jews. In March 1939, events escalate with the dissolution of Czechoslovakia and the creation of the pro-German Slovak Republic. Germany invades the remaining Czech territory immediately, in violation of the Munich Agreement.

Mike's world is gradually being reconfigured now, and he believes his parents are right—there will be war. It seems inevitable—an inexorable cascade of events with only one conclusion. Cable Street seems like a dream now, a brief, glorious moment of triumph against fascism. Poland is the next to be threatened as Hitler demands the return of the Baltic seaport of Danzig to German control. Britain and France make a pact with Poland to defend Poland's sovereignty. On 1 September, Germany invades Poland. Britain and France demand that Germany's troops be withdrawn, and issue an ultimatum.

On the morning of 3 September 1939, Mike is getting ready to go out. He has allowed himself the luxury of a lazy morning and is standing in front of a mirror, stripped to the waist, shaving and listening to the radio. He turns his face in profile and touches it to see if he has missed anywhere. He bends his head to the bowl, cupping water onto his face and neck with his hands. Then the familiar voice of BBC announcer Alvar Lidell speaks briefly, calmly.

'At 11.15—that is, in about two minutes—the prime minister will broadcast to the nation. Please stand by.'

A jolt of realisation passes through Mike like an electric shock:

the deadline for Germany to withdraw from Poland has passed.

It is a long two minutes. Mike dries his face, combs his hair and then stands waiting, staring into the mirror.

'You will now hear a statement by the prime minister,' Lidell says.

Chamberlain's clipped and measured delivery begins.

'I am speaking to you from the Cabinet Room in 10 Downing Street. This morning the British ambassador in Berlin handed the German government a final note, stating that, unless we heard from them by eleven o'clock that they were prepared at once to withdraw their troops from Poland, a state of war would exist between us.

'I have to tell you now that no such undertaking has been received, and that consequently this country is at war with Germany.

'You can imagine what a bitter blow it is to me that all my long struggle to win peace has failed. Yet I cannot believe that there is anything more or anything different that I could have done and that would have been more successful.'

Chamberlain's voice fades to a mesmerising murmur, rising and falling as he explains himself to the nation, and then breaks in on Mike's thoughts again.

'Now may God bless you all. May He defend the right. It is the evil things that we shall be fighting against—brute force, bad faith, injustice, oppression and persecution—and against them I am certain that the right will prevail.'

The radio falls silent—it is as if the whole country is silent until Lidell's voice is heard.

'That is the end of the prime minister's statement. Please stand by for the important government announcements which, as the prime minister has said, will follow almost immediately. That is the end of the announcement.'

Church bells start ringing on the radio and outside the window. Silence again from the radio for a moment.

'This is London. The government has given instructions for the following important announcements. Closing places of entertainment. All cinemas, theatres and other places of entertainment are to close immediately until further notice ...'

Mike stares at his reflection. The face that stares back is much the same as it was when he finished shaving only a moment ago but the world that it inhabited is gone now and the one to come is unfolding. In a way it is a relief that all the conjecture, the speculation, is over. Air-raid sirens begin their rising wail.

•

The heatwave in Canberra has passed at last. After weeks of burning temperatures, a soft grey sky teases the senses with the possibility of rain. I open the blinds and window to feel the breeze that is shaking the leaves with a soft, papery sound. A fine spray of drizzle blows in. Burying myself in the past has been a welcome distraction from the turmoil of the present. I am still sweating, still not sleeping. When I have exhausted reading, I watch old films, and when I am not up to either reading or watching films, I lie on the couch and stare into the dark. I still cry now and then. There is so much to miss about my old life. My beautiful garden, the softness of the subtropical climate, my wonderful friends, my young

pup Lily and, yes, even my husband, though I have no desire for reconciliation. I miss the things that have glued me together for a very long time now, and without them I am a psychic refugee, my being stripped back. Now I am seeing what is left, what can be pieced together. I think again of Rosa, uprooted at sixteen, and my father's theories of inherited trauma; perhaps Rosa and I do share more than just our likeness.

Waiting for war

Many things change after war is declared. Buildings are sandbagged, gasmasks are issued, windows are blacked out at night, rationing begins, squadrons of bombers fly overhead, and troops in trucks rush back and forth. Many things change, but nothing happens. A strange eight-month hiatus ensues: the Phoney War. It is a label that my mother might have argued with, Germany having invaded Denmark in April 1940.

Mike might also have taken issue with it, since it was in April 1940 that he joined the Royal Fusiliers in Hounslow, a pointed reminder that it was only a matter of time before phoney became real. I find a diptych in the family album that seems to bridge this strange time between the declaration of war and its unequivocal outbreak. I call the two panels the Boy Soldier and the Young Gentleman. They are on facing pages: the Boy Soldier on the left and the Young Gentleman on the right. There are no captions, though the photograph of the Boy Soldier, a studio portrait, has *F. Addy* and *Bargate, Boston* embossed in the bottom right-hand corner.

I know the Boy Soldier is Mike Lewis, but I am uncertain about the Young Gentleman. Is he still Michael Weisenberg, or has he become Mike Lewis? I do not know when he changed his name, as he did not make it official until after the war. Surprisingly, he spent six years in the British Army under an alias.

The Young Gentleman looks just as serious as the young Michael Weisenberg on the way to his first job, but there is more confidence in his bearing. He is wearing a smarter suit, and his tie is neatly knotted. The knuckles of one hand rest on a table, while the other is in his trouser pocket, holding back the flap of his jacket like a curtain swag. He has struck a sophisticated pose that references classical portraiture of men of power or learning. I wonder if it was his idea or the photographer's. Is it a statement of

reinvention? I think so. I think this is Mike Lewis. I can see this Mike shaving and listening to Chamberlain's broadcast, and I can see him months later reporting to the Hounslow Barracks of the Royal Fusiliers.

•

The new recruits are ushered into a hall, still in their civilian clothing, to listen to a pep talk from a young NCO. As the young officer offers his closing remarks, he makes what is, to Mike, an astounding statement.

'There's one more thing, chaps. From here on in you're in the army, and subject to military rules. And there are a lot of them. My advice to you is, of course, follow the rules, but if you … Well, if you should get into difficulties, let's just say … don't get caught.'

There is a slight stirring from the assembled tenderfoots, a murmur of appreciation and surprise, and then the officer is gone and military life begins.

•

The two photographs—the before and after of the outbreak of war—jostle strangely together on their opposing pages in the album. Mike Lewis the Boy Soldier is undoubtedly older than Mike Lewis the Young Gentleman. Yet it is the Boy Soldier who looks younger—fresh-faced and newly minted and a little lost. Perhaps it is the uniform that accentuates his youth.

It is spruce and clean. Boston is on the Lincolnshire coast, so maybe this is Mike in his new kit, having just completed basic training and on his first posting. The tightly clasped hands and

crossed ankles make him appear tense; perhaps he is wondering what to expect of the army. I suppose too that this is his first time living away from home. There is a directness in his gaze that is disquieting; his eyes seem to engage mine out of the past, and for a moment I am sure I see movement at the corners of his mouth, as if in the next second he will smile and speak to me.

What would he say? What could he say? I know more than he does—about his future, how the war will go for him, Mike Lewis, new recruit in the Royal Fusiliers.

Another photograph in the family album shows Mike with other young recruits, larking about for the camera. It is clear from their playful manner and casual state of dress, and undress, that they are off duty. Mike stands to the left of the group and forward of the rest. He is bare chested, wearing his regimental peaked cap, and has his hands clasped 'at ease' behind his back. He seems to occupy a quarter of the frame. The neat, serious Boy Soldier is gone, and the bare-chested Mike is smiling and looks leaner and

fitter. There is some sort of caravan with a serving hatch behind them. Perhaps this is the end of a training camp, and they have stopped for tea. The photograph's inclusion in the family album seems incongruous. I wonder why it is here, and not in my father's war diary.

•

Basic training ends. Military life continues. The recruits get used to being corrected for minor infringements: belt not centred perfectly, shave not close enough, boots not shined sufficiently. Mike learns about 'dumb insolence' and tries not to get caught for it. From the Royal Fusiliers he is drafted into the Queen's Royal Regiment with the rest of his intake.

The regiment is sent to guard the Kent coast, and Mike and his unit are stationed at Broadstairs in a hotel. Meanwhile, German troops sweep on through Europe. By May 1940, they are moving on the 'lowlands', and by June, Belgium, the Netherlands, France and Luxembourg have fallen in quick succession to the irresistible German blitzkrieg. The Battle of Britain is playing out overhead, and England is beginning to feel like the last man standing. At Broadstairs, Mike and his fellow recruits meet survivors of Dunkirk, who tell them disturbing stories of the horror of their escape and the might of the German military machine.

Mike is coming off watch one morning, just before dawn, walking back along the pier that juts out from a low cliff above the beach. It would be a pretty scene but for the metal scaffolding scattered across the sand to prevent landing craft and tanks getting up the beach. A familiar roar signals the early-morning patrol of two

British Spitfires. They are flying low and close, one above and just slightly behind the other. Mike turns to follow their path over the charcoal sea, which is relatively calm today. It is a glorious sight in the dusky half-light, two grey forms flickering as they turn slightly against the backdrop of the rising sun. Then suddenly the lower one is gone, and an ever-widening ring of ripples spreads across the surface of the water. A small fishing boat changes course and makes toward the epicentre of the ripples, but Mike knows it is useless—the pilot's death would have been instantaneous.

Sometimes the routine of military life comes as a welcome distraction. There is a lot of blanco-ing and polishing and cleaning of shoes and rifles, and there are parades too, and drills, week after week. Then someone has the bright idea that soldiers should get used to working at night and sleeping in the day. A sergeant major prowls the building looking for 'illegal sleepers'. The game becomes one of cat and mouse. In the rambling hotel, it is possible to get your head down and sleep, woken only by some deep inner instinct of the sergeant major's whereabouts, or by mates watching out for you. Mike participates in the 'illegal sleeping' but, remembering the young NCO's injunction, does not get caught.

The regiment is sent to Sussex, where the waiting and the boredom continue. Mike is 'browned off', along with thousands of other young recruits, but underneath is a grudging acceptance. There is a war on, and England has her back to the wall. What else can you do?

They are sent out on yet another mass exercise. The recruits are used to it now, being moved around the countryside like chess pieces according to some grand battle strategy. Military helmets

and woollen caps denote the opposing sides, and an officer in a white armband adjudicates, deciding who is wounded or dead. Those with initiative adapt. Instead of vigorously entering into it, as they did on their first exercise out from basic training, the recruits somehow manage to be seen by the enemy early in the exercise.

'You've been hit by machine-gun fire and are wounded,' says the officer, pointing to Mike and those in his vicinity.

The more theatrical of them fall to the ground, groaning and clutching various parts of their bodies. The medical corps arrives to triage the wounded. Everyone receives a tag describing his wounds and saying whether he can walk or not. In character, they begin to limp away. Mike is one of the last to be examined, and the young medic looks down at him with a serious expression.

'I'm afraid this is very bad—a stomach wound,' he says, tying the tag on. 'He'll have to be stretchered out,' he tells his aide.

'Stretcher!' the aide calls.

Mike is amazed at his good fortune as he is gently lifted onto a stretcher and carried out across the muddy ploughed field, past the walking wounded trudging in the rain. They groan more fervently when they see him pass by in comfort. Ambulances are waiting on the road, and Mike is transported to a warm, dry hospital, where he is given tea. Back at the battlefield, other heroes fight on for several more days.

It is September 1940 now, and the Battle of Britain segues into the Blitz as the Germans change tactics. Mike worries for his family, as the East End, and particularly the docklands, draw the brunt of the attack on the first day. Six hundred and fifty people

are killed, buildings are demolished and fires rage—and this proves to be just the beginning.

On leave, Mike meets his sister Nancy, and they walk home together past the rubble of bombed-out homes and buildings. Some streets are barely recognisable. It is the first time Mike has seen what has been happening night after night in London. It assaults the senses. Street trees have been snapped in half, and terraces opened up like doll's houses, with bits of furniture hanging precariously from their upper floors. There is a pervasive smell of dust and powdered brickwork, of burnt timbers and furnishings and smoke and something else too, slightly sweet, but as yet unrecognised. The pavement crunches underfoot with a gravel of glass shards and fine-ground rubble.

An air-raid siren starts to crank up, indicating another attack. Mike looks up at the sky; he can see the aircraft, tiny motes glinting in the late-afternoon sun. Then there is a sound that is fast becoming familiar to Londoners, the rush and whistle of falling bombs and the *bang, bang, bang* of ack-ack guns hammered out in reply. With nowhere else to go, Mike and Nancy duck down by the remains of a garden wall.

When there is a lull and the smoke has cleared enough, they make their way home to find Leo sleeping under the stairs, even though it is still early. Rosa sits in the basement kitchen. She has made cholent especially for Mike. She watches Mike and Nancy eat while Leo sleeps fitfully. Then suddenly there is a tremendous bang, and the house shakes violently as the bombing starts again. Leo sits bolt upright and yells.

Later, back at his barracks in Sussex, Mike watches the glow of

the fires in London and ponders the absurdity that soldiers tasked with defence of the nation and its people are safer than the civilians living in London … and other cities too.

One night, just after Christmas, the London skyline lights up with a brilliant orange glow. The roaring wall of flames is clear, though it is forty or fifty miles away. The whole of Mike's barracks assembles to watch. It is a frightening spectacle, frightening and beautiful. Mike wonders how anyone could live through that inferno, but his family survive … and so military life goes on in fortress England.

Blue wings

I was probably about ten when I realised my father had a fear of heights. I went with him to St Paul's Cathedral on one of those rare, privileged occasions when he took me with him to work. I cannot remember why we had come to St Paul's, but we climbed to the Whispering Gallery, and then higher still to an outside balcony with an iron railing. It was an impressive view, and I was occupied for some time trying to recognise landmarks, until eventually I glanced around and saw that my father was standing with his back pressed against the wall.

Seeing the puzzlement on my face, he said, 'I don't like heights.'

I was truly flummoxed. 'But you jumped out of planes,' I finally said.

'Yes, but I don't like heights.'

He did not tell me then or later—and strangely I did not think to ask—why someone with such an anxiety volunteered for the newly formed parachute brigade, but now I suspect it was boredom. Churchill had pushed for an airborne corps of five thousand men after being impressed by the German use of paratroopers in France. The chiefs of staff put out a joint memorandum that set

things in motion at the end of May 1941. It was a colossal undertaking and, when I think about it, a grand gesture in the midst of deep crisis. Airborne troops were still a relatively new development in warfare, and only the Italians, Russians and Germans had used them till now. The whole enterprise had to be planned from scratch, as there were no parachutes, no suitable aircraft and, most importantly, no expertise in parachuting. A training facility, the Central Landing School, was set up at Ringway Airfield, near Manchester, and the work began. Then a call went out for volunteers for the formation of four battalions.

•

Mike reads a notice asking for volunteers for a new airborne corps. Applicants will be selected on the basis of an interview and then sent away for a few weeks' training to test their suitability. Mike had been feeling ground down by the waiting and routine of army life. He had tried out in the medical section hoping to learn something useful but had been disappointed with the course. He is looking for something, anything, to break the boredom and convinces himself that volunteering will be like some sort of holiday. After all, he does not have to go through with it, the actual jumping. Probably he would not be able to go through with it, considering that he is scared of heights and doesn't even like fairground rides, like the big wheel. He is reassured at his interview when the officer tells him that if he doesn't make it through, he'll simply be RTU'd—returned to his unit.

What Mike does not expect when he reports to Hardwick Camp, with its rather drear redbrick huts and barbed wire fences,

is that being RTU'd will quickly come to seem like a terrible failure and that qualifying to become part of this newest branch of the armed forces will prove an irresistible goal.

The brigade is so new that it does not even have its own headgear yet, so each man wears that of his previous corps when they are on parade. Mike has never seen so many different types of hats, caps, tam-o'-shanters and cockades. He marvels at the diversity of the men, too, who come from all over the United Kingdom and were artists, poets, engineers, teachers, farmhands and labourers in their civilian lives.

In making their initial selection, the recruiters are looking for a particular type of soldier, capable of not just extreme physical fitness but also independent thinking. The sort of thinking that might not be appreciated in other branches of the military. Many who volunteer do not pass the initial interview. Those who do pass are about to undergo the most exacting and gruelling two weeks' training of their army lives, all carried out at the double.

Synthetic training, as it is called, breaks the parachute jump down into stages that can be practised on the ground as separate exercises: leaving the aircraft; descent and turning in harness; landing; and collapsing and gathering your chute. The volunteers are swung from ropes to test their vulnerability to airsickness and made to jump through the wells of mock fuselages, simulating the exit from the converted Whitley aircraft they are to use.

They learn to gather up their chutes in windy situations, an exercise giving cause for much hilarity and witty repartee. Strong gusts of wind drag the lighter recruits long distances if they are unable to get control of their chute or to release themselves from

the harness. It is not unusual to see a hapless man being dragged along the ground with an instructor running after, trying to catch him.

There is much weeding out, physically and emotionally, and their numbers drop away unnervingly fast. Mike is plenty fit enough, and he has managed to tackle most of what is thrown at them, but he finds the landing practice particularly difficult.

The recruits are required to jump from a platform about thirteen feet high, holding on to two gym rings attached to lines mimicking the parachute harness. After a swing or two, the recruit lets go, landing on his feet and using his forward momentum to roll. The officer below reminds them of the procedure.

'Remember, if you put one leg out, you could easily break it—so keep your legs together, then let go and roll with the fall.'

Mike has seen many of his fellow recruits perfect this art after a few goes, curling themselves up on landing, some arriving back on their feet with perfect balletic precision. It seems the stockier among them find it easier to master. But Mike, one of the taller recruits, tipping six foot, cannot do it. His feet touch down together, but every time he tries to let his head go forward into a roll, he stops short, convinced he is going to break his neck. The uncontrolled forward momentum sends him skidding and flailing off the mat, ploughing through the layer of liquid mud that the winter rains and hundreds of feet have churned, spraying himself and anyone close by. A resounding cheer of appreciation goes up from the onlookers.

In spite of these hiccups, the time finally arrives when the surviving recruits are deemed ready for their biggest challenge

yet—the qualifying jumps. They are to travel up to Manchester, to Ringway Airfield, and execute two jumps from a balloon during the day and one at night, and then five from an aircraft. After the successful completion of all jumps, they will receive their 'wings'— a shoulder patch of blue wings flanking a white parachute that will show everyone they are a qualified military parachutist. It is the grail. Many cannot sleep on their last night at the Hardwick barracks, as they anticipate jumping at last and wonder whether they will earn their wings.

They are in good spirits on the journey up and settle into their Nissen huts. It has been a wet winter, and there is much chitchat about the weather—if it will be favourable for jumping or not. Personally, Mike does not want any delays—he just wants to get it over with. Succeed or fail, it does not really matter which, as long as it is over. At least he thinks he feels this way until something he hears makes him change his mind.

The exacting physical and psychological demands of their training have helped to break down barriers, and Mike is beginning to make friendships among this disparate group of recruits, but there will always be one or two … Mike finds out that some of the men in his hut are laying bets that he will not jump, because he is Jewish. It is disappointing to hear, but he is not really surprised. Life has taught him to expect this sort of casual prejudice. He reminds himself that some of them have never seen a Jew before— a few were even gauche enough to express surprise that he does not conform to the caricature in their heads of a Fagin-like individual with long beard and hooked nose. All this is part of what he has grown up with, painfully, but this is not what influences his

decision. That comes from one of the friends he has made, who leans across and whispers into his ear, 'My money's on you, Lou, and there's quite a few of us rooting for you, too.'

In that moment Mike determines that his backers will not lose their money, but that his doubters and detractors will.

The first sight of the balloon with the cage strapped beneath it sends a nervous wave of banter and backchat rippling through the group. Suddenly it has all become real. Four men and an instructor climb into the cage and float up to a height of about eight hundred feet, whereupon the instructor gives the command to jump, one by one.

Time passes slowly for those on the ground waiting their turn. Again and again, they watch the balloon slowly ascend to jumping height. From the well in the bottom of the cage comes a man with a plume of yellow silk above him. The chute opens with a *crack* and then floats gently as a dandelion seed to the ground, or so it seems. As each man's turn grows closer, he suddenly feels the need to check his gear, or asks a mate to take a look. This goes on hour after hour in an agony of anticipation for those waiting. Finally, in the fast fading light of the winter's afternoon, Mike realises with a conflicting pang of relief and distress that he probably won't jump today—that the agony will persist. At four o'clock, the proceedings are called to a halt, and everyone returns to their huts. Those who have made their jump are maddeningly loud with affected bravado on the return journey, while the 'virgins' try to look nonchalant. Mike feels as if he will burst with the tension of having to wait till the next day, and he can see that the other 'virgins' feel little better. There is no sleeping for Mike; he stares out at the moon in a patch

of sky framed by the window and tries to hold his nerve, and then it is time for blackout.

The next day finds him sitting in the cage with three others. The instructor stands over them as they begin their ascent.

'Look at the silver fabric of the balloon above you,' the instructor says. 'Do not look down. Look at the balloon.'

Mike fixes his gaze on the balloon. This time he is happy to obey orders. There is a very slight movement, and then nothing seems to be happening. Perhaps there is a problem with the balloon. Although it is another cold winter's day, sweat begins to pour down Mike's face, and his heart hammers till it hurts.

'Do not look down,' the instructor intones. 'Look at the belly of the balloon above you.'

Mike's neck is starting to hurt with the effort of looking up, and he drops his gaze to the man sitting opposite, who has a hunted look. It is obvious he is in the grip of some deep inner struggle. Mike can see it in his eyes, which meet Mike's briefly before being jerked downwards, as if by an invisible force, to stare through the hole in the cage. The man's eyes widen and his body gives a visible shudder. *He's from Norfolk*, Mike thinks, for no real reason, before his own eyes too are pulled downwards. It is a terrible sight. Where the grass was, only two or three feet below, there are now hundreds of feet of air. The trees are like matchsticks, and a slight mist smudges the skyline. All Mike can hear now is the noise of his own heart.

'Number one!' yells the instructor. The stricken man opposite shuffles to the edge and dangles his legs through the hole.

'Go!' shouts the instructor.

The man disappears, and his static line snaps tight.

It makes Mike think of a hanging.

'Number two!'

The next man shuffles to the edge.

'Go!'

Then Mike's turn comes in a dream.

'Number three!'

Mike dangles his legs over the edge as instructed, his hands gripping the sides, ready to push off to avoid 'ringing the bell', as hitting your head on the sides of the well is known.

'Go!' shouts the instructor, and Mike is shooting downwards at a tremendous speed. He looks past his feet and sees that the ground is shaking and vibrating. No, not the ground—his body. Mike realises that he is trying to draw himself back from the up-rushing ground. He lets his body go, and in that second feels a sharp tug at his shoulders as his parachute is pulled open by the static line. Relief. He looks up and sees a gorgeous yellow silk canopy above him. Everything swings into focus now—trees, hedgerows, buildings and those waiting below. It is exhilarating. His whole body feels charged and alive as he tugs on his rigging lines and makes a neat landing. He collapses the chute and gathers it up as if he has done it many times before.

A man from his hut, Wills, comes running toward him. He is still waiting to jump.

'Mike, Mike, what's it like?'

Mike can see that Wills is filled with the same apprehensions he had just minutes before, and wants to be helpful.

'It's a piece of cake, Wills. A piece of cake.' He smiles

reassuringly. 'Now I think I'll go and pay the NAAFI a visit for my tea. I hope they've still got some rock cakes.'

'Rock-hard cakes, mate,' Wills corrects. 'If you don't eat 'em, you can always use them as a weapon.'

It is a sweet cup of tea, literally and metaphorically—a victory cup—though the rock cakes are teeth-breakers that needed a good dunk before yielding. But it is not over yet for Mike. He has not yet conquered his fear—in fact it is about to get worse, because tomorrow he has to do it all over again, and now he knows what it is like.

They graduate to jumping from the Whitley aircraft. Each time he jumps, Mike thinks that next time he might refuse—but each time he thinks he might refuse, he jumps. There are a few casualties among the other men, caused by awkward landings. Somehow he manages to get through unscathed and finds himself climbing aboard one of the converted Whitley aircraft and shuffling into position for his last, and qualifying, jump. The cramped conditions and mingled odours of rubber, petrol and dope no longer bother him. The instructor passes along between them hooking up their static lines, and the plane taxies for take-off. Fifteen minutes later, Mike lands at the jumping field and gathers up his chute, no longer a novice who can legitimately refuse to jump. Now he is a fully-fledged parachutist, and will get his wings and an extra two shillings a day for 'dangerous duties' and he will jump when ordered.

There is a lot of sentimentality about the wings. Mike feels it too. They are still wearing their old regimental headgear, whatever it happens to be, but the shoulder patch is something they now

share. They have all worked hard to get their wings—a symbol of achievement that draws them together and cements friendships. Some men want to wear the wings on their chest, like the RAF. Despite the cold, a lot of them refuse to wear their greatcoats when they go home, so the wings can be more easily seen.

Mike transfers to the 2nd Parachute Battalion in December 1941. He is twenty-three years old.

•

In Canberra, autumn is giving way to winter, and leaves blow about the streets, gathering in yellowing drifts here and there. I travel up north to my old home once more to pack up a few more possessions and to pick up my dog, Lily, and bring her back with me. I can tell she has suffered from the long months of separation; she is quieter and more reserved and does not exhibit her normal border collie exuberance. Mornings, I take her walking on Mount Majura, and in the evening she stretches out in front of the fire while I work.

I have been watching episodes of *The World at War*, a television series, which I remember seeing with my parents when it was first shown in 1973. At twenty-six episodes it is an epic series covering every theatre of the war and provides useful background for what I am learning about Mike's war.

The dining table is covered in books and documents, and on top rests a small, worn scrap of embroidered material, which I found tucked in between some of my father's papers in an envelope. I pick it up; the blue wings and white parachute are discoloured with age and the khaki background is frayed. A thread of grey cotton

hangs down from one edge; perhaps a remnant of the stitching that attached it to Mike's uniform. I bend down to sniff the fragile keepsake, half-expecting it to have some fragrance of khaki, of the army, of the past, but it is odourless. Time has removed any trace.

When I found the wings in the suitcase, I wondered what they meant, why my father kept them. Now I think I am beginning to understand. They signify achievement, but they also signify belonging. I think for Mike this sense of belonging was of even greater significance than the achievement. He was no longer an outsider but part of something—accepted and included in a way he had never been before. Though he had begun to move away from his Orthodox upbringing well before the war, the war's arrival and his co-opting into the army facilitated the break he wanted to make. He told me once that he started eating bacon in the army, and I wonder now if his family knew. It seems contradictory, but I begin to see that the army—this 'iron-hard' institution, as he described it—helped Mike find out who he really was, and who he could be.

Goodbye to England

Now they are qualified, the new paratroopers might have thought that life would settle back into the routine they had come to expect. But winning their wings is just the start. They begin jumping once a month, to make sure they do not lose their nerve, and they also begin battle training. They are told that a parachute operation is expected to be self-supporting and hold its own against superior forces for a time, after which they will be joined by land forces. They will take everything they need for the first two days of an operation with them: weapons, rations, radios, medicines. If they are able to commandeer transport, all well and good, otherwise everything must be carried—a tough ask if you are part of a three-inch mortar crew.

They train in what to do upon landing, how to find each other and form up into units; how to work out where they are and where their targets are. In teams they throw and catch huge telegraph poles; individually, they box, wrestle, throw medicine balls and are pitted against each other in unarmed combat. Mike tells the others that if they go at their training any harder, the blood won't get to their balls and they'll be neutered. There is much guffawing in

agreement, though Mike thinks one or two of the men look genuinely worried.

There are exercises too, out in the countryside. They go out for days with the bare minimum of equipment and rations and live off the land and improvise—the officers as well. Use of weapons and navigation by compass and stars are also part of the mix. Extreme physical demands are made of them, and long marches at fast speeds in full battledress are common. Many times they hardly have any energy to talk at all, but sometimes, when they have made it past the pain threshold and back again, they hit the sweet spot—like the time their company slogged home at the trot, euphoric, having covered fifty miles in just twenty-four hours.

These new soldiers attract attention, and at a time when there is not much good news, they fill a need. Other soldiers start to treat them differently when they meet in pubs, sometimes with unwelcome and rowdy results. Articles begin to appear about them here and there that credit them with spartan virtues. The phrase 'intelligent but tough' is bandied about. The paratroopers are learning that great things are expected of them, and soon they come to expect great things of themselves.

News of the Japanese attack on Pearl Harbor and America's declaration of war reaches them, and the Japanese begin attacking British possessions in the Pacific. By February 1942, Singapore has fallen, it is a terrible blow. But the end of February also brings some heartening news; C Company of 2nd Battalion, Mike's battalion, has completed a successful overnight raid on Bruneval on the French coast to steal key components of a narrow-beam German radar that their technicians wish to study. It is thought

that the radar is responsible for the heavy losses of RAF bombers. When C Company return the next day with the equipment—and a German technician for good measure—they are hailed as heroes. The paratroopers have struck a blow in the war—a great thing on the part of the newest branch of the armed forces.

Their continuing training manages to produce splendid moments of absurdity—like the time a Major Pine-Coffin lands in a cemetery, or the day when the wind gets up and two paratroopers, Mike being one of them, land in trees. The first unfortunate hurtles straight to the ground and breaks a leg when the tree collapses his chute, while Mike catches on a branch and hangs there like a Christmas present. He cannot make his quick-release work, though he hammers at it a number of times, and the harness begins to tighten painfully around his testicles. *This time I really will be neutered*, he thinks, but can do nothing but hang there, in extremis, waiting for someone to come and cut him down.

Gradually the connection that they all felt on graduating is maturing. Mike senses that they are being worked on by their trainers to blend them into a cohesive team, but it does not lessen the real bond that is forming through the shared adversities of a paratrooper's lot. He becomes especially close to Fred, with whom he is assigned to work in B Company's office. The work is interesting enough but not terribly demanding. There is time for two 'intelligent but tough' paratroopers to uncover inconsistencies in company paperwork. Mike is filing away documents when a firing range report gives him pause. He leafs through the earlier reports in the file and spends some time comparing results.

'Here, Fred,' he says. 'Take a look at these. It's the firing range reports. It's very odd, but the results seem to reflect exactly the rank of the firer.'

Fred takes the reports and flicks through them. 'Blimey, I see what you mean. The officers always get top scores.' Fred is straight as a die, and he is outraged. 'This stinks, Mike. We've got to get to the bottom of it.'

After much discussion, they work out that the only way to ensure that the firing range scores are accurate is to post a man at either end of the range to record the results and report back. These men would have to be trustworthy and able to keep their mouths shut.

When the scores come in and they collate the figures, the results are astonishingly different and it is hard to keep the news from spreading. They are inundated with requests to see the figures. To head off the stream of people coming to the office, they post the results on the bulletin board just outside. A crowd gathers. Seeing Major Cleaver striding toward them, Mike and Fred slip back in the office and watch from the window as the crowd parts to let the major approach the board. He reads for a few moments before tearing the notice off the board and turning to the men.

'Who's responsible for this?' Major Cleaver roars. There is a noncommittal murmuring and shuffling, but Major Cleaver is not waiting for an answer and, guessing the source, turns smartly and steps toward the office door.

'This doesn't look good,' says Fred. As the door opens, they snap to attention. Major Cleaver brandishes the firing range report at them. The reckoning is swift. There is no real defence open

to them, so they try to look suitably ashamed as Major Cleaver dresses them down.

'And you are never again, I repeat *never*, to publish anything without my express say-so.'

'Yes, sir,' they answer, and Major Cleaver dismisses them. Mike thinks that they have learned an important lesson about democracy in the army. There is none.

•

In May 1942, the paratroopers are given their official headgear, a red beret, and a shoulder patch depicting the Greek hero Bellerophon, wielding a spear and mounted on the winged horse, Pegasus. In October, the three battalions so far mustered begin training to jump from United States Army Air Forces Dakotas.

For the British paratroopers, used to the cramped conditions of the converted Whitleys, the Dakotas are luxury. You can stand upright and walk to your place and you have a seat. Their main problem is adapting to a side door exit. But the training does not begin well. On the first day, Mike and his 'stick', as a plane-load of paratroopers is known, are already safely down on the ground when they see a flailing man hurtling toward the earth, a wisp of unopened parachute streaming behind. The paratroopers call this a 'Roman candle', and those it happens to do not survive. Later they learn that one man got caught up on the tail of the plane and hung there, and that another had hit him and dragged them both down. Altogether three men are killed during this period of 'adaption'.

It is an unnerving introduction to an exercise that is already

fraught with tension. It is all too easy to lose your nerve for jumping—everyone has seen it happen. What amazes Mike is how quickly it becomes an unwritten rule not to criticise another man, however obliquely, if he jibs. Your nerve can go without warning just as you get to the door. They know that the man who comes down without jumping is, in a way, much worse off than those who jumped. It is rather like sex, Mike thinks—you build up a lot of tension leading up to the moment of the jump, and if you don't go through with it, you miss out on the bliss of consummation.

They are sent out on an exercise on the Exford moors. It is a wet one, and everything turns to mud after a week of constant rain, but the paratroopers get through in high spirits and end with a smoke bomb fight among the bell tents that have been set up for them. They are keyed up with the sense that something is finally about to happen. After the exercise, they return to barracks and are given leave.

They are now stationed at Bulford, in Wiltshire, and Fred, who grew up nearby, has a surprise for Mike.

'Mum's expecting us for tea, Mike—you too, Chalky,' he says to another of their friends. 'It's not far, and I've managed to borrow three bikes.'

They ride through the deepening autumn of the Wiltshire countryside. It is a glorious day, the windy wet conditions they endured while camping having given way to bright sunshine. The country lanes and fields have an idyllic radiance, and the Wiltshire downs are lovely too, with sweeping hills of green and little copses of trees scattered here and there. The sky is unusually clear, with only occasional daubs of cloud. After months of training, they eat

up the miles, talking to each other excitedly.

Fred's mother appears at the door so quickly when they arrive that Mike thinks she must have been watching for them from the window. An ample, motherly woman, she ushers them in almost immediately to a laden table and fusses over them while they eat. It is a magnificent spread—not just tea but high tea, fit for royalty, Mike thinks. There are bacon and eggs and bread and butter, jam and cheese, fruitcake, seasonal plums, every kind of goody and even a few bottles of local ale. She has been saving up her rations to spoil Fred and his friends. As the three of them stuff themselves at her urging, a few neighbours call in to say hello and see these strange new soldiers, the paratroopers. As Fred laughs and jokes with the visitors, Mike notices that Fred's mother is staring at her son with a peculiar expression.

•

There is a photograph of the three of them with Fred's mother, taken outside the front porch of the house before they headed back to base. Mike stands to the right of the frame, arms folded. He has been in the army for more than two years now, and the changes are noticeable. The Boy Soldier has gone and been replaced by a leaner, fitter and more worldly-looking young paratrooper.

Fred's abundant large curls give him a choirboy look as he peers, squinting against the sun, from behind his mother, while Chalky, hand in pocket, smiles like a man used to attracting attention. Fred's mother stands a little self-consciously among the three of them, smiling shyly.

I colour this image with the exuberance of that carefree ride through the English countryside, yet strangely a tinge of sadness attaches to it. I know that this is almost the last untroubled boyish moment for each of them, a moment that will inevitably be overwritten by what is to come. Then it becomes clear to me why these images of Mike in uniform are in the family album and not the war diary. The war diary begins in North Africa because North Africa is where Mike's war really begins.

Winter has set in. On clear cold mornings I walk on Mount Majura with Lily. I can see the distant blue ripple of the Brindabellas iced with the first falls of snow. In the rising sun, their irregular scallop of white pierces the eye. In the evening Lily and I share the couch, next to the wood stove that warms the house. She sleeps with a paw shading her eyes, snoring softly as I bone up on the Second World War and follow Mike's fortunes.

I have uncovered a lot about Mike, and myself, since I came back to Canberra, but still I have not faced the reason I am here. The reason I turned my life upside down. The five photographs remain as yet unassailable. *All in good time*, I tell myself. I think of the Belsen film I viewed at the Imperial War Museum in London, but somehow it seems a blur, as if I did not comprehend what I was looking at—as if it defied looking.

I take out the folder again, the edges of the five photographs protruding. Since I have not the heart to study them more closely, I look at them technically. The images do not quite fill the paper they are printed on. I measure the paper size; it is unusually large, 35 by 28 centimetres—size 11R, I discover when I check online. The photographs are too large to be part of the war diary, but their space in the timeline is filled by six other Belsen photographs and half a page of typed text. I can see now that the size of these images would have amplified the terrible subject matter for a child.

But why have these images been printed in this huge format? Why did my father keep them at all? Do they say something that is not said by those in the war diary? My mind will not go there, not yet. *All in good time*, I tell myself again. I must come to Belsen

as Mike came to it—after North Africa, and after Arnhem. There is a long way to go.

First blood

The Allies had argued about and then discounted an offensive in Europe. Now the plan is for an offensive in North Africa, Operation Torch. The Western Desert campaign, begun in June 1940 after Mussolini declared war on Britain and France, is now coming to a head. It has been a long and gruelling campaign, and the Italian forces have been joined by a German contingent, the Afrika Korps, under the leadership of Generalleutnant Erwin Rommel. The second battle of El Alamein is underway, and if the British are successful this time, the Eighth Army, under the command of Lieutenant-General Bernard Montgomery, will push Rommel's forces back toward Tunisia and into the Allies' oncoming First Army.

The plan is to land the Allied First Army at points along the North African coast and push toward the Eighth Army as fast as possible, ultimately capturing Tunisia and the city of Tunis. Churchill thinks this will be their way back into Europe, through Sicily and then Italy. I find a map of the Mediterranean and its contiguous countries. Northern Tunisia is like a clenched fist with a 'thumb' of land pointing toward Sicily and Italy beyond,

AIRBORNE TROOP ACTIONS IN NORTHERN AFRICA, OPERATION TORCH, 1942–43

separated by a narrow strip of sea. With Axis forces using the ports at Bizerta and Tunis to resupply their troops from the Italian mainland, it is not hard to see why taking Tunisia from them is the objective.

There is another reason too. Morocco and Algeria are under French colonial control and nominally part of 'free France', or Vichy France as it is known. Vichy France, which covers the south-eastern part of France, signed an armistice with Germany in 1940 when the rest of France was occupied. The Allies hope that the Vichy French can be persuaded to cooperate with them in North Africa.

As the British Eighth Army turns the Axis forces about and pushes them back toward Tunisia, the Allies assemble a large amphibious landing. It comprises over a hundred thousand troops and more than three hundred ships, split into three groups. The Western Task Force is charged with taking Casablanca in Morocco, the Central Task Force Orana in north-west Algeria and the Eastern Task Force Algiers, the Algerian capital. Mike is destined for the Eastern Task Force aboard the *Strathmore* with the 1st and 2nd parachute battalions and A Company of 3rd Parachute Battalion, B and C companies being already on their way to their first mission.

The *Strathmore* sails from Greenock in Scotland on 29 October 1942 under sealed orders, orders that are not to be opened until the ships are on their way. The men spend their time doing exercises on the deck, playing pontoon and trying to guess where they might be going. At night they sleep in hammocks below deck, which Mike finds tricky. His night is punctuated by spills onto the floor every time he turns in his sleep.

Then suddenly they are racing through the Strait of Gibraltar at night, and the next morning a blazing city appears on the horizon. It is Algiers, and Mike's first glimpse of the Mediterranean. Dazzling white buildings seem to rise up out of a pure blue sea, and the brilliant sunshine makes them shimmer like a mirage. Mike is so struck by this amazing luminous spectacle that he almost forgets why they are there. That such a place could exist only days from a grey and murky England with its fog and rain is a revelation to him, because, as for most of the young men shipped out to North Africa, this is his first experience of 'going abroad'. By the time they disembark at Algiers on 13 November, the 3rd Battalion's B and C companies, who travelled independently of the others, have already taken the port and airfield at Bône, in north-east Algeria, halfway between Algiers and Tunis. Operation Torch has begun.

•

The paratroopers in Algiers are stationed in an old school building in a district called Maison Carrée, while their equipment is moved to the Maison Blanche airfield close by. The First Army begins its march toward Tunis, and the next day, 16 November, 1st Battalion drops at the Souk el Arba airfield in Tunisia, tasked with securing the road intersection and making contact with the French forces at Beja, ninety miles west of Tunis. They are given a warm welcome by the locals on landing and press on with their mission. Meanwhile 2nd Battalion is being held in reserve.

Mike is on guard duty outside the school, watching the locals in long robes and turbans pass up and down. A terrible argument breaks out between two of the passers-by, and others gather

around, shouting encouragement. Mike is just wondering whether he should intervene, how far his jurisdiction extends, when one of the antagonists flashes a knife, and in a moment there is blood spurting from the other man's hand. Mike is startled; it is the first time he has seen blood gushing like that. He lunges toward the injured man and grabs him, trying to drag him into the courtyard. The man, mistaking Mike's intentions and thinking he is in worse trouble, resists, and a tug of war ensues as the man's attacker grabs him from the other side. It is chaos, and everyone is shouting, including Mike, who finally manages to drag the man away and toward the room that is serving as sick bay. He pushes him through the door.

'Quick, do something. Take a look at his hand—his thumb's nearly off.'

The surprised medics speedily treat the wound and bandage it up. The man's pitiful protests subside as he realises he is being helped. When the medics have finished, Mike escorts him back to the street, where the crowd that had gathered is still waiting. The man stands at the entrance, beaming, and holds out his thumb, bulbous with bandage, calling on everyone to look. A mutter of surprise and approval rumbles through the spectators as they turn toward him. Mike is relieved; he had begun to wonder if things might turn nasty after he dragged the man away. Still brandishing his bandaged thumb in front of him like a trophy, the man walks over to the incredulous onlookers, talking excitedly, clearly explaining what has happened to him. Though he cannot understand the words, Mike grasps that everyone is pleased and impressed. He realises that the local population are not used to

being treated so well and that this has done the reputation of the newly arrived paratroopers a power of good.

•

My reading habits have changed greatly since I began this research. From having avoided thinking and reading about war, recently I have done nothing else. I once skirted the shelves of military history in bookshops and libraries; now I stand and browse, looking for books of interest. Fortunately for me, the formation of the British Parachute Regiment and its operations are a popular topic, though strangely I find the regiment's time in North Africa under-represented. There are dozens of very good books on Arnhem, but I struggle to find enough detail of the Parachute Regiment's operations in North Africa to help me make sense of my father's account, which, though vividly evoked, is tantalisingly vague on the materiality of time and place.

The wood stove purls comfortingly as I make notes on cards, dropping them on the floor next to the couch while Lily chases phantoms, her paws twitching. I work hard trying to marry my father's account with the military histories to see what locations and actions I can identify. I plunge from the personal to the epic and from memory to history.

I look for images, trying to 'put myself in the picture', but there are really surprisingly few images of the paratroopers in North Africa, considering the paratroopers' novelty at the time, and the fact that great things were expected of them. I find none of the 2nd Parachute Battalion's B Company in the Imperial War Museum's online archive. There are some images of 1st Battalion on its way

to Souk el Arba, taken by Sergeant Wilson of No. 2 Army Film and Photographic Unit, but other images I find seem to have been taken later in the campaign, when the paratroopers were used as infantry. In one account I read Colonel Frost, commander of the 2nd Parachute Battalion, claims that information on the paratroopers' use at the battle for Tamera was deliberately suppressed, though he does not offer any explanation as to why that might have been.

Most of the images in the war diary were taken after the battle for North Africa was over, when Mike joined the Army Film and Photographic Unit. In these few photographs there are flat, treeless plains and distant slopes that—if I did not know better—might be somewhere in arid central Australia. In some a heat haze is visible, and one shows troops stirring the dust as they march past General Alexander, who commanded the desert campaign in North Africa. Most of the North African campaign was fought in the winter months, when it was cold and wet.

It was the beginning of winter when Mike's battalion went in, and cold; cold enough not to be able to sleep at night. They had been in North Africa only a few weeks, and I wonder how they adapted to the unfamiliar landscape, all their survival training having been done in the soft green English countryside. I remember how strange the dry bushlands of Australia were to me when I first arrived from England.

I get a better idea of the terrain and weather conditions from a documentary on the campaign in Tunisia, which has a compilation of Allied and Axis footage. I see barren open plains, treeless hills, deep, rocky wadis and driving rain, water sluicing over the

landscape. The airfields are mired in deep mud, so deep that the aircraft have to be dug out and soldiers struggle to walk. I try to imagine this landscape, and what it might be like to drop into it, to trek through it, but the whole thing seems too far removed in time and place to be imagined.

A thunderous crash outside intrudes into my reading as two possums drop onto the garage roof, each uttering a curious percussive gurgling sound indicating a territorial dispute. I push the curtain aside and open the door for Lily, who rushes out silently into the cold stillness toward the two dark shapes crouched on the garage roof. They stop their argument to turn their glowing eyes toward her, and then, even though they are well out of reach, they turn and shin up the overhanging tree.

Discretion is the better part of valour, I think.

In the light from the house, I can see the sparkle of frost beginning to settle. I shiver for Mike and those cold African nights.

•

It is late spring now and I am walking in a rugged stretch of bush known as the Budawangs on the New South Wales coast with an intimate from my past. Here the Clyde and Endrick rivers rise, and there are stands of gum and banksia trees and, in places, thick tea-tree scrub. The rivers are strewn with huge, smooth boulders and carve their way down to the coast through barren plateaus fractured by narrow ravines. It is hard walking, and we are carrying everything needed for seven nights out. The physical demands clear the mind like meditation and draw us together.

My months of grappling at the interface of memory and

history have been rewarded by finding clues that help me overlay my father's account on the published histories of the Parachute Regiment in North Africa and with the help of maps I begin to understand the strategies and logistics of the campaign. But the execution of these strategies at the frontline—that strange and ferocious place where reports of battle losses are often relayed casually, like sporting results, and the objectives sometimes seem insignificant—requires moral calculations that I struggle with. I feel as if I am still missing something that will round out my understanding of what young Mike went through.

If I had thought 'roughing it' out in the bush would bring me closer to his experience, I soon realise the folly of that notion. My walk is pleasurable—any physical 'hardship' rewarded at the end of the day with a swim in a rock pool, a drink of whisky as the last light slips away, and a warm, dry bed. The Australian bush can evoke strange moods; it can be alien and dangerous, but it is not hostile in the sense that a war zone is hostile.

We descend a deep cut down to the river below. The flow is low at the moment, but a flood could quickly fill this place. To reach the bottom, the sun penetrates through a narrow skylight. I have a slight feeling of claustrophobia; the air is so still down here. Even though it is early, we decide to camp, as we are both exhausted. There are still pools big enough to bathe in, and it is good to wash off the day's grime and change our clothes. We declare the cocktail hour and prepare our drinks and then a meal, but we are too tired to linger on and talk, and soon go to our tents to rest. In the relaxation after the day, the mind crowds in again.

Sleep usually comes easily after a day's walk, but tonight I feel

that it is uncomfortably close in the tent. I unzip the top of my sleeping-bag. I wish there was a breeze, but the steep sides of the gorge stop any movement of air. My face and neck feel damp, and I wriggle my legs out. My heart seems to be beating unusually fast. Perhaps I have a fever? I put the back of my hand against my forehead: it is damp but not hot. In the dark, I have a sense that the walls of the gorge are closing in, that all the oxygen has been sucked out of the air. I open the tent and thrust my head and shoulders out. The night is cool, and I gulp the air. A realisation rises: I am having a panic attack. I shut my mouth to slow my breathing, forcing air through my nose, then lie down again. It comes to me then, as I begin to quiet my mind and body, that this visceral experience of fear is part of war, and that while I have been busy trying to authenticate my father's memories and pinpoint them geographically and temporally, the real story lies just where he located it in his oral history: in his impressionistic montage of the sensory and psychic experience.

I begin to see now that it is at the intersection of personal and historical memory that a deeper knowing is to be had. Here the cost of war is counted differently, not merely in numbers, though those are bad enough. The personal narrative measures the war in loss: lost comrades, lost fathers and sons, lost sweethearts, lost limbs, damaged minds and bodies, and the numerous unimaginable (for the civilian) sufferings and hardships at the front. The personal narrative also measures it in the heart-pounding moments of kill or be killed; in the horror of traumas received and inflicted; and in how those who survived dealt with these things. I see now that my ponderings are really about my father's nature, about how

he negotiated the experience of war. Perhaps it should have been obvious. As I lie here in the dark trying to control my own primal fears, I wonder how my father dealt with his.

•

Back at home I pull out the war diary again to review the section on the North African campaign. As I open the cover, the Tunisie franc tumbles against the cover, its mix of Latinate and Arabic script signifying a French colonial past that began in the 1880s. There are three scene-setting images: two on the facing page and another overleaf. The first is of a young paratrooper with one hand resting on a memorial. His airborne insignia and sergeant's stripes are clearly visible, but the plaques on the memorial are unclear. The caption says it is Sergeant Christie at the 1st Parachute Brigade memorial in Tunisia.

The second image is a close-up of the memorial in which the words can be read. It lists the eight actions that the 1st Parachute Brigade was involved in at Bône, Souk el Arba, Depienne, Beja, Medjez el Bab, Djebel Mansour, Bou Arada and Tamera Valley.

In the captions accompanying the two photographs, Mike says simply:

> The 1st Parachute Brigade fought in the North African campaign. This campaign begun in Algeria and then for months in Tunisia was apart from the climax unspectacular in comparison with later campaigns. But in terms of the hardship and endurance for the individual participant it was great indeed. Until about three months after the campaign started the entire British force was one division of infantry, plus a tank formation, plus the 1st Parachute Brigade. The paratroops undertook three parachute operations of which one was unsuccessful. In addition they fought as infantry. Their casualties were heavy. On the site of one of their battles a memorial was erected. Later I was able to visit it with Sgt. Christie who is in the picture.

Over the page, a black and white photograph pasted over a coloured topographical map takes up half a page. The map shows the Lake of Tunis, Tebourba and very faintly Oudna. In the photograph, parachutists discharge from planes like pollen dust against a backdrop of sky. The whole thing reminds me of a filmic device of the time in which an aircraft traces a broken line across a map to denote a journey.

The photograph could have been taken anywhere, but to me its positioning over the map suggests it is one of the three parachute operations that were part of Operation Torch—probably 1st Parachute Battalion on their way to the Souk el Khemis airfield

in Tunisia, because there is a record of an AFPU cameraman, Sergeant Wilson, covering 1st Parachute Battalion's drop.

> The 1st-Parachute Brigade was made up of three battalions. One of these battalions the 2nd., flew from Algiers to a point south of Tunis in order to capture this city and port and so cut off the German Afrika Corps then retreating before 8th.Army. We were to meet a tank unit and operate with it, but when we arrived there was no tanks. Tunis could be seen from our positions south of the

An extended caption in the war diary outlines the fate of Mike's battalion:

> The 1st-Parachute Brigade was made up of three battalions. One of these battalions the 2nd., flew from Algiers to a point south of Tunis in order to capture this city and port and so cut off the German Afrika Corps then retreating before 8th. Army. We were to meet a tank unit and operate with it, but when we arrived there was no tanks. Tunis could be seen from our positions south of the city shining white in the sun, a blue lake lay to the west of it. One third of the forces who took part in the para., operation returned

to our lines some forty miles away. Later I heard that as our armour was not able to rendezvous with us as arranged the operation was cancelled. But by this time it was too late. We had taken off on a 300 mile flight and all efforts to recall us by radio failed.

It is a strangely dispassionate summation of the actions, particularly as only a third of 2nd Battalion returned.

•

Another year has turned a corner and another intimate from my university days has come back into my life. There is a feeling of synchronicity and symmetry in our meeting as we discover that during the intervening years we have both developed a passion for gardening and landscaping. When I discover a parcel of land in a beautiful hinterland valley of the far south coast of New South Wales, we drive out to the property together and make our way to the top of a vast shoulder of granite upon which another stack balances. A mop of creamy yellow rock orchids hang down from the rock between thick green leaf blades. Sitting among them, as if in her boudoir, is an enormous lace monitor, nearly two metres long. We look out over the small stone cabin below and across the valley and buy the place a few days later.

As we are clearing out the cabin of belongings that have been left behind, we find a tatty red cloth-bound volume, published in 1950—*The Red Beret: The Story of the Parachute Regiment at War, 1940–1945* by Hilary St George Saunders. There are all sorts of universes colliding in the bringing of this particular book to me

in such unexpected circumstances, but I struggle to read it at first. I am put off by Saunders' Boy's Own Adventure view of war and his rhetorical style. I have plenty of very good histories that eschew his eulogising tendencies.

But perhaps because of the way that Saunders' book came to me, I persist, and am rewarded with a great deal of useful detail and what seems to be insider information. Saunders, who was on Admiral Mountbatten's staff during the war, writes just a few years after its end, presumably drawing on battalion diaries and firsthand accounts. There is a rousing handwritten foreword by Montgomery of Alamein reproduced in the preliminary pages. Saunders' style reflects something of the times, and that is informative too. My education in military history is expanding. I now understand why there were a First Army and an Eighth Army in North Africa even though there were no second or third or other armies; apparently it confuses the enemy.

Saunders introduces me to the arcana of military language and nomenclature. Unfamiliar words like 'enfilading' and 'debouching' enter my vocabulary. I find that features such as hills and mountains can be referred to interchangeably by local names, nicknames and numbers, like Hill 648 aka Djebel Mansour, or the Bowler Hat aka Sidi Non Delaa. A number of the most prominent of these features are shown on maps as tiny inverted vees that seem to belie the fact that some are enormous obstacles.

Then there are the curious nicknames and diminutives of the officers and men: 'Swifty' Howlett, 'Boy' Browning, 'Dicky' Spender—there is a collection of Spender's poems among my father's things—and 'Chalky' White, who went to Wiltshire with

Fred and Mike. The names smack of boarding school and secret boys' clubs. Maybe the subliminal suggestion that the soldiers are really eternal boys, looked after by clever prefects (officers) and paternal masters (commanders), helps maintain discipline and morale in a situation where it is vital they obey orders. The intensity and uncertainty of war permits men to be demonstrative with each other; nicknaming can be a form of endearment. There are also the nicknames of the leading protagonists; the 'Desert Fox' aka Rommel; and 'Monty' aka Montgomery which seem suggestive of comic books—good old Monty up against the wily Desert Fox.

Naming can be a way of dehumanising an enemy, or making him less threatening—Jerry, the Hun—or exciting a sense of adventure, hence the exotic names for operations: Tuxedo, Wastage, Wild Oats, Beneficiary, Sword Hilt, Hands Up and Transfigure. These were just some of the operations planned and then abandoned before Market Garden, which took Mike to Arnhem. I wonder if there was a special unit devoted to the naming of military operations; the Office of Military Taxonomy, perhaps. Or maybe a marketing arm charged with this task—the naming of operations being of some public relations value. Though the moniker 'Wild Oats' left me smiling at this most obvious, and perhaps ill-chosen, allusion.

I study the map of the airborne operations in Saunders' book. It is clear that the three drops on 12, 16 and 29 November 1942—at Bône, Souk el Arba and Depienne respectively—are aimed at leapfrogging the Allies toward Tunis as fast as possible. But the success of this leapfrogging strategy is dependent on the First

Army catching up with the paratroopers, and the North African campaign had hardly begun when problems arose. In spite of its small size, the First Army had made reasonable progress initially, reaching Souk el Arba, but the onset of winter rains and the shortage of transport to bring up supplies began to slow it down.

It is into this rapidly turning tide of war that the 2nd Battalion is dropped. Paratroopers lightly armed and provisioned cannot survive long behind enemy lines without resupply. Ultimately they are in danger of being surrounded by the enemy—and this becomes the fate of Mike's battalion almost fifty miles behind enemy lines.

Blooding

After the success of the first two parachute operations at Bône and Beja, several attempts are made at deploying 2nd Battalion and then called off at the last minute. The seesawing of emotions that these cancellations cause frays nerves, and when a hangar at Maison Blanche airfield is damaged in an air raid, the men of 2nd Battalion begin to wonder if they will ever get to jump at all. Maybe they will just be used as infantry. It is not a happy thought.

Because of this, there is, perhaps, more relief than is warranted when, at midday on 29 November 1942, they board the forty-four Dakotas that are to carry them to the drop zone and into action for the first time. The plan is to land on the airfield at Depienne and walk about fourteen miles to Oudna airfield, with the goal of destroying any enemy aircraft found there. After that they are to link up with the First Army at St Cyprien, near Tunis.

The onset of the winter rains has turned the Maison Blanche airfield into thick mud, and take-off is difficult. As they leave Algiers and the soft, cultivated richness of the coastal strip behind in the mist and start to climb toward the foothills of the Atlas Mountains, the countryside becomes rugged, and the weather

rough; a few breakfasts find their way into the pail that is passed around. Spitfires and Hurricanes sweep around the Dakotas, protecting them against possible attack.

Mike stares out of the window at the changing landscape. When all traces of vegetation disappear, the Atlas Mountains rear up around them as they follow what seems like a natural pass. Their aircraft flies higher than usual because of the mountainous terrain, and it is very cold inside the aircraft. About three hours later, as he watches two eagles spiralling round each other in the distance, he becomes aware that they are leaving the mountains now and losing altitude. Olive groves appear below, and the crew chief shouts to them to ready themselves.

Preparing to jump, Mike feels that customary dip in his insides. He knows it from practice jumps, but now this is it—this is the real thing.

'Five minutes to go! Stand up!' comes the order.

Your face changes colour with the lights, Mike thinks, trying to humour himself. *Red for stand-by and green for go.*

The plane is bouncing around and they steady themselves against the fuselage, waiting. Then Mike sees the light go red, then green, and one by one they disappear into empty space.

They land on a parched open plain surrounded by a ridge of stony hills, dotted with some kind of thornbush. There is what looks like a cactus hedge in the distance and some low buildings behind. There are the usual few casualties on landing, and someone says that there was one Roman candle, though no one seems to know who it was. They are able to leave the injured with some sympathetic French farmers. The rest of the battalion set about

gathering their equipment and forming up into their sections and companies, but not without difficulty, as their drop was somewhat dispersed. Some mules and carts are commandeered, but a lot of the gear has to be lugged by the men along with their regular kit. Mike's job is to carry the haversack of grenades and the launcher—a tremendous weight, and very dangerous if you are hit.

The locals tell them that the Germans were in the area just three days before but have withdrawn to the north, and a reconnaissance patrol that passes through reports that the Germans have blocked the road toward Oudna. Lieutenant Colonel Frost, their battalion commander, decides that they will rest up until after dark and then take a track to Oudna through the hills to the north-east.

If the men think that the exercises they went through in England were gruelling, they are about to experience another, more profound level of exhaustion than they have ever known before. What starts out as a broad track quickly deteriorates and becomes jagged rock and loose stones; ordered marching is impossible and they trudge along in single file, for the most part silently. The track, such as it is, dips and climbs along the range of hills. In places it seems to disappear altogether, and even the mules suffer. Occasionally a wheel becomes stuck and the cart has to be pushed and shoved free.

Mike groans and sweats along under his perilous load with the rest of the men. Struggling to the top of one hill, he sees another loom out of the dark and lets his weighted legs carry him down and forward toward it mindlessly. When the moon rises about midnight he can see from the top of yet another peak their strange

caravan strung out along the track in front and behind. Short halts are called to let the men and beasts recover and everyone drops where they stand, gasping, before finding that, cruelly, it is too cold to remain still for long. As they start off again, Mike lets out an involuntary groan of pain as the straps of his haversack fit back into the tender furrows he feels sure they have carved in his shoulders. He staggers off toward the next hill. One of their sergeants comes after him.

'Mike, for God's sake ... drop it,' he says, tugging at the haversack, 'or you'll never get there.'

It is a tempting offer, but Mike knows the sergeant is just being sympathetic.

'No, sarge—the hell I won't. I've carried them all this way. But thanks.'

They halt just after four o'clock in the morning, having come out into more forgiving terrain. They are told to try to get some sleep, but Mike, like everyone else, finds it impossible because of the cold. They are on their feet again at six o'clock and moving out toward a well called Prise de l'Eau. B Company lead the way and establish themselves on one of the low hills overlooking the well. To the north-east Mike can see Oudna and the airfield—if it can be called that. It is just a flat field, bare of trees and houses, level and bare all the way to Tunis—enough for twenty airfields, thinks Mike. It seems deserted, and there is no sign of any activity, but there has been—a crashed aircraft lies crumpled in the middle.

Mike sits looking out from his post on a rocky knoll, feeling a bit exposed. No digging in here if you had to, and not much cover. He is still not used to the clear blue skies that North Africa can

turn on, so clear and bright that everything stands out sharply. Tunis is glistening white in the distance, with a topaz-blue lake to the west. Mike can see German Junkers taking off from the airfield at El Aouina nearby and thinks he can hear distant artillery fire. The intelligence is that the Axis forces are withdrawing toward Tunis.

About midday Frost gives orders to secure the landing ground below. A Company leads this time, with B Company bringing up the rear with headquarters. They skirt around what appear to be some sort of ruins not far from the railway station. A Company is the first to encounter resistance when they are mortared and strafed by German placements on an outcrop they are bypassing. They fight through and the enemy withdraws. Some of the men occupy Oudna railway station. At about 4.30 that afternoon, Messerschmitt fighters swoop low over 2nd Battalion's positions, but the men are well hidden.

Mike flattens himself to the ground on his back and puts his camouflage net scarf over his face, looking through the mesh at the oncoming aircraft. One seems to be heading straight toward him but swings around and dives low forward of his position, machine-gunning what Mike takes to be A Company. All sorts of things are whistling overhead and exploding around all of them, but no one is badly injured. Then enemy tanks appear to the north. Having found no aircraft to destroy at Oudna, Frost orders the men to withdraw south to their original positions at Prise de l'Eau to wait for a signal from First Army about their rendezvous.

That night is painfully cold, and no one can rest. In the early hours of the morning the word goes around that the expected

link-up with First Army will not happen. Mike quickly realises that they are now in an extremely dangerous situation, about forty or fifty miles away from their own lines at Medjez el Bab and running low on ammunition and supplies. Now that the Axis forces know they are here, it is only a matter of time before they are found. Mike wonders why they do not move out immediately, but they are ordered to stay put.

The three companies arrange themselves on the slopes around the well: A Company to the west, C Company to the south, and B Company, Mike's company, to the east, with headquarters at its back. About midmorning, while Mike is watching from his post, he spots two men heading down to the well to fill their water bottles, seemingly oblivious of how exposed they are. Mike is incredulous at the men's stupidity.

Then he sees an enemy armoured car approaching the well along the road from Zaghouan, to the south. All hell breaks loose, and a terrible confusion follows. Mike hears a shout in German and a sudden crackle of small cannon fire. A man halfway out of the turret of the armoured car is hit by a bullet, and someone hurls gammon bombs, but they do not hit the vehicle, which makes off back down the road to Zaghouan. Mike's heart is pounding—it all happened so quickly—and he keeps thinking, *Is this really war?*

A little later they can hear the sound of tanks manoeuvring. The armoured car has returned with the rest of the column and shelling begins, but the German column is driven back by their mortar fire, leaving a number of bodies behind. There are casualties on their own side too, horrible injuries caused by splinters of exploding rock. At midday they are given the order to move

to higher ground on a ridge called Djebel Sidi Bou Hadjeba, to the north of their present positions. As they are moving out they hear that some of their men were tricked by German tanks and armoured cars appearing from the south bearing the First Army recognition symbol, a yellow triangle, and taken prisoner. One of the prisoners was made to take a message to the battalion's headquarters, telling them they are surrounded, and to surrender.

As he climbs with his section to their position just on the crest of a flattish hill, Mike thinks that the Germans would probably have driven straight past them if the two men had not been down at the well. They can hear the German column manoeuvring, and there is no doubt they are being pursued. Then suddenly an enemy armoured car, cannon pointing toward them, appears, about a hundred yards away. Mike is glad that he did not drop the haversack. He sets up the grenade launcher and fires it, but is appalled when the grenade lollops out a few yards in front of him and explodes. Miraculously, it does not hit anyone.

'Jesus H,' he says.

He works quickly, altering the arc of the launcher and reloading. The next grenade seems to explode among the German troops behind the armoured car, who are moving up with the vehicle, hugging the ground. He can just make them out by the hump of their backs. He is surprised at the devastating effect: there is a sharp movement from all of them, and the armoured car stops coming forward—but more are on their way. The attack continues and the grenades run out. Mike and his section retreat further below the crest of the hill for cover. Just when it looks likely they will be overrun by another armoured car, paratrooper Harry Wain

arrives with a Boys anti-tank rifle—a strange-looking weapon with a long, slim barrel.

'Look,' says Mike, 'there's no cover, and nothing to rest it on to take aim. We'll stay below the curve of the hill, and when you're ready to fire I'll hold it up, but don't waste time—they're almost on us.'

Mike lies on his back, holding up the barrel over his head, and says, 'Right, fire.' He tilts his head back to see if he can see the armoured car. He is excruciatingly aware of each second passing. He keeps thinking, *Why doesn't he fire? He's taking too damn long in the aim.* Then he feels a powerful kick of recoil as an explosion hits his eardrums.

'Well, did you do anything?' Mike's ears are ringing painfully.

'No.' Harry brings the rifle down, and they quickly reload.

'Are you ready now?' Mike asks. 'Why don't you let me take it? You're taking too long in the aim. We've got to keep firing.'

'No, Lou. I want another go.'

Mike holds up the barrel again. The armoured car is less than a hundred yards away, an easy target now, but Harry hesitates.

'For God's sake, fire it! You're taking too long … fire it!' yells Mike, looking up at Harry. The armoured car is so close now that when Mike bends his head back he can see its cannon being moved slightly left and right. He knows it is lining them up. 'Fire it—fire it *now*.'

A tremendous explosion breaks over them both, and Mike cries out in shock and disbelief as Harry is split wide open from neck to legs. Blood and bits of tissue spray over him. Mike lies perfectly still for some moments before reaching up to his chest, trying to

brush pieces of Harry off himself. Then he notices smoke coming from his trouser legs: there are holes in the cloth and gouges in the flesh of his legs. But the armoured car has stopped coming forward, and the men with it. *Harry must have got the shot off*, he thinks. He cannot seem to make up his mind up to move, and wonders if he can. Suddenly a voice breaks in on him.

'Lewis, Lewis, come back.' It is Lieutenant Crawley, the platoon commander—he was just behind them during the attack. Mike rouses himself and manages to roll down the slope. Crawley's face is streaming with blood, and he has been blinded by the explosion.

In the late afternoon, Messerschmitts appear again but mistakenly attack their own troops, providing some respite for the paratroopers, until finally the fighting tapers off at dusk. Their attackers appear to withdraw. The order is given: on Frost's signal the men are to move out in groups and make their way back to their lines at Medjez el Bab, independently. The badly wounded will be left behind and cared for at a nearby farm. The walking wounded will make up a separate group.

They tend to Crawley's eyes as best they can and bandage them up. Mike's legs are beginning to stiffen with his injuries. When Frost gives the signal—a blast on his hunting horn—Mike's party hobble off down the mountains. It is a cruel journey for all of them. They put Crawley's hands on the man in front of him. It is very difficult going, because they have to move at night and the ground is rough. During the day they rest and hide as best they can among tussocks of grass. They run out of water but continue to make their way westwards, knowing the Germans are on the hunt for them, and not knowing what has happened to the other

groups of men. One night their sergeant major, the only fit man in their small group of walking wounded, goes off on his own. Mike supposes that he thought he would stand a better chance on his own than with the lame and the blind. Over the next days, the remains of the battalion straggle back to their lines. Mike finds out later, when he is recovering in hospital, that the sergeant major who left them was captured.

He is released from hospital after a short stay and rejoins the 2nd Parachute Battalion at Souk el Khemis. He considers his wounds trivial compared to those others have sustained. Hospital has given him time to think about what happened to him, to them all. They got a mauling, no doubt about it. Including officers, 266 men have been lost—two-thirds of their battalion. There is almost nothing left of B and C companies. How could this operation have turned out so differently from the Bône and Beja ones? Mike hears that the First Army could not get to them because the winter rains had turned the ground to mud. But surely they could have sent some help, and why was it that Frost took so long to give the order to leave, after he knew First Army was not going to meet up with them? The survivors who gather and talk about the Oudna operation share a sense of shock and a feeling of betrayal, of being let down by poor planning and inept leadership in the field.

•

Later military historians seem to agree that Headquarters First British Army were responsible for the disastrous operation, though they do not necessarily point to inept leadership in the field. Several of the accounts I have read mention the blinding of Crawley, who

recovered his sight and returned to his battalion; none mentions Harry Wain, who died saving Crawley and the others. Military histories drawing on company and battalion diaries focus on units of operation such as squads, platoons and companies, and the individual deeds recorded are usually those of officers and commanders. Maybe what the other ranks think and what they experience, whether they are alive or dead or wounded, is not significant to the outcome of the battle and the larger strategies of war. In the thick of fighting, their world is small, circumscribed by exploding shells, gunfire and the single purpose of survival. But it is clear from Harry Wain's story that they can make a great deal of difference.

And what of Frost's part in all this—was his leadership inept? The poor planning affected him too, but once they were in trouble did he lead his men well? What were his obligations when he found there were no aircraft at Oudna to be destroyed? Did he wait too long to withdraw toward the British lines? Should he, could he, have started back before he found out that their expected link-up with First Army was not going to happen?

I can see that my father would not have warmed to a man like Frost, a leader who rallied his men with his hunting horn as if they were a pack of dogs. His doubts about Frost run counter to the accepted portrayal of Frost, whom military historians mostly remember as the archetypal officer, the one who led the paratroopers in a heroic stand at the bridge in Arnhem, a bridge that was later renamed in his honour. By his own account, Frost was not happy with the way the 2nd Battalion was left unsupported and described it as 'the most disgracefully mounted operation of

the whole war'. Perhaps the truth lies somewhere in between, in that shadow land of war where moral calculations about risking men's lives must be made and lived with.

•

It is the beginning of summer, and I have moved out to our cabin in the bush. I let the quiet of the place and the rhythms of the bush take me over, getting up with first light and sitting out in the evenings watching the mobs of kangaroos that gather to feed as the sky darkens. I wish I could have gone to North Africa and visited the places that Mike fought in. It has been difficult reading and writing about what he experienced, but I have learned something important about him.

It comes back to me now what Harry Oakes, the AFPU cameraman who went to Belsen with Mike, said about him when we met. It stuck in my mind. He said that Mike was a 'soldier's soldier'. I was not sure what he meant at the time, but now I think I am beginning to understand.

Saunders recounts the 'initiatives' of two 1st Battalion officers, Philip Mellor and Stanley Wandless. Mellor, after wiping out an enemy outpost, sent his patrol back and entered the local town, Mateur, alone, walking the streets and 'pistolling Germans'. Wandless snuck into a German billet and threw a gammon bomb among some German officers who were dining. They seem like unnecessary actions, though Saunders sounds rather admiring of Mellor and Wandless, despite Wandless later being killed as a result of 'adventures of this kind'.

But Mellor and Wandless demonstrate that men faced war in

very different ways, according to their nature. I see now that some relished war, while some found it terrifying, and some did what they had to do, hoping to get through. I think Mike was in this last category, and that made him a reliable soldier to have at your side, 'a soldier's soldier', who would not take risks needlessly, and would not get you killed because of his own recklessness.

I was not expecting such horror so soon. I have been braced for Belsen, as if all the horror of Mike's war were bound up in that one event, but of course war is one immense horror made up of many small ones. Harry Wain was just one of the 266 men who did not return to their lines. My father lived his whole life without speaking about this terrible memory to anyone, except once, in his oral history interview. But how could you speak of such a thing to those you care about; to your children, even when they are grown up? Then it occurs to me that perhaps he did speak of these things in his own way, through the literature and films he led me to, like *Catch-22*. There are shades of the death of Harry Wain in Kid Sampson's and Snowden's deaths. Mike has been blooded, and the war is real now.

Red Devils

Mike kept his red beret and wings, but I cannot find the Bellerophon shoulder patch though I have searched for it. I wonder why it is missing. If he kept the wings, why would he not keep the shoulder patch? The three items would seem to go together as keepsakes—to ask to be kept together. I suppose that the shoulder patch could have been lost, but then again, perhaps he never kept it. It is puzzling, and makes me wonder if its absence means that it did not have the same significance for him as the wings and the beret. But if the wings are a badge of attainment and belonging, what does the beret signify?

I have it in front of me; it is musty from storage and makes me sneeze, and the first thing I note is that it is not red but maroon. It is made of what seems to be thick felted wool with a charcoal-grey cotton lining—maybe it was once black—and the size, seven and three-eighths, is still faintly visible printed in white. A leather strip binds the edge and provides a channel for a strip of material that still hangs down like a tail, presumably for tightening the brim. There are two black metal eyelet holes toward the back on the left side, and a silver metal cap badge incorporating the wings emblem

topped with a crown and lion positioned slightly to the right of the centre front. The badge is oddly shiny and new looking against the moth-pricked felt and faded lining.

I pull the beret on, tilting it down slightly on the right side like paratroopers in the photographs, and go to look at myself in the mirror. It fits surprisingly well, given my father was a large man, and tall. I wonder when he last wore it, and if it went through the whole war with him?

Back at my desk, I search online for more information about berets in the army. It seems a strange piece of headgear for a soldier to wear—not very protective, I think, but then I learn that berets, a twentieth-century development in military headgear, are swapped for metal helmets in combat. I learn too that berets have many beneficial attributes that appeal to the military: they are cheap and easy to make and can be worn with headphones. I find YouTube clips showing how to 'shave' and 'shape' your beret. The main thing I learn from my skim reading is that the 'Red Beret' is synonymous with the British Parachute Regiment, and with another name for the paratroopers earned in North Africa, the 'Red Devils'.

Mike also kept a slim blue book, *Parachutist* by 'Pegasus', with his memorabilia. It seems to be one of the earliest accounts of what it was like to be a volunteer paratrooper and was written by a Corporal Mayberry under a pseudonym, because the war was still on. Sadly he was killed the year it was published, 1944. In the introduction, he explains how the paratroopers came to acquire the appellation:

This title was given by the Germans themselves (Roten Teufel) to those men of the 1st Parachute Brigade who held some of their finest troops at bay for several weeks [in Tunisia] and taught them to fear the strange battle-cry of 'Wah-haw-Mahomet'.

A handwritten inscription on the flyleaf says: *To Lou (that mighty disciple of Wah-haw-Mahomet) + all best wishes New Year 1945 from Chris.* I think this Chris must be Sergeant Christie, the one in the photograph at the beginning of the war diary.

So Mike, my father, is the stuff of legends. It is astonishing and strange to think that the young Mike Lewis was a warrior hero. I try to imagine him charging into battle—a mighty disciple—yelling, 'Wah-haw-Mahomet!' I am intrigued as to how that battle cry came about.

I wonder too how heroes are made—by fate, by circumstance, by the wearing of a shoulder patch? Young, spear-wielding Bellerophons flying to war on winged horses. Perhaps heroes are necessary to war, to make it more bearable. Else how could you endure the terrible losses, the hundreds and thousands of Harry Wains, if they were not the heroes?

Mike has annotated the paragraph about the Red Devils in the introduction with an asterisk and written below: *Tamera Valley.* Is this where he thinks the name was forged?

The beret is still on my head, and I reach up with both hands to touch it, as if I might find some answers trapped there in the felted fabric, some memories.

Eisenhower has decided to delay the advance on Tunis because of the weather, which gives the Axis troops time to reinforce. Allied and Axis troops are facing each other across a 'static line' from the Mediterranean in the north to Gafsa in the south. The 2nd Battalion is reinforced with new recruits fresh out of training, and Mike and others of the originals left form up in one company. They gain some comfort from staying together. The 2nd Battalion is sent to hold positions in the Beja area while the 1st and 3rd move to Algiers for a new parachute operation. Saunders claims that it is while the 2nd Battalion is in the Beja area that the battle cry Wah-haw-Mahomet was adopted. He says that the locals shouted messages from village to village, and each message began with that call and the men copied it. This story has many versions, and the origins of the battle cry many claimants.

Toward the end of the month, they hear that airborne operations planned for the other two battalions have been cancelled, and that a decision has been made to use the 1st Parachute Brigade as infantry to reinforce the line wherever there are weaknesses.

On 8 February 1943, the three battalions come back together in the vicinity of Bou Arada, south-west of Tunis, which becomes known as Happy Valley, named because for a fortnight or so there is not much action. After two months in North Africa, the men are veterans and have adjusted to the routine of soldiering and living in the mud and wintry chill, though Mike is still surprised that North African nights can be so cold. The wind never seems to stop blowing, and they wrap their plastic gas capes round themselves to keep out the tearing gusts.

In Happy Valley, Allied and Axis troops oppose each other

along two ranges of hills, looking out over the scrubby trees and bushes and the broken ground of a valley that runs north and south. Even with all the battalions back together, there are not enough men to cover the line that they have been sent to reinforce. Frost spreads out the 2nd Battalion over three miles. The spaces between are filled by artillery. Sometimes they are ordered to take the trench mortar to another position, set it up and fire off some bombs before coming back again. It is exhausting, but Mike supposes that it keeps the enemy guessing how many of them are actually there, and where they are.

One day after artillery practice, a local Arab sweeps toward their position, yelling and sobbing. It is such wild, remote country that Mike is surprised to see him. He is wringing his hands and gabbling a story that Mike cannot understand but someone translates. Fragments of shell have hit the man's only cow and it is dying, and what can he do for milk for his children, so it is interpreted. The man's keening over his loss is one of the saddest things Mike has heard.

Mike's world is beginning to take on a different shape now. He knows it was silly, but somehow he had expected to see Hollywood-style Arabs in flowing robes riding white horses. Instead he has seen poor, downtrodden and starved people whose thin blue limbs shiver and shake in the winter chill. Perhaps Mike's experience as an outsider gives him a special sympathy with them. They are caught in a titanic struggle taking place across their land, a struggle not their own, and yet everyone is indignant at them, calling them 'pests' and 'looters'. It does not seem to worry anyone else that the Allied and Axis forces commandeer the locals' mules, donkeys

and horses to move supplies, or summarily shoot those believed to be collaborating. They are just in the way.

The veteran paratroopers find new recruits can be a health hazard to themselves and others, and Mike and 'little Geordie', with whom he is on duty, are dumbfounded when a newly arrived major exposes their position on a hill by driving his fifteen-hundredweight truck almost to the top and stopping.

'Good God almighty,' Mike mutters as the major jumps down smartly.

'Aye, they'll see us right enou,' says Geordie, and as the major approaches they stiffen up their stance in lieu of coming to attention.

Things take an unexpected turn as the major looks them up and down without saying a word. They are covered in mud and have several days' growth of beard. He is plainly outraged, and the lecture begins. Standards must be upheld, military pride, what did they mean by it. Mike knows there is nothing they can say, no use telling him they would love to have a shave and clean the mud off, but Geordie tries.

'Well, sir, we only had three razor blades when we invaded Africa.'

'Well, man, you could have sharpened them, couldn't you?'

Days later, the same major takes two of their section on what everyone considers a useless and dangerous mission to capture a machine-gun nest. He never returns, but the two men do.

On the morning of 26 February, not long after Mike and Geordie have come back with their breakfast from the cookhouse, the relative peace of Happy Valley is shattered as a big attack

comes in and the whole brigade is engaged. From their position near the top of the hill, Mike and Geordie can see groups of Axis troops moving, tiny against the brown earth and sparse greenery. Then the Allied mortars go into action up and down the valley, Mike and Geordie's with them.

Their hands seem to blur as they flash mortars into the barrel in rapid and rhythmic succession. Even so, the mortars appear to reach the Axis troops slowly: the troops look around and move uncertainly left to right. Suddenly everything explodes around the attacking troops, and they begin to scatter. Lieutenant Crawley orders Mike to go with young Lance Corporal Thompson to the other side of the hill, to the position where the dead major had dressed him and Geordie down. This is a blind spot, and Crawley wants to know if an attack might be coming in from there. They have no problem getting there but almost immediately become pinned down as shelling starts. It is too rocky to dig in, even if they had time, and they do the best they can to take cover as the shelling continues.

From a wooded area below, a line of enemy troops break clear and run toward a dirt track that climbs another, undefended hill, which if captured would outflank their defensive positions. Almost immediately, the paratroopers' artillery, which had been registered on the spaces in between, opens up. The men below can be seen quite clearly, throwing themselves over a small bank that lines the road leading upwards, but they find no cover there, and the explosions fall among them with terrible and deadly effect. Mike feels sorry for them, but at least for the moment he and Thompson have some respite.

'Lou, Lou,' comes from behind them, as Mack, who is acting cook for the day, crawls toward them on his belly. When he reaches them, he heaves out of his battledress jacket a tin of steak and kidney and a tin of rice pudding for each of them, already opened. He has been crawling up the hill to each group of men, even though everything is blowing up around him, to bring them food. They eat with their fingers. Mike thinks it has all the mad sense of a dream, eating food and watching gunfire fall on your enemy. As Mack crawls away, more enemy troops break from the trees and make for the road, where the previous group lie wounded and dying. The artillery opens up again and the shells explode among them, and as before they have nowhere to go. Mike thinks how awful it is for them and is thankful that they are too far away for him to see what is happening in detail.

'We ought to get back,' Thompson says as the enemy's barrage finds them again. 'This shellfire ...' He cannot seem to find the words to finish the sentence, but Mike understands his anxiety.

'I'd like to,' says Mike, 'but it's too risky moving just now, and we'd have to get a helluva long way back to be safe. Besides, they need us here—we're the eyes and ears of the others.' Thompson nods; he can see the sense of it. As the evening draws in, shelling stops. They have been in battle for the best part of nine hours.

During the evening, Mike is ordered out on a patrol with Captain Stark to mop up. They find a lot of weapons, including two-inch mortars on small wooden carts. There are masses of personal goods, too, lying on the ground: perfume, coloured postcards with religious images and others showing Mussolini or the Pope holding a cross and leading troops to war. Mike is

incredulous. He wonders why men want such things when they are going into battle.

A burst of gunfire up ahead cuts off his speculations and sends him diving for a large hole. Regaining his feet, he scrabbles to the edge to rest his rifle and peer out. He thinks he knows where the gunfire is coming from and returns fire into the dark. Then someone else tumbles into the hole and elbows his way to Mike's side to rest his gun on the edge of the hole too—it is Geordie. It goes quiet for a brief moment, and then another burst of gunfire sends another paratrooper diving for cover out of the darkness. They give him a brief glance before replying to the burst of firing, which then ceases.

'Now come on, you lot—get out of there,' says the last man in. Mike and Geordie turn to look and are aghast to see three Italian soldiers in the shadows.

Mike tries to point his Lee–Enfield at the Italians, but they have already moved toward him, arms outstretched. He steps back to be in a better defensive position, but the hole is too small. The Italians are so close now that his rifle points uselessly beyond them.

'*Inglesi, Inglesi.*' One of the Italians embraces his neck and tries to kiss him with embarrassing ardency. The man reaches into his pocket and pulls out a smooth egg-shaped object that Mike realises with alarm is a grenade. But before he can react, the man has unscrewed the grenade and is offering everyone cigarettes. The situation is getting more ridiculous by the second. Mike refuses the proffered cigarette, which exudes a too-perfumed fragrance for his liking, and tries to move to a position where he can use his rifle if he needs to.

'They must have been watching me all the time,' he says to the others. 'Could have killed me, while I was on my own. They must have been terrified.'

It is clear from the Italians' pantomime that they wish to be taken prisoner. After Mike and the others chivvy them out of the foxhole, thirty more appear out of the bushes to give themselves up. They have been waiting for Mike and his patrol and are very happy to see them. It is a busy night.

Later they hear from those who can speak a little English that the Italians were afraid of falling into the hands of the Australians or Indians, who, they had been told, would finish them off. There are also complaints about their allies, the 'Boche', and the fascist government back home. They tell stories of how any hint of rebellion against the government is put down with machine guns by the Germans. Mike cannot blame them for wanting to be out of the war if their hearts are not in it, and it seems the other paratroopers are sympathetic too.

A wounded Italian is carried back and made comfortable in a bed, and the paratroopers take turns to bring him tea and cigarettes and little drops of booze. Mike thinks it comforts the Italians. If you are in enemy hands, at their mercy, you must worry what will happen to you. To be given a cup of tea or a sweet is comforting not just for the sake of the items themselves, but for the consideration they suggest.

Much later, they go out to look for one of their patrol, Lofty Firth, who has not returned. He is found, rigid, having taken a shot straight through the head.

On 5 March, they hand over Bou Arada to the Americans.

The Axis offensive is failing all along the line, except in the north, near Tamera, and it is here that the 1st Parachute Brigade is sent next.

•

Saunders says it is while searching prisoners in the Bou Arada area that men of the 3rd Battalion discover pamphlets giving instructions on how to fight the 'Red Devils'. I see now that nicknames can also signal respect for an adversary. It is strange, though, that I can find no copies or reproductions of these pamphlets. They would surely have been worth souveniring. Maybe that was not how the nickname became known. I think of the annotation Mike made in his copy of *Parachutist* under the paragraph on the Red Devils—*Tamera Valley*—and I wonder again if he thought that this was the place they earned their title.

•

Tamera is close to the Tunisian coast, between Bône and Bizerta. By 8 March, the entire brigade has been deployed astride a road near the village of Tamera, facing half a division of Axis troops. The 2nd Battalion is trucked in that night to relieve a battalion of the Lincolnshire Regiment on a steep hill covered in corkwood trees at Sidi Mohammed el Kassim. The 2nd Battalion is attacked there at dawn, almost before they have finished deploying. The new terrain presents the paratroopers with a very different battleground from the sparse vegetation and rocky hilltops of Happy Valley. Here the enemy can get up close without being spotted, and the Axis and Allied troops become wound round each other like constricting

pythons. The soldiers on both sides dig defensive slit trenches along their frontlines. Mules ferry ammunition and supplies. The weather is still cold and raining and nothing stays dry as the ground turns to a sticky red mud and rain fills their trenches.

From 8 to 17 March, the fighting is ferocious and the barrage of artillery and air attacks relentless. There is little respite, and the casualties mount quicker than they can be replaced, but the battalions do not give ground. Mike is no longer sure how long they have been living like this—is it weeks? Normal life seems far away, further even than England—as if there is nothing else but mud and shellfire and gunfire, and standing in the cold, and this terrible tension as to whether you are going to be hit, and if you *were* to be hit, whether it would be clean or whether it would be nasty. Everyone feels it: the uncertainty of the next hour, the next minute, as they grow smaller in number. There are casualties every day. The world is nothing else but this.

By 17 March 1943, their forces are so depleted they are forced to fall back; 2nd Battalion has twenty dead and 150 casualties. They are pulled back in daylight along the Oued el Madene River. They are supposed to be able to follow its course, but at times they have to wade in chest-high water, holding their weapons above their heads. It is exhausting, and all the while German artillery, who hold the high ground on the other side, shell and mortar them, trying to get their range, which eventually they do. Mike and his group have just climbed back onto the riverbank after a long wade when a shell lands almost on top of them but does not explode. They are too exhausted to move and stare at the shell in a dazed state, not quite believing their luck.

By this time a new name for the river has passed up and down the line of retreating paratroopers: 'Shit Creek'. Mike tries to avoid the necessity of wading, but the bank is steep and at times he nearly slides into the river. Everyone is so tired they have no energy to be worried or fearful of the artillery fire anymore. Occasionally a shell lands among them and the water streaks red with blood.

Weighed down by water, caked mud and equipment, Mike's braces give way, and his trousers begin slipping down over his hips. He stumbles and slithers along the bank, trying to keep his trousers up with one hand, this new difficulty taking his mind off all other problems. Another paratrooper, Harry Bates, notices his predicament and lends him a belt. At about three o'clock in the afternoon, they reach the confluence of a stream with the river and are able to pick up and follow the railway line to Nefza station without attracting any further attention from Axis forces. Two men have been killed in the withdrawal; eleven are wounded and five missing. The 2nd Battalion is quickly relieved and sent to recuperate at Tabarka on the north-west coast for a week.

It is spring, and the weather is starting to warm. Sitting on their outside communal loos, the men enjoy the simple pleasures of life. Away from the sound of guns, the sun on their faces, they share their letters from home.

'Have you heard from your wife?'

'Yes, she's had the baby.'

'Have you heard from that girl of yours at the Rose and Crown?'

'No, me mate said she's gone off with the blanky fire warden.'

'How's your mum?'

'She's better—sent me a picture of her and Pa.'

Each man sits on his particular throne, shouting along to the others. It seems to Mike they are combining two heavenly exercises, marred only by the flies, which are big as Junkers and keep buzzing around like mad, attracted by all the human activity.

The original paratroopers who shipped out from England are a small group now, fewer than thirty men, and they form up into a platoon. They share a closeness born of their bloody experiences and the luck of their survival. They also share the indelible grief of their lost comrades. They gather together to chew the fat and drink a strong mash of tea. An observer from the Royal Artillery tells them that there were quite a few unexploded shells, and that these were Czech-made, filled with sand. They clink mugs and give thanks to the brave Czechs who risked their own lives to render the ordnance useless and undoubtedly saved many others.

There is other news too, which Mike finds appalling. Frost's batman tells him that the signal to withdraw along the river had come through in the night, but Frost had drunk so much they could not wake him to give the order till morning. At least it made sense now of what had seemed an essentially nonsensical decision: to make themselves easy targets by withdrawing in the day.

The withdrawal along the Oued el Madene River and Frost's part in it must have played on my father's mind over the years, because at some point he felt it important enough to write down: I found some undated typed sheets among his papers. Coupled with the Depienne 'mauling', I suppose it gave him reason enough to doubt Frost's abilities as a leader. The amusingly ambiguous title of Frost's autobiography, *A Drop Too Many*, could be an admission

of his fondness for liquor. Was he really dead drunk, though? It is unlikely we will ever know, but he would not be the first soldier to self-medicate through a war.

•

When their period of recuperation is over, the 2nd Battalion joins the rest of the 1st Parachute Brigade at new defensive positions in the Tamera Valley. They are to hold three steep hills known as 'the Pimples', a name which belies the fact that these are huge masses of solid rock, making 'digging in' nearly impossible. But the paratroopers will not be there for long, as the last battle in the Tamera Valley is about to begin.

The largest of the Pimples, known as the Bowler Hat, is held by 3rd Battalion, and a black and white picture of it shows that it is more like a smooth, bald pate than a hat. A big attack is planned in conjunction with two infantry brigades. The objective is to clear and take Axis positions along the road near Tamera.

Mike's platoon is to lead the attack, but just before it begins their platoon leader gathers them round.

'Men, you know Lieutenant Dover who has just come out to us, part of our reinforcements. He has insisted on the honour of his platoon leading the attack.' He pauses, looking at them. 'Well, I allowed him that.'

They all know what that pause means, because they no longer have any desire to challenge the odds of battle any more than they have to.

On the night of 27 March 1943, at 10 pm, the 1st and 2nd battalions walk to the start line. The plan is that they will pass

on either side of the Bowler Hat, which is held by 3rd Battalion. The colossal peak rears up out of the darkness at them, and at the exact moment they move forward a tremendous barrage opens up from their own artillery. Shells whistle over their heads and crash beyond them. Looking back, Mike can see the horizon lit up by the twinkling explosions of the guns as they fire from left to right along the line. It is a spectacular sight.

The night is warm as they trudge forward through the dark, with Lieutenant Dover's platoon to the right of theirs and slightly ahead. Then there is an explosion, and screaming, followed quickly by several more explosions and yells and screams of pain and surprise. Dover's men have walked into a minefield. Everyone in Mike's platoon freezes. There are shouted exchanges through the night. Mike can hear a man screaming about his legs, another shouting for help and someone moaning, but there is nothing he or anyone can do. He wants the wings of a bird to lift him, lift all of them straight up, and he knows that his entire platoon is thinking the same thing: *It could have been us.*

The men may have thought it madness to volunteer to lead the attack, but none of them thought it would end this way.

Mike's platoon is told to move on past Lieutenant Dover's. There is a crush of soldiers and much confusion as they move closer to their enemy and fighting begins. Everyone seems to be firing in different directions. At one point the press of troops is so great that somebody rests his rifle on Mike's shoulder and continues to fire, blasting his eardrums with every volley. Mike pushes the rifle away from his shoulder.

'Christ almighty, you're sending me deaf.'

By dawn on 28 March, they have occupied a place near what they think is the top of a hill, but daylight reveals that it is a false crest and they are in a precarious position. Still some distance from the enemy, they will have to attack uphill through the trees. While B Company carries out an outflanking manoeuvre, C Company leads the main assault. The Germans are pushing back hard. Hitler has told them to fight to the last man and bullet—if they do not stop the Allied troops here, the British First and Eighth armies will join up and the battle for North Africa will be over. Bullets stream from their machine guns, shredding branches and leaves, while their mortaring and shelling hinder evacuation of the wounded.

The Axis and Allied troops are so close now that at some point during the outflanking manoeuvre B Company gets wedged between the German artillery and their own advancing troops, who fire on them, believing them to be German because they appear to be firing back. Caught in the crossfire, B Company has nowhere to go and they drop flat, shouting to their own men to stop firing at them and calling things that they think will identify them.

'Bulford Barracks.'

'Aldershot.'

'Rose and Crown.'

'Why are you firing at us?' shouts one of their own troops, still not believing they are not Germans as more shots whistle over the heads of B company toward them. From where he is lying, Mike can see a man raising his Sten gun in his direction. A spray of bullets hits the earth in front of him, kicking up gobs of dirt,

missing him by inches. The situation is desperate.

'We've got to show ourselves,' says one of the sergeants. 'I'm going to do it.' He steps from behind the tree so that their own troops can see him and stands tall as bullets fly around him. Mike thinks it an extraordinary act of bravery—he could have been shot front and back—but miraculously he is not killed, and his action saves the day for Mike's platoon.

That confusion having been sorted out, B Company moves on through the woods. They are forced to move tree to tree, and it is hard to know where the enemy is. The crack of a rifle up ahead sends them flat on the ground again. Mike throws himself down and puts his head immediately behind the trunk of a narrow tree. He cannot see the sniper, though it appears that the sniper can see him, as more shots come in his direction. Suddenly he feels a hammer blow to his leg and rolls with the shock of it.

He can see Harry Bates making to run toward him, his dirt-spattered cherub face creased in concern. Mike shouts out to him.

'Harry, no! Stay where you are. Don't come over—it's all coming this way. You'll be hit.' Then a bullet goes through his arm, and he rolls again with the pain. It takes him a moment to register that he is badly wounded, and another to think that he will never get out alive if he stays there much longer. He rolls himself slightly downhill—bullets follow but do not reach him—and then keeps going until he is clear of the firing and can rest. Strangely, he is not aware of pain now. A medic finds him and powders his wounds and asks him if can make it to the aid post. Mike thinks he can. The medic helps him to his feet, and he starts to walk further down the slope. He comes out of the dappled shade of the

wood into the bright sunlight and makes toward the Arab house up ahead, which is being used as an aid post. His leg is completely red and his boot squelching with blood. Some men he knows from another company spot him and run out with a flask of whisky, but it is the last thing he wants.

At the aid post, he is given tea, warm, sweet and strong, the finest nectar, and he savours it. Suddenly he feels very tired and weak, but he does not give a damn anymore. He is out of it.

As Mike is being evacuated further down the medical line, he meets Lance Corporal Thompson being stretchered out.

'Mike, have you heard? Fred's been killed.'

Mike is stunned. 'But how, why, what happened?'

It is devastating news. Fred just seemed to be one of those people who could not get wounded or injured in any way—let alone killed.

'Friendly fire.' To think that Fred had been killed in this way is terrible—more painful than Mike's wounds. He is muzzy now from shock and loss of blood. Time and space seem to slip by, and then he is aware of being carried on a stretcher through the night. The stars wheel overhead as he is taken to the operating theatre under canvas. Something is put into his arm. A needle?

A voice says, 'And where else have you got one?'

When he wakes from surgery, he finds an envelope next to him, with the bullets that had been removed from his arm and leg. His relief at being out of it and not too badly injured is punctured by the tragedy of Fred's useless death and the knowledge that only a handful of the men he started out with survive. There is one comfort: next to him is Chalky White, whose tremendous

strength helped him to survive having several feet of gut removed as a result of mortar shell wounds. He is being fed Guinness to keep that strength up. I suppose they must have talked about Fred, the circumstances of his death, and that glorious sunny afternoon only a few months ago when they raced through the English countryside on their bikes to have tea with Fred's mum. Chalky tells Mike that Dicky Spender, the battalion's poet, has also been killed.

By the morning of 29 March 1943, the battle for Tamera is over. The cost was enormous and the roll of honour for B Company 2nd Battalion shows thirty-two killed in two days. The Axis defences are crumbling all along the line, and the British First and Eighth armies press them in a pincer-like grip. The battle for Tunisia ends with the surrender of the Axis forces on 13 May 1943. The Red Beret begins passing into legend.

•

A photograph of Mike at the 1st Parachute Brigade memorial in Tunisia appears in several of the books I have read. It was taken by Sergeant Christie, who appears in the photograph of the memorial that is on the first page of my father's war diary. It seems likely they photographed each other on the same occasion, as they had both joined the Army Film and Photographic Unit as airborne cameramen.

Mike is on the right of the frame, crouched down, a hand touching the memorial. His head tilts down, but I cannot tell whether he is reading the inscription or has his eyes closed in contemplation. He is a young paratrooper caught in an act of remembrance, but what is he thinking? About Harry Wain, or Fred, or Dicky Spender?

About how many of the originals are left? He looks lean and chiselled out by his experience, and there is something else too that shows in his face. I think it is knowing the cost.

The red beret is a badge of survival.

I had always thought that my father did not go to remembrance ceremonies and marches because he thought they glorified war, and this may have been true. But I also think he did not go because he did not want to be reminded; it was too painful, and after all, whom would he meet up with there?

As he said in his oral history interview, sharing this common danger, this common experience, he made some of the best friends he ever made during the war. But as it was war, he added, they didn't last very long. The memories he carried around inside him

were enough; he did not need, nor want, to relive it all again.

I pick up the beret from where it has sat on the corner of my desk during the many months it has taken to piece together Mike's experiences in the North African campaign. Somehow it looks and feels different, as if I am now familiar with its folds and contours, with its travels. In some way, North Africa has been a proving ground for me, as it was for young Mike and the newly formed parachute brigade. It was their first experience of war, and in a sense mine also, so closely have I studied 2nd Battalion's operations there.

I look at the Parachute Regiment's current website and see that the name Red Devils has been adopted by the Parachute Regiment's freefall team. A link takes me to an explanation of the name. The parachutists wore an overgarment called a parachute smock when they were jumping. It protected their parachute rigging lines from being snagged by what they were carrying. A strap went between the legs and buckled at the front to stop it riding up. The men often trailed this 'tailpiece' behind them after reaching the ground, causing the local Arabs to refer to them as 'men with tails', and the North African mud stained their uniforms red. Men with tails. Red men with tails. Red Devils.

•

My father kept in touch with Fred's mother until she died in the early 1980s, but he never told her what really happened. He thought it would be unbearable for her to know that her son had been killed by their own troops. He said it was pretty unbearable to know about anyway.

He says that Fred's mother eventually went to Beja to visit Fred's grave with the help of the Royal British Legion. There is a colour photograph of two women at a cemetery tucked into the back of the war diary, and one of them might be her.

I think of what my father said, many years later, about the visit to Fred's mother before they left England—'Well, I'm glad that happened'—and the strange inflection in his voice. Now I understand what he meant: it was the last time she saw Fred.

I study the photograph of the two women. One is elderly and has on a blue dress and jacket. The other, younger woman holds her arm. I compare the woman in blue to Fred's mother in the photograph taken before they left England. It is her, I am sure of it. For no apparent reason, I remember that my father used to send flowers to a Mrs Selman every year and never explained why. I have the impression it was always in the spring, though I really cannot be sure now. Then suddenly I make the connection. Only one thing remains: I check the roll of honour for Tamera Valley and find Private F. Selman listed there, with the date 27 March 1943 against his name. The photograph is of Fred's mother at the Beja war cemetery, and it was Fred's mother that my father sent flowers to every year until her death.

My father kept a volume of Harry Brown's poems, published in 1945, and I wonder if these lines from 'Soldier' spoke to him of his loss as they speak to me now.

The names on the list never die. They are always around us.
We see them standing on corners or walking along a road.
When we want them they are ready. They don't have much to say,
But they say it when the time comes and they say it very well.

Soldiers with cameras

The North African campaign is over by early May, and Mike is finally discharged from convalescence. He is not yet back 'on strength' with his old battalion and takes the opportunity to explore the city of Algiers—to enjoy the simple pleasure of walking upright on a pavement without being on a hair-trigger for sudden movements and telltale noises. He adores the twisting narrow streets of the older parts of the city and the wide boulevards and bleached white facades of the grand buildings in the European quarter. There is an unmistakable mingling of French and Arab influences in the architecture, with vistas of palm trees and always the blue Mediterranean Sea shimmering in the sun.

The harbour and the city that it encircles are busy with the usual business of cities and the business of war and refugees. Mike turns back the way he came. Through wrought-iron gates he can see inviting public parks offering shade, lush greenery and plashing fountains; and there are other invitations too, on the side streets where the soldiers go for sex. If Mike is tempted to seek release there, his desire is probably tempered by the time he spent convalescing next door to soldiers suffering venereal disease, a

condition the army considers a self-inflicted wound. These patients were kept in a fenced-off section, and Mike was surprised by how many there were, their numbers easily matching the 'legitimately' wounded.

Mike is glad to be out of convalescence, that strange halfway house to health. He has seen firsthand some of the terrible after-effects of battle and considers himself fortunate. He met three men suffering from a sort of shell shock who got him thinking. There was one whose hair had fallen out and was growing back in white tufts, another who sweated constantly, and yet another who zigzagged in a slightly drunken way as he walked. It was clear to Mike that each man had reacted to his nerve going in his own strange fashion, and that if a man's nerve did go, there was nothing anybody could do about it. Some men would try to hold out and suddenly break, while others succumbed bit by bit, but nobody, least of all the men themselves, could prevent it.

He thinks back to when his platoon were sitting exhausted on a railway line somewhere behind the frontline. He hardly knew where and when it was now, but a muscle memory of weariness seems attached to the scene that plays in his mind. They had met some new recruits on their way to the front and of course were asked about what it was like 'up there'. Mike and the others tried to tell them, to give them little nuggets of comfort and advice. But what can you say about war to someone who has yet to experience it? Mike knew their anxiety. War was one big anxiety about the future and if you would see home again, and he knew that in the end, if they survived long enough, the recruits would become fatalistic—if your number's up, it's up—because it was the only

thing that made the uncertainty of war bearable.

This afternoon he is headed for the Hotel Aletti. He has found out that the Army Film and Photographic Unit are looking to form an airborne unit. Mike thinks he might have a chance of getting in, having at least one half of the qualifications and a smattering of the other. No. 2 Army Film and Photographic Unit is billeted near Tunis, but Mike has been told that Captain Rignold, a veteran of the unit and the North African campaign, is in Algiers and can be found this afternoon at the hotel.

As he crosses the street and steps into the deep shade of the colonnade that runs along the front of the hotel, Mike feels a surge of elation at the prospect of change. Here he is with a future—with the possibility of doing something else. There is a terrace with tables and umbrellas and a bustle of people—officers and war correspondents, mostly. The entry gives onto a lounge area with fading leather seats, and he can see what looks like a fancy restaurant. A board to one side displays a poster advertising the casino.

He orders a glass of muscat at the bar, then makes his way to the terrace and finds a seat where he can look out for Captain Rignold. Mike thinks he saw a photograph of Rignold once, but he will know him anyway by the AFPU flash on his shoulder. The muscat is a golden colour and has a raisin sweetness and spice that is warming like the sun, and everything about sitting there under the shade of a large umbrella underscores the miraculous nature of his being there, of his survival. Mike thinks that having got this far, he will never, never complain about anything again. A moment later he smiles to himself at the impossibility of keeping

such a resolution, should he live.

He has been trying to come to terms with all that has happened, with how few of the originals are left now. The thought of going back to find himself a stranger in his old battalion is wretched, and he hopes he can get transferred to the AFPU from here. He feels sure that once back in his old battalion, he will not be allowed to transfer out, because he has so much experience.

'Excuse me, soldier.' Mike looks up and sees a captain addressing him and makes to stand up. 'Don't get up,' the captain says. Mike notices the AFPU flash on his shoulder and cannot believe his luck. This must be Rignold. 'You're one of those Red Devils we've been hearing a lot about, aren't you?' Mike nods, astonished to be addressed so informally by a captain, but it is clear that this man does not stand on ceremony. 'I'm Captain Rignold,' the man says. 'I heard you were looking for me.'

Mike feels encouraged and asks Rignold whether what he heard is true, that the AFPU is establishing an airborne unit; and whether there might be a chance of him getting in.

'I've had some training as an artist and know the basics of still photography.'

'Yes, it's true about the airborne unit. It was decided some time ago, but none of the existing cameramen will put their hands up to learn to jump. And they're not too keen on the gliders either. So you may be in luck.' The gliders are another addition to parachute operations, essentially a one-use, engineless aircraft that can transport troops and heavy equipment to the battle zone.

'Do you think they'll take me?'

'Well, it's not up to me, but you're halfway there, and the

rest we can teach you. Look, you need to see Captain Fletcher at div HQ; he's the one who'll decide. Say I sent you.'

Mike finishes the last of his muscat and gets up to leave. 'Thank you, sir.'

Rignold smiles.

At divisional HQ, Mike is relieved to find that, like Rignold, Captain Fletcher is approachable. He tells Fletcher that Rignold has sent him as a possible candidate for the airborne film and photographic unit and gives him a potted account of his skills.

'I think you'd be a suitable candidate, Lewis. We can request a transfer from your old battalion.'

Mike's heart sinks at the caveat, but he is prepared for it—he is sure it is now or never.

'Sir, I'm not back on strength yet with my old unit. I think that means I don't actually belong anywhere. You could assign me right away. It's just … if I go back to my old unit, well, I don't think they'll let me go … because there are so few of us left … of the original volunteers, that is.'

Mike wonders if he has gone too far in speaking out on his own behalf, even to an officer as open as Fletcher, but his words seem to be having some sort of effect. Fletcher pauses and regards him for a few moments, then sighs and gives a slight shrug.

'Seems a bit like poaching to me, but all right. I'll assign you to No. 4 Army Film and Photographic Unit. They're forming up near Tunis, at Sidi Bou Said—you'll be billeted there.'

•

In the war diary there is a photograph of Mike looking out toward the ruins of the ancient city of Carthage from the AFPU's billet. I wonder if it was taken by Sergeant Christie, the other airborne cameraman, the one who went with him to the memorial. Judging by his bare chest, this is an off-duty moment, and what looks like a mug of tea sits on a small table to one side. Mike thought Sidi Bou Said a 'handsome' place, and the present-day town has lost none of its charm. I find photographs online. It sits on top of a cliff looking out over the Mediterranean Sea, the entire town painted blue and white.

There are a lot of sightseeing photographs in the North African section of the war diary: street scenes, cathedrals, ruins. There are military ones too, though as the war is over here they are all parades and practice. Everyone in them is relaxed; their little corner of the world is secure for the moment.

Only one photograph seems to hark back to the campaign. The image is of a group of Eighth Army men sitting around and on their truck. They have named it Uncle Joe after Joseph Stalin and have acquired what looks like a Jack Russell terrier as a mascot. They look weary and seem to have that same chiselled-out look that Mike had when he was visiting the memorial with Sergeant Christie. Theirs had been a long, hard campaign.

As Mike settles in to his billet and gets to know the other members of his unit, he detects resentment from some. He supposes it to be just the natural effect of absorbing a newcomer, but some of it seems to be jealousy at his status as part of the new airborne section, and one of the few with real battle experience. He is instructed in the use of a DeVry camera by Sergeant Penman and promoted to the rank of sergeant.

Planning for the invasion of Sicily has been underway for some months, and the 1st Airborne Division has been assigned to the operation. They are to land in advance of the seaborne troops and will be part of the Eighth Army, under General Montgomery. On 8 July, Montgomery inspects the division at Sousse, accompanied by Major General Browning, commander of airborne forces. Mike is sent to cover the inspection. He films Montgomery surrounded by cheering troops, meeting Brigadier Lathbury of the 1st Parachute Brigade, and speaking to members of the brigade. He is also assigned to cover the invasion of Sicily and will accompany the airborne troops and drop with them. The operation is scheduled to start on the night of 9 July, with the gliders going in first, towed by their tugs, and the paratroopers are to drop the next night—but the operation is postponed. Finally, on the night of 13 July, they are given the go-ahead.

•

Mike joins a stick of about fifteen men boarding a DC-3, piloted by a young American who appears to have little experience of this type of flying. He is clearly nervous, and it shows in his briefing of the men.

'You guys have gotta get out that door when we get to the DZ, 'cause I'm not goin' in for long. So, I want you to get out as fast as shit, because I'm gunna start climbing fast.'

Mike is dismayed. 'But if you start climbing, your tail will drop. And some of us jumping near the end could get caught on it.'

'No shit—well, I'm gunna keep the tail up.' Mike feels temporarily bamboozled as he tries to calculate whether a plane can gain height while remaining horizontal. Once they are airborne, the familiar noise and smell of the fuselage, the nervous patter of the men and the usual dip in his insides at the prospect of jumping distract him. The night is black outside, but as they close on the coastline of Sicily the sky lights up with streams of beautiful red and yellow bubbles floating up toward them. As they draw near, the bubbles seem to speed up tremendously before hitting the aircraft with a crash that shakes it violently.

For a moment Mike thinks it must be the ack-ack of the Italian navy but realises the Italians are unlikely to be anywhere near them. Then he thinks it must be the British or American navies who are down below, as they are supposed to be in the area. It must be they who are firing at the aircraft. Has no one informed them of the 1st Airborne's flight path? Has someone changed their route and not told the navy? Being fired at from below with no ground to hug is a new and uncomfortable experience for Mike. Everyone is on edge and trying to get glimpses out of the windows.

'There's one going down in flames,' says one of the paratroopers opposite.

'Christ almighty, and I had to be number thirteen in the stick,' Mike says drolly to the men next to him, who laugh nervously.

More red and yellow bubbles float toward them, and this time Mike does not think them so attractive. They crash against the plane, shaking it violently again. The door to the flight deck flaps open and one of the crew calls out.

'Goddammit, the pilot's dying—he's dying.' The pilot staggers out, obviously in shock. Mike goes to him immediately and turns him around to see a gash in his flight suit blushing red. He rips it open to take a closer look and is relieved to see that the pilot is not dying at all. He's been lucky, hit by a splinter.

Mike reassures the pilot that he is in no immediate danger. 'You'll feel a bit woozy later, but that's the shock. I'm speaking from experience.'

The young pilot looks at him quizzically but does not ask for explanation.

'They'll be needing you in there—it's not far now.' Mike offers him a boiled sweet from his pocket and gently pushes him back toward the flight deck.

They seem to be leaving the ack-ack behind, but then a moment later the plane lurches and another crew member appears at the flight deck door.

'We're going back, the pilot's bad.'

There is a murmur of protest from the paratroopers, who are keyed up for the drop, but the plane continues making its turn and they head back. Mike knows how the paratroopers are feeling—he feels it himself. It is a huge anticlimax, to go home without having jumped when you have prepared yourself for it mentally.

In September, Mike is assigned to cover Operation Avalanche, a seaborne operation planned for Salerno in Italy. He is to accompany

Captain Rignold. A day or so before he is due to go, he is taken off the mission without any explanation, and Penman is sent instead. Mike is very worried about this. Their new commanding officer, Major Keating, took over only a few months ago, and Mike thinks that Keating does not like him. He wonders what the problem is, as his work has been good. When the invasion begins and the attack goes in, the jeep Rignold and Penman are in is hit. Rignold is killed and Penman loses a leg. Mike feels conflicted: lucky not to have been there but sad at the loss of Rignold. Keating may unwittingly have saved his life—but he has not finished with Mike yet, and the final blow comes when later he orders Mike to be RTU'd with no explanation.

Mike discusses his plight with some of the other cameramen, who seem sympathetic. Rickie Meyer suggests talking to Colonel McCormack, who is due to come out to the unit from England. Mike does not hold out much hope that the decision will be reversed—he thinks officers are likely to back each other up—but by now he has learned that it is always worth asking. Mike is surprised and delighted by McCormack's decision.

'What I'll do with you, sergeant, is I'll send you back home ... to Pinewood Studios ready for D-day.' Mike can hardly believe his luck. Again the army machine has moved in his favour.

He is sent back to Algiers by train, a slow journey of three or four days covering over five hundred miles. Those travellers in the know set themselves up in the freight cars rather than the carriages. Here they can spread out and travel with the doors open.

After parking his gear Mike sits in the doorway, his legs over the edge, to watch their departure. A pretty young woman is

saying goodbye to one of the French soldiers who is also travelling to Algiers and about to board. As the train begins to pull away, she follows it to the end of the platform, stopping at the buffers, tears running down her face. She stands there alone on the hot platform, watching, growing smaller slowly as the train picks up speed. It reminds Mike that about a year ago he had seen another woman on a railway station, at Chesterfield. It was a rainswept day, and she too was seeing one of the men off. The platform had emptied out, leaving her crying in the rain, the tears streaming down her face as the train slowly puffed its way out. It made Mike think: there were these two women, thousands of miles apart, two individuals out of how many affected by war—millions? And yet of all the tears he has seen so far in his life, he knows he will always remember those of the two women saying goodbye.

It is a grand trip to Algiers, and all those in the freight car enjoy themselves immensely. They travel with the big doors open, legs swinging over the edge or stretched out on their sleeping-bags. Someone produces a brazier from somewhere for cooking and the essential mashing of tea, and they put it in the middle. They pool their 'compo rations' with those of an RAF crew and then feast together. At the end of the day, when they are running short of fuel, some of the more enterprising travellers break pieces off the thick wooden sides of the freight car. The mountains roll by, and when night comes they hang the brazier outside on a hook. Mike sits on the edge of the car, looking out along the line of the train as it climbs slowly up a hill. It is an astonishing and magical sight: a long, sinuous black silhouette winding its way up and down over the hills toward a purple-black sky, tresses of smoke streaming

behind and brilliant patches of light flickering and flaring from all the other braziers hanging outside. By the time the train arrives in Algiers, all the freight cars are just skeletons, stripped of wood.

•

I cannot be sure exactly when Mike returned to England, but a menu pasted in the diary shows that he spent Christmas 1943 in the sergeants' mess in Algiers.

He is happy to be back, honing his skills at Pinewood Studios under Sergeant Rottner, who seems to have taken a liking to him, though Mike is not sure why. He welcomes the partiality anyway, as you can still be RTU'd if you do not please your superiors technically, professionally or personally. Mike has already seen one highly experienced newspaper photographer sent packing for his lack of military 'finesse'.

Pinewood Studios, which had produced films before the war, has been taken over by the government for the war's duration. Four film units are operating out of the facility: the Crown Film Unit; the No. 5 Army Film and Photographic Unit, which Mike has been reassigned to; as well as the Royal Air Force Film Production Unit and the Polish Air Force Film Unit. There is a lot of interesting work going on, and everywhere Mike looks there is something to learn about his new vocation. Garson Kanin, an American writer, and English director Carol Reed have been brought together for an Anglo-American film called *The True Glory*, and they begin to assemble sections of the film. Mike is allowed to watch how this is done and is fascinated. They give a young RAF 'erk', Dickie Attenborough, a small part.

Mike is learning to be a screen journalist, to tell a story with a camera in a way that will need minimal editing—an essential skill and economy when using hundred-foot spools, which give about ninety seconds of running time. There are procedures to be learned too, like how to clean your camera and clear a jam and how to fill out the caption sheets that accompany the film for processing. The caption sheets are designed to provide such details as the date and location, a description, and the names of those pictured, if possible, along with references to the corresponding coverage by other cameramen. Cameramen are also asked to note if any sequences are re-enactments or mocked up in some way. The same system is used for still film.

Mike gets the sense that some of the work they are doing is pioneering, and certainly it seems that the War Office has, in its own strange way, contrived a great convergence of established and new talent, and not just in films. At the Curzon Street offices in London, where Mike goes occasionally for lectures, he meets Abram Games, a graphic artist producing posters for the War Office. Mike thinks his work quite brilliant and likes to drop in, when he can, to watch Abram work and to chat.

Mike is part of an airborne group within No. 5 AFPU, with Sergeants Christie and Smith on stills and him and Walker on cine. Eventually they join the 1st Airborne Division, stationed near Grantham, to wait for the Allied assault on Europe, and Mike meets up with men from his old battalion again. To pass the time he decides to set up a photographic shoot at a local factory where they make and pack the division's parachutes. He asks some of the paratroopers to come and demonstrate to the women who work

there how a parachute operates. It takes a lot of organising to get everyone together, and a crowd gathers. He asks the paratroopers to let one of the girls put a parachute harness on and takes a photograph as the parachute begins to lift in the breeze. He sends it in to the Ministry of Information and thinks no more about it.

Next morning he wakes to find the image has been published in the *Daily Mirror* and is practically a full page. The girl in her peaked cap and overalls is shown leaning back in the harness, a paratrooper hanging on to the rigging lines as they pull up and away from her.

Mike is astonished. His photograph must have struck a chord. People are getting tired of pictures of big guns and explosions. Here was something human, more to scale, that everybody could appreciate. It was the perfect image to lighten the gloom of war and boost morale: a pretty young woman, representing the

home-front war effort, and a gallant paratrooper, the frontline, pulling together for Britain, those in the background enjoying the spectacle. Mike's stock in the regiment goes up no end. Some of the officers look at him almost in awe, and Mike tries to assume the air of someone who had expected the result while keeping to himself that it was a sheer fluke.

The waiting goes on, and in early June Mike is granted leave and goes down to London for a tryst with a girl he has met. On Tuesday 6 June, he gets up with the idea of having a leisurely breakfast before heading back to Grantham but is appalled to hear on the morning news that the invasion of Europe has begun. What on earth has happened? Has the whole 1st Airborne Division gone without him? Has he missed D-day because of his tryst? What would the consequences be? His mind races with anxiety and regret that he has missed the biggest event of the war. He dresses quickly and runs down the street to a telephone box on the corner, hoping it is working. Relief—it is the 6th Airborne Division that has gone. All the same, he returns up north quickly, anticipating that the 1st Airborne will follow very soon.

•

It is autumn now, and I have come back to the stone cabin after spending the summer in Canberra working. I have installed a large woodfired heater to keep away the chill while I read and write. When I need to get away from my desk for some perspective, I can wander through the bush. One morning, I walk up to the orchid rock, now named Anna's Rock in honour of the goanna who lives there. She watches me as I perch on a rock below, looking out over

the valley, pondering Mike's precarious journey through the war. His next destination will be Arnhem in the Netherlands, and I will travel there soon, to tread the ground.

Robert Voskuil, one of the Friends of the Airborne Museum Hartenstein, the old hotel which housed the airborne forces headquarters during the battle, emailed me while I was on my trip to London after hearing about my research. Remarkably, he has a particular interest in the AFPU photographs, an interest he shared with his father, who lived through the battle. Over the years Robert has identified the locations at which many of the photographs were taken. He has also alerted me to the fact that Mike took stills as well as cine at Arnhem. I was quite surprised by this, as it was not apparent from the Imperial War Museum's archives, and it was unusual in the AFPU, where photography and cinematography were normally discrete tasks.

Robert has offered to take me on a battleground tour of Arnhem, using the AFPU's photographs to re-create the route Mike and his fellow cameramen took from the drop zone to their final escape across the Rhine. It is a most generous offer, and I feel I am in for a momentous trip.

Film as a weapon

Considering how widely the AFPU's film and photographs have been used over the decades since the war, little has been written about the development and operation of the unit. There are a handful of scholarly papers, a history and a few memoirs. Many civilian war correspondents, such as Robert Capa and Joe Rosenthal, became celebrated for their war photography. Capa's photograph of a Spanish Loyalist soldier falling after being mortally wounded in the Spanish Civil War and Rosenthal's image of US marines raising the US flag on Iwo Jima in the last year of the Second World War are well known and often referred to as iconic, even though there are questions about their authenticity.

In spite of their huge body of work, the men of the AFPU seemed to fade from the story. In books and documentaries, even in academic papers, their material is often used uncredited, or credited only to the Imperial War Museum. It is as if some omniscient being had been roaming the battlefields capturing those moments, and it makes me wonder if their lack of recognition stems from the British Army's initial reluctance to use publicity, particularly in the form of film.

While Hitler industriously harnessed the power of film and photographs at home and abroad, the British Army dug its heels in and was suspicious and somewhat blind to the possibilities, the necessity even, of this type of mass communication. It is an attitude that is hard to comprehend today, at a time when organisations and individuals deliberately and purposefully seek to control the 'optics', as the public perception of events and people is often called now. I suppose the military has never liked war correspondents roaming freely in battle zones. Secrets can be revealed through ignorance as well as malicious intent—and then, of course, there are uncomfortable truths.

During the Second World War, radio and print were the main source of daily information for most people, supplemented by cinema newsreels produced by the likes of Gaumont, Paramount, Pathé, Movietone and Universal. Television was new and the BBC service that had begun regular broadcasts in 1936 was suspended for the duration of the war. To meet their peacetime needs, the British Army had relied on a comfortable arrangement with the newsreel companies, but all that changed with an initial blanket ban on filming all things military. Perhaps realising that this was an untenable situation, the War Office appointed Harry Rignold as an official cinematographer soon after; other cameramen, shooting both cine and stills, followed.

The first wave of recruits were professional cameramen, not trained soldiers. They were given honorary ranks, taught to use pistols and were subject to military orders and discipline. Their advent did not, however, signal an embracing of publicity on the part of the military. This was a much longer and more involved

process that began with the appointment of professional publicist Ronald Tritton as the War Office's publicity officer in December 1939. Tritton realised that he would need many more cameramen to effect a full coverage of the war effort and had to think of a way of changing the ingrained military fear of publicity, especially film, so he could get permission for further recruitment. It was a challenge that caused him to observe: 'To some sections of the Army a cameraman is a more sinister figure than a whole regiment of Germans.'

In March 1941, Tritton contrived, together with Jack Beddington and Sidney Bernstein of the Ministry of Information Films Division, to screen a compilation of captured German newsreel and documentary film footage, titled *Film as a Weapon*, for senior War Office staff. The film was captioned with explanations about how the National Socialists in Germany were making use of propaganda and how the Allies could do the same. Tritton's ploy was successful and he was authorised to expand the AFPU.

Interestingly, the official war diary for No. 2 AFPU in North Africa shows that a lot of the early lessons in battle photography and organisation were learned there under the command of Major Hugh Stewart, a film editor and producer in civilian life. It was his experience in North Africa that helped him refine the idea of the combat cameraman and convinced him that turning soldiers with combat experience and some prior knowledge of cameras into cameramen was preferable to recruiting professionals and trying to make soldiers of them. Mike became part of this second wave of recruits.

Whose idea the airborne film unit was, or indeed any evidence

of its existence at all, is hard to find, because it did not seem to last long. But there is one reference in the official diary to Sergeant Lewis being moved from No. 4 to No. 2 AFPU in August 1943, and there is no further mention of No. 4 AFPU after that. Perhaps it was the brainchild of Hugh Stewart, or perhaps Rignold and Stewart had dreamed it up together as a logical extension of the experience they gained during the North African campaign. Whatever its origins, men with the requisite skills of soldier, parachutist and cameraman were obviously in short supply, which gave Mike an unusual opportunity.

There is a photograph of him operating a DeVry, which I suspect was taken in the early days of his training in North Africa. He is standing in an unlikely pose for a combat cameraman, behind a tripod and without any cover. When I was allowed to hold a DeVry at the Imperial War Museum in London, I was surprised at how heavy and unwieldy it was—just an oblong box with a lens and a mechanical winder, no grip to help you hold or steady it.

Mike referred to it as a 'coffee grinder'; another nickname I came across was 'the lunch box'.

It looks like a medieval relic against the digital cameras of today, but even back then there were complaints about the equipment. The writer of the No. 2 AFPU official war diary opined:

> Whilst we were in the field in North Africa we had things very much our own way, as competition was practically non-existent. Since then the Canadians, Indians, New Zealanders and the Americans have entered the field. We are in the position to cope with all the people except the Americans who have superb equipment. As practical proof of this we can state that for the bombing of Orsogna [Italy] we were in the same OP [observation post] as an American Unit. Our longest focus lens was 6" theirs a 20"—there is no argument as to who would have obtained the best pictorial records. This is not an isolated case, but an example of what is happening daily.

There follows a camera wish list that includes a Newman Sinclair, an Eyemo and a full range of lenses, but it was the coffee grinder that Mike took to Arnhem to film his portion of that history.

•

After the Normandy landings in June the Allies meet fierce resistance, and it takes until August for the invading forces to break out of the Normandy beachheads. When they surround German troops at Falaise, they take many prisoners, and move on toward the Seine and Paris. Some of the German troops manage to

withdraw across the Seine to the west, but for a short time the German forces appear to be in disarray. The retreating trickle of weary German troops builds into a frantic rout as they head for the German border and home, many passing through Arnhem.

Brussels is liberated, and Montgomery heads directly for the Belgian port of Antwerp, which is big enough to cope with the Allies' supply needs. It is captured intact, but German-held positions on the River Scheldt initially prevent the port being pressed into use.

The Dutch civilians are jubilant and expect the Allies to cross the border every day, but all reports turn out to be false. The Allies do not cross into the Netherlands, and the gap between the departing German forces and the Allies grows as the Allied advance finally pauses. As in North Africa, stretched supply lines are the problem: the Allies are still transporting everything some 250 miles from the beachhead, having not yet secured Antwerp. Heady with their successes thus far, the Allies still talk of finishing the war quickly and being 'home by Christmas', an often expressed and often thwarted aspiration of many wars, it seems, but as the Allies close in they also find opposition stiffening behind the Siegfried Line, a fortified defence along Germany's borders.

The way forward now becomes disputed among the Allies. Undercurrents of tension between the upper echelons bubble to the surface as the advance slows. British General Montgomery believes that Allied resources should be concentrated in a single thrust that would cross the Rhine at Arnhem and then outflank the Siegfried Line and break through into Germany to capture its industrial heartland, the Ruhr. He wants his 21st Army Group to lead that

mission. His rival, American General Patton, also thinks that his 3rd US Army are in a position to make a concerted thrust into Germany from the French city of Metz, not far from the German border.

The decision is not a simple tactical one for Eisenhower. He tries to hold to his strategy of liberating the channel ports before moving ahead on a broad front, but Montgomery is relentless in his arguments, using reports that the new German weapon, the V-2 rocket, which has been used to attack London, is being launched from sites in the Netherlands. He proposes an immediate advance to put them out of action and establish a bridgehead over the Rhine. Eisenhower finally gives his approval, but he wants the operation launched as soon as possible. The Normandy parachute operations had six months of planning; Operation Market Garden is made ready for 17 September in just seven days.

The plan is to use most of the First Allied Airborne Army to take and hold five key bridges along sixty miles of the Eindhoven–Arnhem road simultaneously. Three separate airborne operations, two American and one British, will be centred on the towns of Eindhoven, Nijmegen and Arnhem. The British airborne operation is to take the furthest objective, Arnhem, the bridge across the Rhine. If successful, the operation will open a corridor for the advance of the 30 Corps of the British Second Army. On successful completion of the operation, the Second Army will be in a position to turn east and take the Ruhr.

When told that they will need to hold the bridge at Arnhem for two days, Lieutenant General 'Boy' Browning, commander of the 1st Airborne Corps, is reported to have told Montgomery, 'We

can hold it for four. But sir, I think we might be going a bridge too far.' The phrase, immortalised in Cornelius Ryan's 1974 history, *A Bridge Too Far*, and later a film of the same name, has passed into idiom. The book sits on my desk like a foundation stone beneath a pile of other books on Arnhem, some quite newly published, all of them a testament to the battle's enduring fascination.

To deliver thirty-five thousand airborne troops and all the equipment they will need to fulfil their mission is an enormous logistical puzzle, but there is a missing piece: enough aircraft to get all the men and equipment on the ground at the same time. The RAF suggests night drops to speed up deployment, but Lieutenant General Brereton, the American commander of the Allied airborne forces, rules it out. They will go in daylight, and repeat drops will be made on subsequent days till all men and equipment have been deployed. Any qualms at this decision in the chain of command are soothed by news that the German forces are melting away, but other intelligence comes to hand as the plan is set in motion.

Major Brian Urquhart, a young British intelligence officer— no relation to the divisional commander Major General 'Roy' Urquhart—thinks everyone is being overly optimistic about the strength of the German forces and the ease with which Second Army might move along the corridor. At planning meetings, he strenuously opposes the operation at Arnhem, believing the Dutch underground reports that there is German armour in the Arnhem area. He orders a low-level reconnaissance flight on 12 September and confirms that there are tanks in the area, not far from the designated dropping and landing zones. His advice is ignored

by his superiors, and he is sent on 'sick leave'. Alarm bells ring, but they are not heeded, and doubts are swept aside. Since the Normandy landings, the 1st Airborne Division has been readied for action and stood down seventeen times, such are the vagaries of war, and there seems to be a general eagerness for action.

Having no idea how military plans are usually assessed, I gather the facts and subject them to a SWOT analysis, listing the plan's strengths and weaknesses, and considering the opportunities it provided and the threats it posed. I want to assess whether the opportunities were great enough to risk so much, so many lives. I am scrupulous in my analysis, using only those facts that were known at the time. When completed, the balance sheet does not look good. A key weakness is the decision to deploy over three days, thereby losing the element of surprise so important for airborne operations. Another is the distance from the dropping and landing zones to the bridge, about eight miles. There is also the distance that 30 Corps has to travel in order to relieve the airborne troops at Arnhem, more than sixty miles in two days. On their own, each of these weaknesses may not have been sufficiently compelling to call off the operation, but there are a lot of weaknesses, and more than would point to a sound decision.

•

I have been wondering why it is that some battles, really only a handful of those that have been fought, capture popular imagination—why the Allies' loss at Arnhem did when the many bitter battles that the 1st Airborne fought in North Africa did not. Histories often use the adjective 'epic' in connection with Arnhem,

and certainly in terms of size and logistics Operation Market Garden was epic. In one interview, my father argues that 'All war is an epic, in the sense that men are fighting to live, and many of them are going to die'. This was undoubtedly true of the battle for Arnhem, which was a heroic stand against great odds.

Arnhem was also, in some senses, intimate—the battle contained within an area of little more than five square miles, over just nine days. It was also intimate in the most human sense: the shared suffering of the Dutch civilians and British soldiers forged a bond between them that endured long past the war's end.

The men of the press corps were there, and recorded what they could in words and pictures. Images in particular have a way of fixing events in memory, and I wonder if their publication and circulation afterwards helped cement the story of Arnhem in people's imaginations. Until the war was over, the only images available to the British public were those taken by the men of the AFPU. The story of Arnhem grew out of these images and the stories told by the civilian war correspondents and others. A year later, when the Rhine had finally been crossed, a group of survivors went back with film director Brian Desmond Hurst to re-enact their stories. The resulting film was intercut with the actuality the AFPU had filmed and released in 1946 as *Theirs Is the Glory*. It is a powerful film and it too must have impressed Arnhem on public memory.

•

I arrive in Arnhem in early September. Banners and other signs of the coming annual commemoration hang along the streets.

The weather is warm and sunny, perhaps much the same as it was when Mike bailed out near the village of Oosterbeek, west of Arnhem, on 17 September 1944. I can hear him saying that the day was 'clear and bright'. He described Arnhem as 'a pretty place of neat houses, tidy gardens and leafy streets', and it is. Under the soft September glow, the elegant streets and buildings charm me; alfresco dining areas throughout the central pedestrian precinct and along the banks of the Nederrijn, the Lower Rhine, are filled with people enjoying the beautiful early autumn weather; pushbikes crisscross the town centre; and a range of hills, the Veluwe, rolls down to the river, where houseboats nudge each other along its banks. About the city and its environs there is an interlacing of fields and woods. Germany is about sixteen kilometres to the south-east. It is hard to reconcile this pleasant place with the photographs of smashed buildings, slit trenches and mortar crews in action in my father's war diary. That time is long gone—but if you know where to look, there are traces still, and Robert points them out for me when we meet up. A depression in the earth between the trees where the autumn leaves are gathering is the remains of a slit trench; pockmarks on the steps of the Hotel Hartenstein reveal where sniper fire hit; bullets are still lodged in buildings; and there are callused-over wound scars on the trees. There are other traces too in the preserved implements of war: in documents and memoirs, press clippings and radio broadcasts, and the photographs and film taken by both sides.

Prior to my visit, I spent some time in London in the Imperial War Museum's Photograph Archive, teasing out which photographs

Mike took. The answer lay in the original caption sheets sent back with the film. These were handwritten in the field and then typed up, perhaps by someone in London when the film was processed, though that is not clear. The originals show which images Mike took. Something else that became evident as I dug further into the matter was that there were supposed to be two stills and two cine cameramen covering Arnhem. Sergeant Christie, one of the stills cameramen, became ill just before the operation, so Mike was assigned to do both cine and stills, and this probably added to the confusion about whose stills they were.

Robert and I begin our tour with a visit to the Airborne Museum Hartenstein. In 1944, it was the Hotel Hartenstein, co-opted for use as headquarters by first the German forces stationed there and then the British 1st Airborne after landing. Strange, unanticipated emotions arise as I approach the building. It is as if this place has its own memory—a memory that can be tapped, an afterimage of history still happening. I feel a welling up of sadness. A trace of Mike still exists here and is embodied in his photographs and films and his oral history, which weave it all together. As I walk up the pockmarked steps, I see a fleeting flash of him, bounding past me, under fire, almost falling through the door.

A cameraman in Arnhem

As the war sweeps through Europe toward Paris and then Brussels, Mike begins to get the impression that the top brass really have no idea what to do with the 1st Airborne Division and its ten thousand men, keen as mustard. Plans for operations are made and abandoned till it gets on everyone's nerves. Tempers begin to fray. Then word comes that they are to go to Holland, to capture a bridge at a place no one has heard of, Arnhem. The operation is called Market Garden, and everything happens quickly. At air bases across the country, men are briefed and equipment marshalled, checked and loaded.

Mike attends a briefing round a huge sand model detailing bridges, roads, houses, parks and forest—even copses of trees. They are to be the most northerly of three parachute operations going in south to north in front of the ground forces. The briefing officer points out the designated dropping zone for the paratroopers and the landing zones for the gliders. Three routes to the bridge are marked; they will move up by these three routes to take and hold the bridge and a defensive perimeter around it until the ground forces arrive two days later. The officer says the division will be

dropped over three days and gives the order of deployment. He pauses as a ripple of movement runs through his audience and waits for it to fall away before he continues his briefing. He concludes by saying that there are not enough aircraft to get everyone in on the same day, so the two southern drops of the 101st US Airborne at Eindhoven and the 82nd US Airborne at Nijmegen are being given priority, because the aircraft are American DC-3s and will be crewed by American personnel. Mike thinks it is unusual for a staff officer to provide an explanation for a military decision like that. He is pretty sure that the officer is going as far as he can to express his doubts and disapproval of these arrangements, because he only need have explained the technical part of the operation.

When Mike and the others get back to their tents near the airfield, they sit around glumly.

'Well, this is going to be a disaster,' Mike says. 'A planned blunder, that's what it is.' Others nod agreement or shake their heads in disbelief. 'Sixty miles behind enemy lines, dropping over three days—anything could go wrong.'

'And eight miles from the bridge,' one of the old hands chips in. 'Depienne all over again. I thought we'd learned by now—you gotta drop on or near your objective, not go tramping.'

Mike shakes his head. 'Only question is how we get out of this giant cock-up?'

'Only question is will we?' says another.

'There's a rumour that last lot of recce photos showed German armour near Arnhem. Maybe they'll cancel this operation like all the others,' says someone else, trying to lighten the mood.

'Hope you're right. If there's armour there, it won't be good.'

Mike knows that they are all in the grip of wildly conflicting emotions: a desire for action after so much inaction and so many false starts, and the wish to feel convinced that the operation they are about to undertake is sound. Elsewhere in the camp the mood seems to be more optimistic; the men are happy to be finally committed to something. But the veterans among them doubt the Germans will be so easily overcome. As the hours count down, movement is restricted. With just forty-eight hours to go, many of the bases are locked down, and Mike believes only the weather can stop the operation now.

•

The weather boffins have given the all clear; the operation will begin in just under fourteen hours. There will be no cancellations this time. The make-up of the press corps under Major Oliver has firmed up and shows how successful Tritton's campaign to break down resistance to publicity and film has been. Major Oliver is to be accompanied by Stanley Maxted and Guy Byam from the BBC, Alan Wood from the *Daily Express*, Jack Smyth from Reuters and four AFPU sergeant cameramen from No. 5 AFPU: Mike, Jock Walker, Dennis Smith and Jimmy Christie. There are also four signallers and two censors. They are all to go in by glider, except for Mike, who will parachute in.

Mike's orders are to film the capture of the bridge at Arnhem and the link-up with Second Army. Mike plans to drop with one of the lead aircraft, so he can film the rest of the drop coming in before heading to the bridge. The men spend their remaining hours in whatever pursuits suit them best: some in long card games, some

reading, and others gathered in corners smoking and talking.

In the early hours of the morning they hear the Allied bombers passing overhead, going to 'soften up' resistance by targeting anti-aircraft emplacements where the paratroopers are to be dropped. Then, in the hours left before emplaning, Mike gets a message: a request to take a stills camera as well as the cine. Well, not a request, really. The AFPU might be a very different kind of unit, but it is still army. Mike is not happy and wonders why the established modus operandi of pairing cine and stills cameramen is not being observed. Obviously the order comes from someone who knows very little about the different mediums—perhaps someone who has only ever taken snapshots. With stills, all the elements have to be contained within the one frame. With cine, it is a kind of mosaic—a montage of many small frames that together, in sequence, portray a scene or event. They are two different ways of seeing. Besides, to operate two cameras with two different types of film creates obvious practical difficulties in the field. Mike does not like the stills camera, either. It is quite unsuitable: a Bessa with a bellows front that has to be unfolded before use.

•

By early morning there are men on airfields all over the country waiting to emplane. It is a gloriously sunny morning, and they lie about on their packs, some eating their haversack rations, smoking, or checking their kit and making last-minute adjustments. The tugs with their gliders are the first to take off and form up. There are 358 gliders and 143 troop carriers destined for Arnhem in the first lift.

Mike is inspired to organise a tracking shot of the DC-3s lying nose to tail along the runway. This is not easy, due partly to tight security designed to curtail movement, but also because he has to give his driver instructions on the distance he must keep from the aircraft and the speed he must go for this to work. Mike has also to anticipate the time it will take for the spring-driven motor of the DeVry to wind down, so he can pan away for a natural cut.

The paratroopers' spirits are high, and anticipation is building as the huge sky trains of gliders take shape and head off toward the coast. The roaring noise of their passage overhead brings people out of nearby houses and stops traffic on the road. The sight of masses of tugs with their gliders in tow is quite staggering. With such a conspicuous amount of noise heralding their coming, Mike thinks that dropping in daylight is probably the least of their worries. Then it is the turn of the paratroopers to join the armada, and Mike realises that he has run out of time and finds himself scrambling to join his stick. He will have time to sort himself out on the way, as it will take a few hours to get to their destination.

After take-off, the crew lets Mike into the cockpit to film. If he had thought the armada of tugs and gliders impressive, to be in the midst of it all, DC-3s stacked all over the skies, is stupendous. Everywhere Mike looks in that clear blue sky, right and left, above and below, are planes. On their flanks, British and American fighters dive here and there protectively. Then they are leaving England behind and are over the North Sea. Several white objects are ejected from the aircraft up ahead and begin to unfurl sinuously as they travel downwards. It takes a second or two for Mike

to register that they are Bronco rolls, standard-issue toilet rolls. He never knew there was so much paper in one—and then they are gone. Mike curses to himself that he has just missed what might be considered a statement from the ranks about their mission.

He makes his way back to the fuselage, where there is an air of tense jokiness among their stick now they are really on their way.

'What about a shot of us?' says one of the signallers, taking up an exaggerated pose.

'What, and waste perfectly good film? Bugger off,' says Mike. 'Here, hold this,' he says and, passing the DeVry to the signaller, squats down to grab some extra rolls of film from the box to pack inside his jacket.

'Gotcha,' says the signaller, as the noisy whirring of the DeVry makes Mike look up suddenly to see him filming. Mike gives the

only reasonable response, holding up two fingers; then the spring unwinds and the camera stops.

Mike stashes canisters with four hundred feet of film for the DeVry and several rolls of still film for the Bessa inside his jacket. He adjusts his harness around the two cameras and the film. It is tight, but he still manages to holster his Colt semiautomatic pistol within easy reach. He has arranged with Major Oliver for most of his 35 mm cine film to be held at divisional HQ so he can pick up supplies after the drop.

'Landfall,' shouts the crew chief. Ribs of land show through water where the Germans have flooded low-lying areas along the coast of Holland as an added line of defence. As they fly on, they begin to pass over cultivated fields, the peaceful bucolic scenes below making it hard to imagine that they are over enemy-held territory. Then, in the distance, Mike sees signs of the earlier bombing raids, as plumes of smoke roll upwards into the slight haze. They will be dropping soon, and every man seems to realise this at the same moment. There is a flurry of readying and a checking of equipment and parachutes. Mike gets that familiar dip in his stomach as he too readies himself. Doubts about what they are headed into squirm into his mind along with memories of North Africa. Pretty soon the crew chief tells them to stand by. Mike touches the stock of his pistol as if it were a lucky charm. It feels strange to be going into battle with just a pistol and two cameras. Then the light is red, then green. He checks his watch— it is 1.55 pm—and they are gone, hurtling toward the ground.

Mike shucks his harness as soon as he touches down. Yellow, red and brown parachutes are blossoming out of aircraft and

floating downwards all across the drop zone like some strange bloom of sky-borne jellyfish. Amid the descending men are parapacks with supplies and equipment. He pulls out the DeVry, gives it a couple of winds and points it at the sky, but after a few seconds there is an ominous click as the motor jams. Mike curses in frustration. The damn thing is always jamming, but at this moment of all moments? For a second he wonders whether he should get out the Bessa but rejects that idea. Instead he pulls off his jacket and forms it into a makeshift camera change bag. Working blind, he opens the camera, takes out the exposed spool and exchanges it with an unexposed one from a metal canister. He closes the camera, scrawls the production details on the canister and packs it into his jacket. He will give it to Major Oliver when they meet up.

Mike stands for a moment to properly get his bearings. He has landed close to woods that encircle part of the drop and landing zones. The railway line is to the north; to the east is Telefoonweg, a straight road used as a datum line for the incoming aircraft, which splices the area roughly north to south. He can see some houses in the middle distance and, as he turns to look across the landing zone, smoke rising up from what he realises, as he orients himself, is the village of Wolfheze. Beyond it and closer to the river is Oosterbeek, and then the town of Arnhem, where the early-morning bombing raids were concentrated. He is grateful for the excellent briefing and sand model.

On the landing zone are gliders, broken open like Christmas crackers, some still disgorging jeeps, radios, anti-tank weapons and other supplies. He can see a Hamilcar glider that has flipped over due to the soft ground. He moves to another glider, an empty

Waco, and gets out the Bessa and takes a still across the expanse of the landing and drop zones. A collapsed parachute is in the foreground; men are moving off into the distance, heading south.

As Mike walks on, civilians begin to appear. They are coming toward the paratroopers on ancient-looking black bikes. Coming to greet their liberators, perhaps? But no, they rush past the men to gather up the collapsed parachutes, stuffing them into baskets on the front of their bikes before riding off. The deprivations of war would have meant they mustn't have seen any decent material for years, Mike thinks, disappointed that he is too far away to film this.

As yet there seems to be no opposition, and the bright, sunny weather and calm efficient buzz of activity as men gather equipment and form up has all the air of an exercise. Mike stops to film some paratroopers unloading a container carrying Sten guns,

Brens and ammunition, and then carries on toward the rendezvous points marked by coloured smoke. Near the Heelsum intersection he meets a section of eight men trying to make radio contact with headquarters. In front of them a single showy sunflower waves gently in the light breeze, behind them the line of trees from which he has just come. Mike tells them to ignore him as he lines up the Bessa for the shot.

Most of the paratroopers are moving toward the start points of the two lower routes to the bridge. Frost's hunting horn sounds, rallying the 2nd Battalion. Mike can feel the hair on the back of his neck prickle at the memory of just how quickly things can change. It all seems much too easy at the moment.

More of the locals are turning out or arriving on bikes as

189

they realise what is happening, and the mood is growing more welcoming and festive by the minute. Paratroopers who have been injured in the drop are already being taken away to be looked after. People are offering water and fruit. The paratroopers continue to move to their rendezvous points through the gathering crowds. Mike's uneasy feeling seems like paranoia amid this victory-like celebration.

A man tugs at his arm.

'Come with me,' he says in near-perfect English. 'Come to my house for a small celebration. You too,' he says, gesturing to two paratroopers who have stopped to talk to Mike. It is hard not to be swept up in such demonstrative affection and jubilation and they follow the man. Inside the man pulls out a bottle of whisky and some glasses.

'I have kept this bottle for four years,' he says, breaking the seal and opening it. He pours each of them a glass and then picks up his own, holding it out in toast.

'We have waited a long time for this. What is it you say? Cheers.'

'Cheers,' they respond and raise their glasses in unison.

The first paratroopers have already moved out and Mike is anxious to follow. It feels like the battle is already won, and he is worried the recce squadron might take the bridge before he gets there. He heads back along Telefoonweg, toward the railway line, stopping at a farmhouse where paratroopers have gathered. A jeep laden with men and equipment pulls up, and a woman offers the men glasses of water, welcome on this warm afternoon. Mike captures the scene with his Bessa as she hands a glass to the driver.

Other paratroopers watch. An empty glass sits on the bonnet; bare fields and the encircling woodland are again in the background. Mike takes another still of an older woman with a pail of water. A man, possibly her husband, stands next to her.

Mike assumes that both women come from the farmhouse and are related. He takes some film here as well, capturing the name of the cottage, 'Sinderhoeve'.

Mike checks his watch. It is getting on for four, and he needs to keep moving and meet up with Christie, so they can head to the bridge. He decides to find divisional HQ, so he can get a picture of what is happening on the three routes. Hopefully he will meet Christie there too. He quickens his pace, still thinking that the pleasant sunny afternoon, leafy woods and soft green fields all seem at odds with the fact that this is war. Then, from the direction of Wolfheze, comes the staccato of small arms fire, and something

else, which sounds like mortars. It is some way off, but some of the paratroopers are already engaged.

Mike finds HQ set up in one of the gliders. He is surprised to hear that there has been no communication with any of the three battalions or the recce squadron—the radio net has failed. Signals are busy trying to find out why. Apart from limited short-range capability, the only way of communicating at the moment is by dispatch rider. He also hears that some of the gliders carrying jeeps for the recce squadron have not arrived. It means there are not enough jeeps to get recce to the bridge for the *coup de main*. Major General Urquhart, commander of the 1st Airborne Division, a normally calm and measured man, is on tenterhooks waiting for information. After a brief conferral with his chief of staff, Urquhart decides that he will go and find Brigadier Lathbury,

commander of the 1st Parachute Brigade, and deliver the news that the recce squadron will not be there to meet his men. As Urquhart leaves, Mike gets the distinct impression that things are beginning to unravel already. Without communications, everyone will be fighting solo battles, and without Urquhart here, command is surely compromised.

With little to go on, Mike leaves HQ, considering his options for getting to the bridge. The sounds of engagement are intensifying, and Mike thinks it likely that both 1st and 3rd battalions have met opposition on their routes. He sees Dennis Smith, the other stills cameraman, approaching and hails him. He asks after Sergeant Christie and hears that he was sent on sick leave at the last minute, with conjunctivitis.

'Lucky sod. So that's why I get to take two cameras,' laughs Mike. 'No, seriously though, he must be bad—he really wanted to be here.'

'What's the news?' says Dennis, nodding toward HQ. Mike fills him in.

'But I'm sure I saw recce heading up the road a while ago,' Dennis says.

'What about Jock Walker—have you seen him?' says Mike.

'No ... I think we should press on together. There'd be hell to pay if we miss the capture of the bridge.'

'Judging by those salvos, I don't think there's much chance of that.' Mike looks toward Wolfheze. 'I think we should head toward the railway line and follow the 1st. We're closer to them, and maybe we can find out what happened to recce.'

Dennis nods in agreement. 'Okay, let's cut through.'

They make across the landing zone after 1st Battalion. On the outskirts of Wolfheze they come upon German prisoners being searched by paratroopers, and Mike takes a still.

Some salvos are louder now, but there are sounds of engagement further away too; maybe the 3rd Battalion has encountered the enemy as they travel along Utrechtseweg toward Arnhem. As Mike and Dennis move on, they come upon two Germans being taken prisoner outside a house, or maybe a civic building—Mike is not sure which. He takes a photograph of them, hands on their heads, watched by civilians.

The paratroopers confirm what Dennis thought he saw: recce squadron did start for the bridge, but they were ambushed not far ahead. A tank has been seen to the north of the railway line. A tank! Well, *that* was not part of the plan. If there is armour in

the area, that changes everything. The light is beginning to fade, but they decide to keep going along the recce squadron's route, along the railway line. It is a narrow country lane, pretty; great for walking or maybe biking, but hell for war; an easy place in which to be ambushed or picked off by a sniper hidden in the bushes.

They are in the intertidal zone of battle now—in some ways the most dangerous place, thinks Mike. You are cautious, but that other sense has yet to kick in, the one that puts you on full alert, makes you feel the danger as tiny ripples across your skin. Then, abruptly, they are in it. Just ahead, one of their jeeps has run off the road. Men are lying dead across it—caught, helmeted, haversacks still on. It is a terrible sight, and so soon in the operation, or so it seems. One of them looks like just a boy. It comes to Mike that these are probably the first deaths in this battle. He and Dennis cannot see what is happening further ahead, but they can hear

enough to know they will not get through this way.

'We should take the jeep if it goes,' says Dennis. 'Maybe 3rd Battalion is making better headway.' Mike knows it is the only thing to do. They remove the bodies from the jeep, start it up and turn around to drive back. The Germans were surprised by 1st Airborne's attack, but they are obviously regrouping. They are not the disorganised mob fleeing the Allies that the paratroopers were told to expect.

Near the Wolfheze railway crossing they talk to some men of the 1st Battalion who are setting up defences in shell holes. Dennis takes a photograph. Then they drive on toward Arnhem along a tree-lined road, looking for the tail of 3rd Battalion. At a crossroads they come across a German army saloon vehicle ambushed by the paratroopers who passed through earlier. The occupants are dead; one officer is sprawled half out of the car, his brains scattered along the road. The sounds of battle being joined are everywhere now, and the pretty streets and woods around Oosterbeek and Arnhem are starting to change.

As Mike and Dennis approach the next intersection, there is a sudden burst of machine-gun fire up ahead, and someone shouts to them, 'The road's been cut off. You can't go any further.' In the gathering gloom they cannot see the soldier but call their thanks and turn around and go back toward Wolfheze. It is too dark to work anyway. They will find a bivouac for the night. They rest fitfully, the sound of firefights and the glow of burning forest signalling that those holding the landing and drop zones are fighting hard.

The next morning, Mike films their troops skirting the railway

line near the Wolfheze crossing. Under the trees and between the slit trenches there are jeeps with trailers and tents scattered about. A corporal passes a message to a signaller, who attempts to make radio contact with other airborne units. Another paratrooper digs in among the trees while a Bren gun covers the railway crossing.

Dennis takes a photograph of PIAT gun positions covering the road. The men are from the recce squadron, and Mike asks after the young trooper he saw lying dead yesterday. He is told that he has been taken for burial in the garden of a house close by. He

and Dennis find the house, and Mike takes a still there of a medic kneeling beside the grave. He writes on his dope sheet:

> One of the earliest casualties in this airborne operation Trooper Edmond no 3060103 of Recce Corps was buried in Dutch Soil. By his grave is Cpl. Mills of HARBORN BIRMINGHAM.

It is nearly noon on the second day when they decide to call into 1st Airlanding Brigade HQ, which has been set up in a house in Wolfheze, to see if they have any news.

•

Before breaking for lunch, Robert and I walk the short distance along the lane where the Recce Squadron was ambushed. There is a memorial plaque there. Afterwards we drive to the house where Robert says Trooper Edmond was buried. We stop briefly outside; there is not much to see except a large white gate, but something begins to make sense as I stand there, the image of Trooper Edmond's field grave in my hand. I see now why it is the focus of the Arnhem story in the war diary. It appears as part of a scene-setting collage, similar to the one Mike created for the North African campaign. The photograph is pasted down over a coloured topographical map so that the corner of the image points to Arnhem; a typed explanatory panel describes the objectives of Operation Market Garden and the failures. But whereas the establishing image for North Africa is the drop, for Arnhem it is one of the first deaths of many to come.

The simple earth grave of the young trooper hung with his helmet; a medic kneeling in a gesture of respect. It is emblematic, as Mike perhaps intended it to be, of the carnage that was Arnhem, and universally of war.

Robert and I get back in the car, and he drives on to the intersection near the Café Koude Herberg, the place where the German officer was killed.

Cameramen under siege

The news is not encouraging: there are confirmed sightings of SS Panzer Corps tanks operating in the area; the radio net is still down; the second lift is late; and worse, Urquhart never came back after going to visit Lathbury. On the brighter side, someone has managed to make radio contact with 2nd Battalion, some of whom have made it to the bridge but are under ferocious attack. All available units are now moving up in the hope of fighting through to reinforce them and form the perimeter as planned.

Mike thinks the news grim but not dire. If the units moving up fight through to the bridge and the second lift lands safely, they might just be able to hold the bridge until their land forces arrive tomorrow. Without proper radio contact, though, they do not know what is happening with the lead sections, and the only thing he and Dennis can do is try to catch them up in their jeep. They study a map, trying to work out where they got turned back yesterday. It seems to be an intersection near the Café Koude Herberg, on Utrechtseweg, about five miles from Arnhem. They decide to try that route again and at least find out how far their troops have progressed. They need to be there if they break through to the bridge.

'Lou, Smithy.' Mike and Dennis look up. It is Jock Walker, the other cine cameraman. 'You're a sight for sore eyes,' Jock says. 'I was getting lonely.'

'We found each other yesterday,' says Dennis and gives Jock a brief account of what they have been doing. 'And what about you, Jock?'

'Oh, the same—filming gliders, filming paratroopers, taking prisoners …' Jock pauses for effect.

'Taking prisoners?' Dennis looks surprised.

'Yes, had to shoot one of 'em. Oh, not fatally, just to stop him running away. I took them in to div HQ for interrogation.'

'Well, they say that film is a weapon. You may be the first cameraman to get a combat commendation,' laughs Mike. 'We're thinking of taking a drive into town. Want to come?'

'Might as well. I took Major Oliver's jeep forward earlier, but it was too damn hot to film then. Might be better now.'

'Well, let's go and see if they've managed to clear Jerry out,' says Dennis.

A little later the three of them catch up with the tail of the 2nd Battalion South Staffordshire Regiment, moving up to Arnhem. They stop at the crossroads where the dead German officer still hangs out of the car like a torn rag doll, and Jock films the troops marching past. Dennis takes a still of the scene. They drive on further along Utrechtseweg, coming into a straight section of road bordered by trees. The interlacing canopy forms a tunnel down which the men march. They stop their jeep at a break in the canopy where the sun pours through. The stamp of the men's boots and the clatter of carts on the cobbles mingle with bird calls and now

the sound of firefights and mortars from somewhere ahead. Mike is captivated by the filtered light of the cathedral-like canopy and the stunning vanishing point of the men marching into battle. It is a strangely serene tableau. The marching men seem relaxed and have not yet encountered much enemy resistance—but they will soon, Mike thinks. Dennis takes a still and Jock some film panning along the line of marching men, catching Mike on the edge of his frame.

Back in the jeep, they drive on past the marching troops toward Arnhem and the bridge. This is Mike's first experience of being driven into battle and being unarmed. However comforting the Colt might seem, he knows that it would be of little use in these conditions. His instinct tells him to hug the ground; sitting in the

jeep he feels like a target at a fairground shooting gallery. He scans the road in front continuously, looking for unusual movements or the glint of weaponry. They can see the smoke rising from burning buildings in Arnhem and hear the clamour of fighting, though they are probably still a couple of miles away from the bridge. The road starts to curve around, and the land rises up on their left. Then there is a sudden hammer of machine-gun fire from the high ground. Jock, who has been driving, slams his foot down hard on the brake, and they pull to a screeching stop. In an instant, Mike rolls himself out of the jeep, and Jock and Dennis follow. A reply from the woods on the other side of the road lets them know that they are not the target of this attack. It seems that their forward echelons have been pushed to the south of the road. There will be no getting to the bridge this way.

That afternoon they make three more attempts to get through, even trying to weave their way through from the back streets of Oosterbeek, but the machine-gun and mortar fire is too heavy, and every house and garden a potential hiding place for enemy troops. The leafy streets that had seemed so charming and inviting when they arrived have become filled with menace, and Mike cannot help but remember the deadly fighting in the corkwoods in North Africa when he looks at the surrounding woodlands.

When the three of them decide to call it a day, they make an uncomfortable and rather shocking discovery. German troops have infiltrated behind them, and they have no option but to make a mad, careering dash back along the road until they reach safety. Their vehicle picks up a few bullet holes, but they are lucky. As they near a place called the Hotel Hartenstein, they are happy

to find their own troops digging in, and the war correspondent Alan Wood camped in the ditch with them. He tells them that the second lift with 4th Parachute Brigade came in five hours late and took a hammering on the landing zone at Ginkel Heath. Some of the heath caught fire and men got burned as well as shot at, but most came through all right.

Mike wonders if the Polish paratroopers will be so lucky tomorrow. He and Jock study the maps while Dennis takes a still of Alan sitting in the shallow ditch, fag hanging from his mouth, typing his despatch for the *Daily Express*. As far as they can tell, they got turned back near somewhere called Mariëndaal, but fighting seems to be going on all around them. The situation is very confusing. They do not know for sure whether they will be able to get through to the bridge to film, or whether they have been cut off permanently. Still, after his experiences in North Africa, Mike thinks this confusion is not unusual. As a soldier of the ranks, you only know what is happening immediately around you, or maybe a couple of hundred yards away, depending on the terrain, how far you can see and how high you can raise your head. Your battle may be very small in the scale of things, but not to you. To you it is the biggest and nastiest one anybody has been in.

He is finding that being a combat cameraman is not so different, particularly when it comes to how far you can raise your head. But then he does have a choice, unlike the average soldier. He can go back to his billet at night and have a decent sleep, wake up fresh and decide if his nerve is up; whether to have another go or wait till after coffee. Even with orders and requests he knows he does not have the same continuous exposure to danger as the

man with the gun. He feels privileged, relatively. The day before at Wolfheze, one wag asked him where the director was when he was filming.

'Just over there,' Mike said, pointing to some bushes. 'He gave me the direction *duck* at that last lot of incoming.' The wag guffawed appreciatively.

It is late afternoon now, and they decide to find a spot for some afternoon tea. They are back in the village of Oosterbeek, a place of quiet gentility with its neat houses and gardens and lush woods. A bit further on they pull off the road in a laneway. It is heavily wooded and muffles the sound of battle till you could almost believe you were out for a Sunday picnic. They unpack their compo rations on the bonnet. Mike starts to lever a tin open with his pocketknife when a wave of bone weariness washes over him. He can see it in the others too. He remembers this from North Africa, how the fight would suddenly leave you when there was no need for it anymore, and how you would feel deathly tired.

From one of the neat houses nearby comes a young woman. She introduces herself in halting English, asking if they would like some freshly made coffee. They gratefully accept. She brings the coffee back to them in dainty cups, and Dennis captures the moment. Mike is perched on the back of the jeep, eating his rations straight from the tin. Jock accepts a cup across the bonnet, as if he were taking afternoon tea in the family parlour.

It is too late in the day to get any more pictures, and they decide to set up a headquarters for themselves nearby. They commandeer a house on the corner of a side street that runs off Utrechtseweg, reasoning that Utrechtseweg still provides their best chance of

getting to the bridge. It is an attractive white building with dormer windows and some kind of thatching that hugs the building like a woollen cap. A couple lives there with one child, a daughter, and they make the paratroopers welcome, inviting them to a meal. It is good to have freshly prepared food. They dine to the sound of gunfire and explosions in the distance. The family is troubled by the sounds of battle but happy to have them there.

The next day, Tuesday 19 September, they hear that divisional HQ has moved to the Hotel Hartenstein. It is only a short walk away through the woods, and Mike decides to go there to find out what the situation is at the bridge. Troop movement into Arnhem has been going on all through the night, and he is delighted to find that Urquhart has returned after being freed by the advance of the South Staffs in the early hours of the morning. But Urquhart's

return does not seem to herald a changing of their fortunes; rather they begin to deteriorate. Recce squadron has reported that the enemy is concentrating north of the railway line at Wolfheze where the third lift, bringing glider elements of the 1st Polish Independent Parachute Brigade, is to land. Civilian reports have one hundred enemy tanks arriving from Apeldoorn, a city to the north of Arnhem. All available units are still pressing toward the bridge, but the fighting is savage. Platoons and companies are being virtually wiped out, and stragglers are regrouping where they can.

Mike is told that it is impossible to get through to the bridge, and that even if he could, the fighting is so confused and dispersed that it would not be possible to film anyway. About six hundred men have made it through to the bridge on this side of the river, but overnight they have had to repel attacks from the southern side of the bridge as well. Ammunition and supplies are dwindling as the numbers of dead and wounded and captured rise. The word *decimates* springs to Mike's mind, but it is likely much worse than that. Yet he still believes that if the land forces arrive today, the situation can be saved, and he worries whether the film he is carrying is enough for the capture of the bridge and the meeting up of 1st Airborne and 30 Corps.

In the afternoon, they hear that 4th Parachute Brigade have been forced back to Wolfheze from the line they had been holding along the railway, leaving the third lift coming in completely exposed. At four o'clock, the familiar lumbering forms of Stirlings, Halifaxes and Dakotas, with gliders in tow, appear. The sight of them filling the skies is comfortingly solid, and the deafening drone of their engines reassuring, but this all changes abruptly

with the opening of an ack-ack barrage. For a long moment, nothing seems to happen, and then there is chaos in the air: explosions, and aircraft falling in flames. Though he is too far away to see what is happening in detail, Mike can vividly imagine it. He knows men coming down exposed to enemy fire are unlikely to reach the ground alive.

It is a terrible blow, quickly followed by another. The zone designated for the supply drop is now in enemy hands, but without any means other than signals from the ground to communicate this, most are dropped there. Troops use yellow smoke, yellow triangles and every conceivable means to try to attract the attention of the RAF pilots, but with limited success. Very little of what they have been promised gets to them. Mike takes some film and a still of the drop. At this distance, the aircraft and their parapacks are black

specks over the trees. Then, as luck would have it, one parapack drops into the garden of their HQ, and Mike takes another still of the six men who come to gather up the boxes of ammunition. One of them, Corporal Freddie Webster, chews on a cigar nonchalantly.

Mike hears that German prisoners are being held in the tennis courts near div HQ and goes across to film there. Dennis accompanies him and takes some stills. The prisoners are a mixed bunch of mostly middle-aged Wehrmacht and Waffen-SS, but there is one fresh-faced seventeen-year-old with worried eyes.

At HQ, some Dutch underground workers have arrived, and Mike films them before going inside to see if he can get some footage of Urquhart, but it is too dimly lit. Urquhart and his chief of staff, Lieutenant Colonel Charles Mackenzie, agree to come out onto the hotel terrace so that Mike can film them. Not wanting to have

Urquhart standing there looking at the camera, Mike gives him a map to study. When Mike gets back to his AFPU HQ, he finds a six-pounder anti-tank gun and crew set up in the front garden and other troops digging in nearby.

On Wednesday, radio contact is finally made with those remaining at the bridge, but Urquhart can only confirm what they must already have guessed: that all attempts to get through to them have failed, and they are on their own. Any troops who can are to fall back around the Hotel Hartenstein. It is disconcerting how quickly the picture around them is changing. There seem to be pockets of enemy soldiers everywhere now. As Mike is doing a round through the woods, a mortar shell comes through the air, making a curious flapping sound, and explodes in the trees above his head. Jagged pieces of wood and branches are sprayed about and leaves fall as Mike throws himself to the ground. He lies still, unhurt, and although he can hear the mortars, no more reach him. It seems the frontline the cameramen have been seeking is coming to them.

Later, back at AFPU HQ with Dennis and Jock, he can hear the screech and rumbling of enemy tanks, manoeuvring somewhere along the road in front of their HQ.

Then a new horror unfolds as they watch. A young officer is spotting for a 75 mm gun a little way off when an attack comes down from a self-propelled gun fitted with a flamethrower. The young officer stays at his post until he is hit by a burst of flame, then he turns and staggers toward them, screaming.

'Shoot me, shoot me. Please! Please, someone shoot me!'

It is terrible, an unbearable sight. He is one grey pall from head to toe, his face featureless. From his hands hang what look like strips

of paper, Mike thinks. Men rush out to meet the young officer as he staggers on toward them a dead man, still moving somehow, a few steps more, weaving more slowly now, until he drops at the side of the road, where his rescuers finally reach him and smother any remaining flames. Mike does not try to film or photograph him—he is too appalled—but Dennis does. Most likely the image will never be seen. No one has given them any specific orders, but everyone knows that you do not film your own dead. Wounded being carried away is one thing, but maimed bodies strewn about after battle—well, the footage would never be used anyway. Mike is glad, though, that Dennis has captured this abomination. It needed to be recorded somewhere—that this is what it was like.

By Thursday morning, they hear that the remnant force at the bridge has been overrun. They had fought almost continuously for eighty hours. The remainder of the troops now form a horseshoe-shaped perimeter around the Hotel Hartenstein, about two miles long and a mile across at its greatest width; the Germans are to the north; to the south, the river protects their backs. 'Morning hate', as their bombardment by the Germans has become known, begins early, at about seven, and there is heavy mortaring and shelling as the German forces concentrate around them and squeeze their lines. Mike goes to div HQ to get a more definite picture of their dispositions. He does not want to wander into enemy lines in the woods.

He finds that a sniper has penetrated into the grounds close by the Hartenstein and is harassing all movement. No one can quite work out where exactly he is or how he got there undetected. Men are skirting around where they think he is through the woods to try to flush him out. Mike decides to sprint for the front door

of the Hartenstein. He charges, head low, taking the stairs two at a time, and slides to a halt in the passageway inside. A bullet thwacks against the face of the hotel. In front of him, sitting on the floor, are General Urquhart and some of his staff. Two things are clear: the idea of getting any firm indication of their lines is obviously out of the question, and Mike will have to wait until the sniper is cleaned out before leaving. He slides to his bottom with the others in the passageway. The sniper thwacks away at the building periodically.

Unexpectedly, an officer snaps, scrambling to his feet and saying, 'I'm not going to stand this any longer. I'm going out,' and before anyone can say a word or grab him, he is gone through the door.

They wait, looking at each other in silence. Then they hear the sniper's shot and the officer's scream, but they can do nothing— only sit on their bottoms and wait. Eventually the men who have been circling through the woods find the sniper and clear him out. Outside and on his way back to AFPU HQ again, Mike is intercepted by one of the censors, Captain Brett, who calls to him.

'Sergeant Lewis,' he says, waving him over. 'I'm digging in, sergeant. Is this all right?' He is standing next to a square hole about a foot deep with leaves all around it.

Mike can tell he is finding the going rough and feels sorry for him. 'Look,' he says, 'you've got to get down deeper; that's much too shallow.' Captain Brett looks momentarily deflated but picks up the shovel again and starts to scrape away the leaves.

By the afternoon, tanks as well as self-propelled guns are attacking the perimeter. The crisscrossing barrage is intense and relentless. Resupply is hampered by enemy aircraft, but in the late

afternoon they are encouraged to hear that the Polish paratroopers, who were due to drop just south of the bridge, have now dropped south of the river near a town called Driel. The Poles try to cross the river to join the British troops but come under heavy attack.

The next morning, they hear that radio contact has been made with the forward artillery units of 30 Corps, who have linked up with the Polish paratroopers and are holding a line at Driel. The perimeter contracts under heavy fire—in places it is barely three-quarters of a mile across now—and the casualties are mounting. Attack and counterattack are becoming the order of the day, and the nights too. The days slide one into another as the troops are pressed hard everywhere. The fighting is very close in, but in the heavily wooded landscape, the enemy is heard more often than seen. Mike takes a still of a six-pounder in action against a self-propelled gun that cannot be more than eighty yards away, though he cannot see it.

He thinks that war is really more sound than picture: a sound picture. The air is so full of noise, full of gunfire, hot steel twanging, machine guns hammering, mortars exploding, sometimes the cries of men, sometimes the cries for stretcher-bearers, but always full of uproar.

The few exhausted men left still defending the perimeter use Benzedrine to stay awake. Supplies of food and ammunition have begun to dwindle, and water is rationed. Mike takes a close-up of two of the six-pounder gun crew in their slit trench; one of them is drinking from a bottle.

Mike wants to take action pictures, but getting seven kinds of hell knocked out of you makes any kind of photography almost impossible. Jock thinks it is time to join in the fighting, but Mike and Dennis disagree. The time might come when they will need to pick up a gun, or have no more film left, but it is not yet.

Mike does his cautious round of the perimeter, taking some footage of a seventeen-pounder gun and tractor being moved and a still of some men near the tennis courts taking advantage of a brief pause in the shelling to prepare a meal, the first for days.

He passes the foxhole that Captain Brett was preparing and sees that it is now a decent size and presently occupied by Alan Wood, who is typing furiously. He takes a still of Alan, who asks him what it is like on the perimeter.

Mike does not want to be a doomsayer, but he cannot lie. 'The troops are magnificent,' he says, 'doing deeds of valour as a matter of routine. But the line is getting weaker. The area is so laced and crossed by mortars and shells and small arms that men are being hit by strays and ricochets. To tell you the truth, I feel a little

ashamed not to be fighting alongside them, but I might have to soon. It will be a close finish.'

Alan offers him a cigarette silently.

Behind the Hartenstein, Mike stops briefly to check the statuette of a woman that still stands, but barely, in the grounds. Once she might have been the focal point of a handsome garden. Now she is disintegrating among a mess of weeds. Her destruction since they took up residence here seems to reflect their deteriorating position and the grinding down of the besieged paratroopers: first her head went, then her neck, then her torso; piece by piece, she is being annihilated.

The enemy are firing airbursts now, black clouds of explosions showering down, and men are running for any shelter they can find. It is dangerous to walk anywhere, really. The only safe place

in their AFPU HQ is the cellar now, and the family have not been out for days. The pretty village of Oosterbeek is being reduced to rubble and shell craters. Houses are demolished, trees shredded, and all the while a flow of wounded are being stretchered in for treatment. The dead lie unburied.

Mike goes out one last time to film a three-inch mortar team in action near the river. Dennis goes with him. Exhaustion is written across the faces of the men, and desperation too, yet they keep flashing the shells into the barrel.

Mike takes some more film of the 75 mm gun crew under fire, but then his camera jams with just ten feet to go. He only has film for the Bessa now.

Another supply drop comes in. It is now difficult for the RAF pilots to drop the containers of food and ammunition accurately

in the shrinking zone. Mike captures an image of troops trying to attract the aircraft's attention with a yellow parachute.

In these confined conditions, the DC-3s and Stirlings become easy targets for the German artillery, but they keep coming anyway, low and steady, those flying them displaying incredible bravery. Mike can almost hear their briefing: 'You must get those supplies in. Those men are surrounded, cut off.'

What sounds like all the ack-ack protecting London opens up on the incoming aircraft; the ground shakes beneath Mike's feet. The aircraft are big and black through the trees now, large as houses, desperately holding their courses to deliver their vital supplies. Some are hit, bursting into flames over the Rhine. It is awful to watch; it seems such a terrible waste, Mike thinks, to sacrifice so much for so few. Only very small quantities of supplies are picked up that day, collection being further hampered by snipers

everywhere and roads blocked with rubble and fallen trees.

The Germans begin to burn the troops out, house by house, along the little country lane where they have their AFPU HQ. When the time comes to leave because logically their house is next, Mike goes down to the cellar where the family are hiding. He cannot bear to leave them behind. The Germans will undoubtedly clear the house room by room, and the cellar probably with grenades. Their host indicates that somebody else is hiding there in the cellar too. In the shadows Mike finds a private—a British paratrooper—apparently unhurt, at least physically. He looks up at Mike without speaking. For a minute Mike does not know quite what to do. He cannot help but feel that it is natural to choose the safest spot you can when so much steel is flying about; when even if there is a moment's quiet, you cannot quite be sure when it will start all over again. He decides to say nothing to the man and instead tells the Dutchman that they will be leaving the house tonight to go to the Hotel Hartenstein, and that the family should come with them. Mike can see the man is surprised that he has not ordered the paratrooper out.

As night falls Mike goes down to the cellar to get the family and bring them out. They have the shock of their lives when they emerge into the open. Even though it is getting dark they can see the debris, the ruined houses, the fallen street lamps, the blasted trees. The last they had seen of this street, it was a pretty little country lane. Mike can see that the devastating change has frightened the life out of them. Just the same, he warns them not to speak in case the sound brings gunfire down on them. Together they creep in and out of the rubble and over fallen logs until they reach the Hartenstein.

In accordance with the strange chivalry of war, a truce is organised in order to evacuate their wounded to St Elisabeth Hospital in Arnhem, which is under German control. Mike takes the opportunity to capture one of the action shots he was frustrated in getting earlier. He asks a section of four men to move toward him through the ruins of a small building next to the Hartenstein as if they are patrolling. He is pleased with his mock-up, though some of the men in dugouts close by give them a few boos and catcalls by way of a ragging.

A PATROL OF BRITISH PARATROOPERS SEARCHING A RUINED HOUSE IN OOSTERBEEK. These are the men, unwashed and unshaven, who held out for eight days against everything the Germans could fling at them before the order for their withdrawal from Arnhem was given

Finally word comes that their land forces cannot get through to Arnhem along the road. The new plan is to form a bridgehead on the opposite bank of the river, so that the able-bodied and walking wounded of the remnant force can be withdrawn by boat. Operation Berlin, as it is called, is scheduled for ten o'clock that night. The last still that Mike takes on the north side of the river is of a soldier on the first floor in the ruins of the Hartenstein.

That night there is a strange sighing over the trees; it comes from the other side of the river and goes way beyond them somewhere. Then suddenly there is the crash, crash, crash of shells, and they realise with something like joy that their artillery is in range, and for the first time the traffic is going the other way. It is generally agreed that this is the most gorgeous sound they have heard for a while.

There are strong winds and heavy rain that night. Those furthest away from the river leave first. A concentration of artillery and tracer fire from the south bank is used to distract attention and provide protection for the withdrawing troops. The way through the woods to the river is marked with white tape, and men are placed at intervals to keep them from straying behind enemy lines. Mike has an odd thought as he passes each one: *Who is the last man? Who tells them it is okay to go now, that there is no one else to come?*

After emerging from the woods, the men still have to cross an expanse of open ground to get down to the riverbank. There are too few boats, and they can only ferry fourteen at a time. The wounded go first. The rest crouch or lie in the thick, sticky mud at the river's edge, strafed by German positions on the high ground to the west, too exhausted and hungry to really be scared. It is a long night for those waiting. Mike lies there with the rest of the press corps, thinking about what hot flying steel does to hard rock, to vehicles and guns; his flesh feels very weak. Many are wounded as they wait.

Boats are hit and sunk through the night, and eventually those who think they can are given permission to try to swim. But the river is swift, and the stretch of bank held by the British small. It is easy to be swept into enemy-held territory. Mike can hear some of the swimmers getting into difficulties, crying for help, perhaps drowning. The longer he waits, the worse it becomes. He is exhausted, covered in mud, and wonders if he will ever get across. For the first time he considers whether he should ditch his film and cameras. The BBC reporter Guy Byam is obviously feeling

much the same, because he says to Mike, 'I don't think we'll get across this way. I'm going to swim. Are you coming with me?'

Mike knows he is not a good enough swimmer for that fast-flowing river. He wishes Guy the very best of luck. In the early hours of the morning, Mike boards a boat with Alan Wood. The ferrying goes on until daylight, at around five-thirty, when about three hundred are left on the north side with no option but to surrender.

After nine days of fighting, those men fortunate enough to get across the river make their way south to Nijmegen, now under Allied control, in small parties. The members of the press corps have all made it out, with only a few minor injuries. They meet up in Nijmegen, and Mike asks Captain Brett to take a photograph of him and the others. He poses, his hand on the shoulder of Squadron Leader Coxon, with Major Oliver, Stanley Maxted and Flight Lieutenant Witham.

I find a disturbing coda to the withdrawal of the troops recorded on Dennis's dope sheet, but I have not been able to verify what he says he witnessed. In an entry dated 26 September, he writes:

> ... about six hundred men were left on the Northern bank of the river. Unfortunately it was daylight & it was impossible for them to cross the river so they had no alternative but to surrender. One officer climbed onto a man's shoulder with a white flag and was immediately shot down. Another officer tried it & he was shot down too. Then the enemy opened up with his machine-guns & mowed the whole six hundred men down. The withdrawal was sheer slaughter. I was lucky enough to get away with only a bullet wound in my right shoulder.

Robert and I drive the short distance from the Hotel Hartenstein to a laneway adjacent to the river. We stand at a gate, looking out across a field. The river is hidden by the fall of the land. This is where the Arnhem story ended for a lucky few. Most of the ten thousand who went there were left behind in graves, or hospitals, or prisons. The civilians were driven out of their homes, and it was a cruel winter for them.

Arnhem was a propaganda victory for the Germans. It was here they halted the rout after Normandy. It was also a propaganda victory because of the extensive coverage of the events,

much of which was shot by their frontline soldiers because nobody was stopping them, unlike British soldiers, who were subject to many restrictions.

At the time, Montgomery, now a field marshal, did manage to spin it as a victory of sorts for the British when he declared Operation Market Garden ninety per cent successful. The Allies had reached Nijmegen, about eight miles from Arnhem, before they were halted.

The Arnhem archive is remarkable, given the circumstances of its creation, mostly under siege conditions and with only basic equipment. It makes sense of something I read in No. 2 AFPU's official war diary:

> The main complaint of London in the past is that when there have been reports in the papers of fierce fighting, [No. 2 AFPU] has nothing to show for it. Going into it more carefully, one finds adequate coverage when the Allies are doing a set attack ... but inadequate coverage when the Allies are on the defence. It should be realised that the photographs will never reflect the written word in battle without a certain amount of reconstruction. The camera cannot exaggerate as the written account can nor can it photograph what ... so often, all too often from the photographic poi [point of interest] ... takes place in the dark and other unsuitable conditions for camera operation.

The first observation is common sense, really. The flow of a set attack has been planned and is therefore reasonably predictable, meaning that the cameraman can anticipate the best position

to film from, whereas an army on the defensive and retreating is reacting to circumstances and is unpredictable. The second observation seems to imply that when it comes to battles, filmed actuality does not in fact reflect the reality of war. Perhaps it is not so much that the writer can 'exaggerate'; rather that written accounts can synthesise and collate information gathered from different sources to create a bigger picture. The writer also benefits from the time to reflect, alter and embellish. Without editing or re-enactment, the combat cameraman gets one chance to capture the moment, and it is fraught with difficulty and danger and limited by a single point of view. I suppose much of what was filmed on the battlefield were not the crucial seconds but those that followed immediately after.

This may explain Mike's need to set up the photograph of the paratroopers patrolling through the ruins. Maybe for Mike the point was that, at some time during the nine days, a group of paratroopers much like these men had searched through a ruined house for the enemy. What do we really mean by actuality anyway? If we mean truth, then I wonder what 'truth' we expect from battle pictures. Pluck an image from my father's war diary and exhibit it without context and it will only have the meaning contained within its frame: a soldier on a battlefield, somewhere, firing a weapon. An expert in military history may be able to place it within the Second World War in Europe, and determine the weaponry and even the branch of military represented, perhaps, but more than that would be unlikely.

If by truth we mean proof through record and evidence, then we need the creator to supply the image's provenance, and often

this is missing. We also need to know the limitations of the record, as with the AFPU's self-censorship about filming their own dead. While I was at the Airborne Museum Hartenstein, I viewed German footage of the streets surrounding St Elisabeth Hospital, where some of the fiercest fighting occurred. Dead British paratroopers lay everywhere amid the debris of the battle, a point of view entirely missing from the AFPU coverage. I suspect, too, that no one has ever seen the image of the burning man that Dennis Smith took.

For me the film and photographs have another dimension, in a sense allowing me to see through Mike's eyes, and to see him there in the midst of it all too. Mike on his way to Arnhem; Mike picnicking on the back of the jeep; Mike a phantom image on the left of the frame as Jock Walker pans along the line of marching men under the trees. I imagined him there as I toured the dropping and landing zones and walked the streets of Oosterbeek. I imagined him filming and taking photographs, trying to get action shots, dodging in and out of the ruins and debris as the Germans pressed in, surviving to bring it all home.

There is an image in the war diary with a caption that simply says: *In Nijmegen after evacuation*. Mike is touching the chin of another man, as if he has just reached over and tilted his face so that he can see him, perhaps remarking on his growth of beard or maybe just pleased to see him again. The exchange of looks between them seems to express affection, as if they know each other well and are happy to see each other alive on the other side.

My mind wants a name for this man and for no apparent reason suggests 'little Geordie'—one of the men who survived North Africa, one of the few left of the originals. This is what I want the story of this photograph to be. Unless I can discover its provenance, it is unlikely I will ever really know.

•

Mike, Dennis and Jock meet up again in Nijmegen, where they are among the first to be flown back to England. Their photographs and film are eagerly awaited and released worldwide. The three of them are given a tremendous welcome home and for a brief time find themselves celebrated. The picture of the three of them appears in newspapers along with the stills Mike and Dennis took.

Mike clips stories from the *Hackney Gazette and North London Advertiser* and *Picture Post*. There is a rumour that they are to receive a British Empire Medal for their coverage of Arnhem, but nothing comes of it.

Facing terror

I am back in Canberra now, *home.* Yes, that is what the old house I purchased after my divorce has become: the interior renovated in warm colours, and the garden, once a shoreline of concrete washed by an expanse of weedy grass, now blooming. It is filled too: with my new partner; Lily, my dog; and friends—some old, many new.

Since my return, I have been exchanging emails with Robert Voskuil, checking details, locations, the correct spelling of street names and so on. He was an unstinting host in Arnhem: the battle tour, his knowledge of the photographs and his willingness to share his research helped enormously in my reconstruction of Mike's experiences. It was he who alerted me to the fact that Mike mocked up the shot of the paratroopers searching the ruins. Now he has another piece of news for me: the still from the film showing my father giving a two-fingered salute to an unknown cameraman was taken not on the way to Arnhem, but on the way back—the information I found in the Imperial War Museum catalogue was incorrect. The truth of this is obvious when you examine the image more closely, and a friend of mine versed in things military confirms Robert's assessment. The men

are not in battledress and are without parachutes. It brings home to me how easy it is to make mistakes, how you can never do too much checking of facts, and how sources are subject to error as well as bias.

I have a meeting with a curator from the photographic archive of the Australian War Memorial, Ian Affleck. While I delved deep into Mike's early war years, I was able to rationalise not looking at the Bergen-Belsen images as a logical and chronological quarantining of thought and attention, but I cannot put off confronting them any longer. It is not that I have been ignoring them entirely. I have been reading about the Holocaust, about the concentration and extermination camps, about Bergen-Belsen, and lately about the images in particular.

Over the years since the war, a *Bilderverbot*, or prohibition against looking, has grown up around the photographs and film of the camps that were made as the Allies liberated those left alive. Some scholars have said the Belsen images, and others like them, demean and dehumanise those depicted, and label the cameramen who captured them as transgressive and callous. Even though what I know about the filming at Belsen contradicts these interpretations, they are uncomfortable, and do not help me negotiate the twin dimensions of the public and the personal that these images have for me. My thinking about their importance as historical records, their relevance today and their meaning for my father becomes snarled in his pain at remembering Belsen, in his absolute rejection of seeing the film he took again and of going back there, and in my own memories of finding the images as a young girl.

My reason for going to the Australian War Memorial is tenuous;

my father gave a talk or two at the Australian War Memorial and donated to their collection a segment of film showing a parachute training drop. Australian troops were not directly involved in the liberation of the camps in Europe in 1945. It was mostly British and American troops in the west, and Russians in the east, who liberated the camps. So I am quite unprepared for the next development.

After looking through my father's war diary, Ian Affleck picks up the five Belsen images and looks at them one by one. He stops suddenly and holds one out toward me.

'This is one of ours,' he says. 'It was taken by Alan Moore, one of our official war artists.'

There is a moment of confusion and puzzlement as I tell him that the image comes from the Imperial War Museum's collection and was taken by Lieutenant Wilson of the British Army Film and Photographic Unit. He goes away to fetch a copy of Alan Moore's photograph. When he comes back, we review them together. The similarity of their composition is extraordinary, but a slight difference in the framing shows that they are not the same image and the archivist points it out to me. The image taken by Wilson is a larger format than Moore's.

As the extraordinary coincidence sinks in, I realise that the similarity of the images suggests the startling possibility that Alan Moore, having travelled to Bergen-Belsen independently, met the AFPU team there and perhaps joined them as they moved around the camp in their jeep. If this is so, it is just possible too that he met Mike—and that he might remember him, because Alan Moore, now in his nineties, is still alive.

Ian Affleck tells me that Alan Moore spent three or four days at Bergen-Belsen taking photographs and sketching. On his return to Australia, he painted a number of canvases. They are also held in the Australian War Memorial's collection. In the research centre, as I start to scroll through the thumbnails of the photographs that Alan took, I spot a familiar profile that I feel sure is Mike. I enlarge the image to see the detail. Mike's sergeant stripes, his beret and his camera emerge. He has been wrongly identified in the caption as a soldier of the Welsh Guards, the group Alan Moore travelled there with, but it is definitely him. He seems to be filming a central figure, a woman, to whom the other women have turned. She has one hand in her apron pocket, the other raised as if she is expounding a point. I remember seeing that piece of film at the Imperial War Museum. To be able to confirm through this photograph that Mike's and Alan's paths crossed in Belsen feels extraordinary.

The freakish similarities of the two images taken by Moore and Wilson compel me to look more closely at them, to look past my automatic response of revulsion to see the differences for myself. What was it that the photographer and artist saw in this subject that made them both want to capture it? Perhaps in simply recoiling from these photographs, I have missed their point.

Staff at the Australian War Memorial help me get in touch with Alan, and he invites me to his home in country Victoria. As I drive out from Melbourne airport, I find myself still thrilled by the serendipity of our introduction, as if our meeting was fated. Alan meets me at the front door. He is in his mid-nineties now, but still surprisingly spry. He had just been cleaning up the remains of a fallen tree before I arrived.

I end up spending nearly two days with him. He is an engaged and gracious host, and our conversations, which I record, go on for hours over meals and glasses of wine. We soon range across the whole of his war, through New Guinea and Italy and finally Germany. We look at photographs and paintings, sketches and documents. We look at works in progress in his studio. We look at my father's war diary and the five photographs and Alan's photograph of Mike filming.

There is a glassiness in his eyes when he talks of Belsen, the same that I saw in Harry Oakes' eyes when I talked to him and he seemed to look straight through me, and in my father's at times, too—as if they were looking back into the past and seeing it happen all over again. Like most of those who went to the camp in those first two weeks after its liberation, Alan had no idea of what to expect, and nothing he had yet seen in the jungles of New Guinea

or during the battle on Los Negros Island had prepared him for the atrocity of Belsen. His reaction was to sketch frantically to try to capture it all—the acres of bodies, and the wraith-like remains of those barely alive.

He says that a soldier involved in the relief effort interrupted him once, telling him that he was mad to be sketching.

'He said to me, "They'll think you made it up," and I thought he's right. That's why I took a photograph of everything I drew, so it's a definite reminder, or a recording of it.'

Alan painted the Belsen canvases after he returned to Australia and, thinking them to be of huge historical importance, offered them, along with the photographs and sketches, to the Australian War Memorial. Sitting in the office of the director, Lieutenant Colonel Treloar, Alan was shocked by the response.

'Colonel Treloar told me that he didn't want anything else except Australian troops. I was horrified,' he says, and then a little later adds, 'He threw them back across the desk at me.'

I can see that Alan is still indignant and hurt at that meeting, even now. Like him, I find it hard to believe that his Belsen work was not regarded as an important part of his war oeuvre.

Time seems to have polished some of Alan's memories and worn away others. Many telling details seem destined to emerge between recording sessions, surfacing in moments of quiet reverie, when he seems almost to be talking to himself. He looks hard at the photograph he took of Mike, searching for any memory of that time, trying to recall their meeting, but it eludes him.

As I prepare to leave, he says that it has been good to speak with me about these things, these haunted memories, the bad

dreams. 'You get it,' he says. Over the years there have not been many who do.

Before I go, he tells me the story of how he met a girl called Olga in Belsen. He recorded meeting her in his diary. Years later, when the Sydney Jewish Museum was organising an exhibition that included some of his Belsen work, he asked whether they knew of her. Of course he only had her maiden name, but it turned out that the one Olga who worked for the museum as a volunteer was his Olga, now Olga Horak. It is another one of those extraordinary coincidences. He tells me a little of her story and says that he thinks it would be good for me to meet her.

I drive back to Melbourne with a distracting hubbub of thoughts and images racing through my head. When I take a wrong turn on the outskirts of the city, my GPS recalibrates my route through a maze of backstreets.

•

Alan gives me an introduction to Olga, and I travel to Sydney to meet her. It will be the first time I have met a Belsen survivor, and I feel apprehensive meeting a stranger under such circumstances. I have told Olga my story over the phone, and she has asked me to bring the war diary and the five photographs. We meet at the museum. She is slim and elegantly dressed in a blue suit, her grey hair swept up neatly, and she welcomes me with the warmest of smiles. She tells me her story in softly accented English, and my unease melts under the intensity of her story. Olga was born in Bratislava, Czechoslovakia, and was just thirteen when the war began. Life became increasingly hazardous for her family after

German occupation, and when Olga's older sister was taken away, the family went into hiding. Denounced by the neighbour who had been hiding them, Olga, her mother, her father and her grandmother were deported to Auschwitz.

After separation from her father and her grandmother, Olga and her mother managed to survive Auschwitz, a brutal forced labour unit, and in early 1945 were marched 375 kilometres west toward Germany and away from the advancing Red Army. It was one of many so-called death marches, in which already brutalised prisoners were forcibly moved. By the time Olga and her mother arrived in Belsen they were both extremely emaciated and weak. Olga has published a book about her experiences, and in it she writes:

> Whatever body fat I had on me disappeared many months ago. My bones stuck out, my breasts had all but disappeared, my teeth were loose in my mouth, I was covered with open weeping sores and I crawled with lice. My eyes were sunken in their sockets, the little hair I had was patchy, and I could barely stand upright let alone stand straight. And yet I was not as sick as the inmates I saw standing before me in Belsen.

It is a little hard to grasp at first that after all Olga had been through others could be worse off, but her words underscore the misery and torment that leaches out of the Belsen images and perhaps help to explain too why Belsen seems to have become some kind of benchmark of Holocaust horror, even though it was not set up as an extermination camp with purpose-built gas chambers.

Like others in Belsen, Olga and her mother soon succumbed to the diseases that had been ravaging the camp's population since January—typhus, diphtheria, tuberculosis and cholera. Olga's mother died just hours after the camp's liberation. When Alan first saw Olga he doubted that she would live, and she says herself that it was sheer determination that stopped her from dying. She could not eat even the most meagre of rations and weighed only twenty-nine kilograms. Even after she was discharged from hospital, it took years for her eyebrows and eyelashes to grow back. After a long recovery, she met and married another Holocaust survivor, John Horak, and they migrated to Australia in 1949. There are many stories like Olga's, voices from that apocalyptic race war that changed the demographics of whole nations.

Olga shows me round the museum and especially the Holocaust exhibition. Over coffee we talk some more, and then she asks to see the war diary and the five photographs. Again I feel a wave of discomfort, a sort of embarrassment or awkwardness, as if I am going to show Olga something that she has never seen before and I might shock her. I push the war diary and the five photographs toward her. She looks through the war diary for a while, and then at the five photographs. She looks in an intense way but without much comment, just a slight nod of the head, as if affirming, *Yes ... that is what it was like*. The photographs lie between us on the table, exposed and raw.

As we come to say goodbye, she echoes Alan, saying it has been good to talk with me about these things. Perhaps the only way to live with such trauma is to keep speaking about it. I ask if she thinks that is true. She shakes her head as if she does not know.

With a self-deprecating laugh, she says her daughters tell her that she talks too much about what happened—that she should not live in the past.

'I tell them, I don't live in the past, the past lives in me.'

She says that she has been back to Belsen, and when she hears that I have never been, she urges me to go. That Olga had been back was not something I had expected to hear—maybe because my father never wanted to go. But at that moment, the equivocal idea that 'one day' I might go to Belsen becomes a certainty.

•

Speaking with Alan and Olga has released me in some way that is hard to pinpoint, but my research into the Belsen images is becoming more focused. I have gone back to university to find a way of evaluating them and begun work on a doctorate. I am blessed with an insightful supervisor, Paula Hamilton, who is both encouraging and challenging, and I look forward to every meeting. I start to mind-map the thoughts, feelings, observations and references from my research log, which till now have just been disjointed lists. Like a brass rubbing, the patterns begin to emerge slowly.

I look into Alan's falling-out with Treloar. Treloar's claim that he was rejecting Alan's Belsen works in favour of works about Australian troops is not borne out by the evidence: Alan's paintings of Italian refugees and German prisoners of war were already in the collection at that time. The question remains as to why Treloar did not regard the Belsen works as important in themselves.

Alan carried on a correspondence with Treloar throughout his official tenure as a war artist, and then for some years afterwards as he continued to press Treloar to take his Belsen works. The tenor of their communication suggests that Alan had begun their relationship with a great deal of respect for Treloar and perhaps saw him in an avuncular light, which may explain his bewilderment at the outcome of their fraught meeting about the Belsen works. He was surprised and disappointed that Treloar did not share his sense of the enormous importance of the photographs, sketches and paintings. He could not understand how the man he had looked up to did not 'get it'.

In the Australian War Memorial research centre, I read on through the correspondence files. The story becomes more painful: when Alan would not accept Treloar's rejection, Treloar enlisted two Australian War Memorial art committee members, artists Louis McCubbin and William Dargie, to appraise the paintings.

McCubbin was scathing, saying:

> I felt that as works of art they failed—to my mind, not done with much conviction—gave little idea of horror and lacked drama. As records they might be worth while but in this respect, not nearly as effective as the photographs.

William Dargie did not demur, but said:

> I think that as a record of horrors the photographs are much more affective than the paintings but possibly I would not go so far as to say they failed entirely as works of art. They are at least as good, as paintings, as most of the

> work that Alan Moore did for the War memorial ... I do not think that these paintings convey any great feelings of horror to the spectator.

The sad part is that Alan Moore considered Dargie a friend. The strange part is that Dargie said of his own service as an Australian war artist:

> I was being paid to create a record which would be more personal than photographs ... I think the war artist is lucky to be leaving memories that are often more immediate than photographs. We don't always identify with photographs, even though they are right and true.

It is a perplexing business, and I wonder what Treloar was thinking when he subjected Alan's work to such appraisal, as if he were some tyro, not one of his official war artists. I wonder too at the artists who appraised Alan's work as if there was some aesthetic of horror to which they must conform, an aesthetic borrowed from the photographs and film likely circulating at the time. Perhaps they, like me, had been looking only to be horrified and had missed what else Alan's work had to say.

It took many years, and the passing of Treloar, for Alan's Belsen paintings to make their way into the Australian War Memorial's collection.

•

It is late afternoon, and I am sitting on a bench above the cabin that looks directly along the east–west axis of the valley to distant

peaks. Many years have passed since I began this quest, for that is what it seems my research must be—to have been sustained over such a long period of time, and taken me back into academia.

In a few days' time I will travel back to Canberra and pack my bags for a final research trip. I will present a paper on the Belsen images at a conference at University College Cork in Ireland. Then I will go to London, to the Imperial War Museum, and view the Belsen film again before revisiting Arnhem and ultimately travelling on to Belsen. Something tells me that I will experience the film differently this time; something is shifting in my responses to these images.

My eyes travel over the panorama in front of me. My field of vision takes in the hazy blue-green peaks and forested folds of land, the bright green paddocks, farm buildings, cattle grazing, glimpses of the river and even the infrequent traffic that travels along the dirt road below. By turning or tilting my head slightly and moving my eyes, I can take in more of the panorama. With my binoculars I can zoom in on specific details—a waterfall on the opposing mountain slope, an eagle circling overhead. There are sounds, too: bird calls, cattle lowing, a tractor grumbling along in the distance, a whisper of leaves moving gently in the breeze. Earthy scents and tastes and warmth from the winter sun round out the experience, and wrapped around all this is a tremendous sense of arching space and light. As I drift into thoughts of my coming travels, my eyes carry on looking without seeing, and in that moment it comes to me that this is the way I have been engaging with the Belsen images: looking without seeing.

I am speeding on a train across the Netherlands to Germany at between 160 and 200 kilometres an hour, heading for Celle, and Belsen. The first part of my trip is over: I left Arnhem this morning. It was good to catch up with Robert and talk over some of the ambiguities in my research. The train seems barely to move as we hurtle through the towns, villages and countryside, and I spend the hours reading and thinking and dozing. I would not have known that I had passed into Germany except for a message on my mobile phone. Borders have all but disappeared in Europe since I was a child travelling with my parents. I remember them as part of the excitement of travel: waiting in queues for immigration and customs; the new stamp in the passport; the change of currency and language. As the countryside slides away from me and we penetrate further into Germany, it comes to me that on 24 March 1945, somewhere out there, Mike landed by glider as part of Operation Plunder—the Allies' second, and finally successful, attempt to cross the Rhine.

Christmas has come and gone since Mike returned from Arnhem. He is now attached to the 6th Airborne Division, which is preparing for Operation Varsity, part of Operation Plunder, the Allies' two-army thrust into Germany. They will finally cross the Rhine, this time between the towns of Emmerich and Wesel. Emmerich is just under twenty miles south-east of Arnhem, and Wesel about another twenty-five miles further on. This time the land forces will go in first, and the airborne forces will follow

shortly after. This time they will go in one lift and be landed practically on their objective. This time they will be in range of their own artillery. If all goes according to plan, the airborne and land forces will link up on the first day. It seems to Mike that at last the lessons have been learned. For the first time he is asked to go in by glider. He is to film the link-up with the land forces and then return with the film via France. Mike has no argument with this. He opts to travel on the first troop carrier.

Mike takes some footage of the men assembling and getting ready and their commanding officer, Major General Bols, briefing them. The weather is good in England as they emplane, but as they near the town of Hamminkeln, just north of Wesel, they run into a heavy haze and are targeted by anti-aircraft fire. The poor visibility makes it hard to identify the landing zone; some gliders crash, some are hit, and some collide with each other on the ground. The casualties are heavy, but in spite of this the brigade secures all of its objectives, and by the afternoon the fighting is thinning out. A little later they link up with the 15th Scottish Infantry Division. It is an unprecedentedly quick operation for Mike, and on his way back with the film he manages to take some time out to sketch and explore a little in Paris.

Wandering the streets near Montmartre, he stops to watch an artist at work. The light is fading and the man is working quickly, sketching the scene in front of him, which takes in a glancing view of the famous Moulin Rouge. Another scene of a woman, perhaps a 'woman of the night', a fox fur draped around her shoulders, lies on the ground beside him. The man trades them for two packets of cigarettes. I found these paintings in the

garage of my parents' home after my father died. The silverfish had eaten portions of them away, and I took them to a paper conservator who was able to save them. I love the paintings for their exuberant evocation of the time and the link they have with my father as a young man in Paris.

•

Within a week, Mike is back in the field again. The Allies are fanning out from the bridgeheads they have created, pushing deeper into Germany, and the enemy is starting to crumble. The AFPU have many teams on the ground now, following the advancing troops. Mike has been paired with stills cameraman Sergeant George Laws; they have a driver called Blondy, new to the job. Mike takes to George immediately. He is a good cameraman and a careful man and sees that they are well supplied with rations, carrying a compo box on the back as well as the front of the jeep. The three of them shake down well together as they head closer to the front. Mike thinks Germany a pitiful sight: its cities have been so smashed by air raids that you can only see where the streets once were because that is where the layer of rubble is least thick. It is dangerous too with pockets of fierce resistance here and there.

It is 9 April now, and the Allies are more than sixty miles inside Germany and continuing to fan out. The 6th Airlanding Brigade put down an attack the night before, forming a bridgehead across the Weser River at Petershagen, and Captain Evans, responsible for organising coverage in their sector, has asked them to 'swan up and down' at first light to see what they can get.

It is a cold day, and inside their jeep they have got a nice fug on

by buckling the canvas doors shut. Mike has the warmest spot, in the middle between Blondy and George. Having found nothing of interest, they decide to drive down to the river and maybe cross, if it seems safe. They approach the river slowly along a rough cobble road, Mike mouthing lines from Browning's 'Pied Piper of Hamelin' to himself: 'The river Weser, deep and wide, washes its wall on the southern side.' Blondy pulls up next to a house just short of the crossing. They sit looking out over the river. Apart from one house on the other side, the land is open fields, very exposed. Suddenly Mike gets that tickle at the back of his neck and, instead of feeling comfortably snug, he feels trapped.

'George, look, I've got a feeling—something's not right. Take a look, would you?'

George nods and undoes the buckle of the door, pushing it open and looking up at the clear sky. The sun glints on his glasses and then he dives from the jeep with a warning yell. Mike leans across and looks up where George was looking a moment before and sees Messerschmitts circling overhead.

'Blondy, out, out. No, no time, leave them,' Mike says when he sees Blondy about to grab the cameras. 'Under the jeep.' He pushes Blondy out and dives after him. As George is already under the jeep, the only place left for Mike is under the differential, and he knows he will not fit there. As the first bombs hit the ground, narrowly missing them, the jeep dances with the vibration. The Messerschmitts bank and turn to take another run. It takes Mike only a second to realise that if they hit the jeep, all three of them are gone.

'Blondy, George, into the house, now,' Mike says, rolling to

his knees behind the jeep. The Messerschmitts are diving as first Blondy, then George, makes for the door of the house. Mike can see the black specks of bombs falling toward him as he throws himself after Blondy and George through the door. Stairs lead down to a basement, and they practically fall down them into the laps of a group of young squaddies who are settled in, drinking tea and eating compo rations.

'What are you lot doing here?' says Mike as the sound of their own ack-ack opens up above.

'Same as you ... taking precautions,' says a cheeky one. Blondy and George bludge a cuppa, while Mike goes cautiously back upstairs to see what is happening. The noise from the ack-ack on either side of the bridgehead is deafening and there are black puffs of smoke everywhere, but in between he sees the Messerschmitts hurtling off eastwards. He goes down to fetch George and Blondy, and they make their way back to the jeep. They are all pretty shaken, but they are lucky—the jeep is untouched.

'Whose idea was it to come here anyway?' says Mike.

'Yours,' says George, smiling.

George and Mike decide to leave Blondy with the jeep and go down to the bridge and look across the river. Some of their troops are crossing now, moving up to reinforce the line.

'What about going across to see what's going on?' says George.

'Okay, but it's your idea this time.'

They have hardly started across when they hear the drumbeat of artillery fire opening up in the distance, and then shells begin landing in the water.

'Remember this was your idea,' says Mike as they charge across

the river. They stay for a while on the other side but do not find much worth filming, as the troops have moved well forward by this time.

It is the way of war, Mike thinks, as they head back to Blondy. You have a lot of experience of shells dropping and gunfire, of fighting at a distance, an enemy you hardly ever see. Mostly, though, it is an experience of one's feelings. Not like the films where the viewer looks on like God: one moment one side is firing, then the other, with hardly a drop of blood to be seen. In films you see marvellous charges led by heroic officers, and men who engage the enemy and do individual deeds of valour and win battles. Well, people do win battles, of course. If you do not believe in what you are fighting for, weapons are just wood and metal in your hands. What sustains you, without thinking too much about it, is a belief that you are doing the right thing. Even so, it seems to him that war is won mainly by firepower—overwhelming firepower.

By 12 April, Mike has been reassigned and teamed with Sergeant Harry Oakes, stills, and Sergeant Bill Lawrie, cine. Mike knows Bill already; after returning from Arnhem, Mike spent some time experimenting with ways of fitting the camera to his parachute harness so he could film while dropping, and Bill Lawrie helped him. Eventually Mike managed to attach the camera in such a way that Bill only had to push a button when he jumped. They were both very pleased with the resulting footage.

They are sent in with the 15th Scottish Division to a place called Celle. The Allies have now penetrated over 125 miles into Germany. As their troops overrun the town, they liberate some

prisoners being held there who have been appallingly treated. A short man wearing shabby clothes and a beret emerges from a building that looks like it might have been a school at one time. He walks jerkily, his eyes unseeing because they are completely closed by deep black and blue bruising, the features of his smashed face barely recognisable. Despite his wounds, he seems to know that they are liberators. Others follow him out. Most have been starved and hideously beaten, their wounds left untreated. Many are beyond medical help.

As the Allied soldiers round up the Germans and give what aid they can to the prisoners, a British brigadier of the Royal Army Medical Corps intervenes. He is clearly appalled. He grabs a German medical officer by the throat and shakes him, screaming, 'You are a doctor, and you allow things like this to happen!' He squeezes the doctor's throat until the man's eyes begin to bulge and two junior officers pull him off. The prisoners include Russians, Poles, Jews and even Germans, and they tell the Allied soldiers that they are the only survivors of a group of several thousand prisoners who were being transported through the area when the Allies attacked. Many died in the air raids, trapped in the freight cars they were being transported in. Those who did not die fled, and were chased down and recaptured. The cameramen's experience at Celle is just a hint of what they will find ten miles away at Bergen-Belsen.

The afternoon is dismally grey and the weather miserable when I arrive in Celle, and rain sets in as I take a taxi out to a guesthouse in the village of Bergen. The ashen skies and squally showers weigh me down and seem to underscore the eeriness of finally being here. Then it strikes me that after more than five years of active service and two theatres of war, this was the first point at which the fate of the Jews under Hitler's empire intersected with Mike's war. Yet by early 1943—nearly two years earlier—most of the Jews murdered in the Holocaust were already dead. For Mike's AFPU team, Celle was their first experience of something that till now had just been a few press articles unconfirmed by the Allies, though the British government had received reports that atrocities were being committed, principally against Jews, as early as 1942.

As I sit down to dine that night in the guesthouse restaurant, I cannot help but wonder how it feels to live near a place of such infamy. I feel almost embarrassed to be there, as if I am prying into some dreadful secret that must be kept, or some great shame that should not be remarked on, though there are probably very few left here now who were alive in those days. It is a strange sensation, but a familiar one too, though I cannot identify where it comes from till later that night. After dinner I return to my room and lie in a deep bath, soaking, sipping wine, my mind slipping between memories. I recall my meeting with Olga at the Sydney Jewish Museum, and there it is again—those strange feelings of unease and embarrassment. Then an earlier memory wriggles its way to the surface. I am a child again, and I have just put the photographs back into the suitcase and shut the lid. I feel bad—I opened the

envelope without asking, and its contents were terrible and at the same time unfathomable. But there was no one I could tell, no one I could ask about them—because it was my fault I had seen them.

Seeing Bergen-Belsen

The frontline is advancing beyond Celle now. The procedure is to set any woods on either side of the advance on fire to keep the snipers away and then go through with the tanks. Mike is teamed with Sergeants Oakes, Lawrie and Haywood, and Lieutenant Wilson, and they are given a new assignment. They are told that two German officers have come through the British lines to negotiate a truce for a prison camp still under their control. The Germans are concerned that if the inmates, who are 'criminals and typhus cases', escape during battle they might spread disease. Surrender of the camp, which lies about ten miles beyond Celle near the village of Belsen, has been arranged. Mike and the rest of the AFPU team are to go in after the 11th Armoured Division and cover the handover. Mike thinks it all sounds a bit vague and dull, but safer than following the advancing troops.

Toward evening on 15 April, the AFPU team drive past a white flag and a sign saying *Danger typhus* and then turn left along a narrow cutting that passes between dense pine woods. A strange odour that has been seeping into their nostrils builds to a stench as they reach a fence of barbed wire, intersected by a sentry box and

gates, which are open. Troops of the 63rd Anti-Tank Regiment are already there and give them a grim appraisal of the situation. As far as they can tell, there are about sixty thousand inmates, from all parts of Europe, Jews mostly. It seems that they have had no food for nine days and no water for four. Many are critically ill through starvation or disease or both. Worse, they estimate that ten thousand dead lie unburied.

Their small convoy drives on past what looks like a garrison building further into the camp, and it is then that the statistics begin to materialise into an unbearable reality that seems to grow worse the further they penetrate into the camp. Bodies lie scattered along the road, mostly naked and painfully emaciated. Dressed in striped pyjamas or rags, the living are barely distinguishable from the dead. Skin-and-bone thin, they stare listlessly out from behind barbed wire. The whole place is strangely quiet; death is happening everywhere mutely, caused not by shells and bullets and bombs but by starvation and disease and neglect.

They stop near what appears to be a compound for women and get out and walk. They do not take their cameras. The hush of the place is disturbing. One of the women, better dressed and seemingly in better health than most, indicates that she has something to show them. She takes them to a marquee and lifts the flap. Inside there are bodies piled two feet deep, and it is obvious they have been there for days.

'No wonder Jerry wanted us to bypass the camp,' mutters Bill.

'Who told you that?' asks Harry.

'I heard it from Grant. He filmed the German officers who

came through our lines. It was our lot that made them hand it over.'

They turn, silent now, and together head back to the jeeps. Mike senses that they are all struggling to take in what they have just seen, struggling with the dreadful reek of unwashed bodies and urine and excrement and rotting flesh. This is a deeper, more depraved dimension of horror than all their combined experience of war has showed them.

'Nothing much for us to do here now the light's going,' says Lieutenant Wilson. 'We should go and find a billet for the night and start in the morning.' No more is said as they turn their jeeps around to leave. Mike is thankful for this, because his mind is reeling.

In a village a few miles back along the way they came, they find a small cinema and break in. They make themselves comfortable for the night, preparing a meal and eating it while they talk in a desultory sort of way. No one mentions the camp, but it is there, filling the spaces between them. Sleep will not come to Mike, and the night seems to go by minute by minute. He hears a lot of restlessness from the others and none of the usual sighs, snores and puffs that would indicate sleep. It is as if he can hear in their agitated movements their troubled thoughts and feelings. Then a terrible revelation comes to him, illuminating the awful scenes that crowd his mind. All the stories he had heard from his mother and father about the persecution of Jews—here they are, true.

The next morning, as they prepare to head back to Belsen, Mike feels a pall of horror hanging over all of them. Their journey is unusually quiet and bereft of the normal soldierly banter. At the

gates, Mike films food and water being brought in. German and Hungarian guards are under the watchful eyes of the British. As they drive on through the gates again, Mike thinks it is even worse this time. Skeletal people shuffle aimlessly along, expressionless, eyes glazed, oblivious to the bodies they pass. Others sit leaning up against the dead because they have no strength to move elsewhere. The cameramen's first reaction is to give them something—cigarettes, chocolates, biscuits—but it soon becomes apparent that this is wrong when some become violently ill. A medic they meet explains that their bodies are so malnourished they can no longer digest normal food.

Hugh Stewart, their commanding officer, arrives to assess the situation and quickly decides that there should be comprehensive coverage of the conditions in the camp and the relief effort. For the next two days, they will be joined by another AFPU team, Captain Malindine and Sergeants Morris and Midgley, to boost coverage, and Mike and the others will stay on with Lieutenant Wilson until further notice. They are to expect civilian war correspondents too; news of the camp is spreading. Before they head off to start filming, a young Australian lieutenant introduces himself as Alan Moore. He is an official war artist, and asks if he can cadge a lift on one of the jeeps.

They all travel together initially. It is hard to know where to begin filming—they are surrounded by so many shocking sights, so many dead—but there is an unspoken consensus that they must record as much of it as they can.

Mike films some young women smiling and waving at him from behind barbed wire. They are some of the lucky ones, only

recently arrived, not yet starved or infected with typhus. They are happy to see the young British sergeant and try to talk to him. He tells them in bad army German and then in halting Yiddish that he is Jewish, and they are astonished. One of them has a bit of English and says in a tone of awed incredulity: 'You are a Jew, and you are free!'

Many of the women had been shut up in their huts for days before the arrival of the British, jammed inside—over four hundred in one Nissen-sized hut, Mike reckons—with no facilities. Only those too sick to move remain behind, lying amid their own and others' excrement and urine. The newly released women can at least relieve themselves outside now, but they have no privacy; and many far gone in starvation and disease seemingly have no want of it any longer.

They cover the water tankers being brought in—the only water in the camp for the last four days has been from a disgusting foetid pool—and an impossibly skeletal man still living and picking lice from his rags, sitting among the bodies of the dead as if he has already taken his place in the queue for death. In places there are acres of bodies, and more are being added.

It is strange: when Mike brings his focus in tight on the bodies, he begins to see that death has conferred upon them an almost familial likeness. The blank, hollowed-out eye sockets and rictus of death, lips stretched across teeth, the barrel of ribs and concave abdomen, the parchment of skin pulled taut across the blades of hipbones. He films a man who lies splayed in death as if he has been crucified; there are many like him. As Mike pans his camera across the dead, a woman catches his attention. All you can see is

the curve of her back and neck; her beautiful dark wavy hair is thrown over her head. She looks as if she is hiding her face shyly among the bodies.

Mike decides to climb one of the watchtowers. He wants to get a shot across the camp from a high angle to show the scale of this calamity. The tower is equipped with a searchlight and telephone. It also has piles of excrement in the corners, and Mike wonders why. Had the guards been kept so long on duty that they needed to do that? From the tower, the camp is one vast, wasted landscape, dotted with other guard towers and sliced through with barbed wire fences. Bodies are strewn everywhere; some move uncannily, tiny embers of life slowly going cold. The day warms, and as it does the sickly mix of odours begins to rise. The sheer barbarism of the place is staggering. Mike feels something tightening inside him.

Before they leave the camp for the night, they are dusted with DDT against the lice which have been spreading the typhus. Lieutenant Wilson has found them a closer billet in a nearby farmhouse. On the way there, they take a look at the German barracks just down the road from the camp. It is astonishing to move from the degradation and deprivation of Belsen to this marvellously appointed modern place. There they find spotless tiled kitchens, with huge stainless-steel tubs for cooking food and plenty of supplies. Mike wonders how the men could live there like that, knowing what the people in the camp were suffering. Perhaps they did not see it.

It seems to Mike that no one in the camp or outside it is accepting responsibility. Everyone they talk to points the finger at someone else. The farmhouse they are staying in is close enough

to catch the dreadful odours, and the farmer must have seen prisoners marching past from the railway siding, but he swears blind that he knew nothing about what was happening in the camp. Bill supposes that he must have at least suspected but thought it best not to stick his neck out. That night there is a different kind of silence among them, as they try to come to terms with the enormity of what they have seen, an angry silence punctuated with unanswered questions.

The next day, Mike's team travel by themselves in one jeep. The British troops involved in the relief effort work with a frantic urgency. Standpipes are being rigged up and the first hot food is served to those who can still eat. Mike finds it good to focus on the living for a while, and he gets absorbed in filming the hands of men taking the thin watery soup and bread, and then the hands of the SS guards as they turn out their pockets and provide their papers. The guards are to be put to work clearing the bodies, a task which they had previously forced the inmates to do. Mike finishes the sequence with a tight focus on the death's-head insignia on the collar of one of the guards.

Gradually, it begins to dawn on the internees that the British troops are not just a different kind of oppressor but are here to help, and there are many tearful thanks. A woman grabs Lieutenant Wilson's hand and clutches it to herself, her body shaking in a paroxysm of gratitude. Another young woman takes hold of Mike's arm and hangs on tight, looking into his eyes without speaking. Mike does not quite know what to do. He tries his army German, but she does not respond and she will not let go. When he gently tries to pry her hands away, he finds her grip surprisingly strong.

She squeezes his arm harder, painfully now, and the others have to help peel her fingers away. She has left bruises on his arm, and the incident has bruised him in other ways too.

'She's hanging on to hope, Lou—you're hope,' says Bill. 'I think it's because she knows you're Jewish.'

Later they film the camp guards clearing bodies. In twos they pick up the emaciated dead by their arms and legs and carry them to the truck, where they swing them up onto the tray. As the pile grows higher, the swing becomes more forceful, and occasionally a body hits the wood of the truck with a disturbing thump. It is awful to watch human bodies treated like that, but there are so many thousands of dead, and more dying all the time—nothing else can be done. Some women internees are watching and crying. The cameramen follow the trucks for the unloading, where a new horror awaits them.

Pits the size of tennis courts have been bulldozed—how deep, it is difficult to tell. They are already filling with the corpses of babies, girls, youths, women, men, old and young all tumbled together. The guards unload the bodies, carry them to the edge and drop them in, the bodies flopping their way down to the bottom. The women inmates clap and cheer the fact that the guards are being made to work. One woman starts to scream at them, bunching her fists, her whole body taken up with the effort; another simply cries.

Days begin to merge into one long assault on their senses. At night they still do not talk about the camp, or if they do, it is only in a gallows humour way. Mike teases the farmer's daughters by trying to translate a funny song about Anne Boleyn haunting the

Tower of London. 'With her head tucked underneath her arm, she walks the Bloody Tower,' he sings tunelessly, emphasising the 'Kopf' under his arm. The girls squeal appropriately. The black humour eases the strain a bit, but Mike still finds that it takes a kind of steeling of the nerves to go into the camp day after day filming.

He is glad that he has camera work to occupy him. The two-inch lens of the DeVry is slowing him down, because he has to focus carefully all the time. A wide-angle lens would have made composition much easier, allowing him to fit more of the scene in without having to move so far back. There is something else too about the camera work; looking through the viewfinder seems to remove him a little from what he is filming, which is, in a way, a relief.

It is difficult to decide what to cover—so much is happening at so many different locations. Lieutenant Wilson checks in with the relief team each day to find out what they have planned, but the cameramen make their own decisions too, not hesitating if they see something they think should be recorded. This becomes their modus operandi, and their driver helps them, labelling their film canisters and organising their food and anything else they need.

Mike films the initial interrogation of the camp commandant, Josef Kramer. His crisp uniform is gone now, and he is shackled and has several days' growth of beard. He is taken away, and Mike is told that he and some of the guards will be tried as war criminals by the Allies.

They film the Wehrmacht troops readying to leave their barracks. Under the terms of the truce they are to be allowed

to go back to their lines. Mike thinks it bizarre to get so close to the enemy, as close as you will ever get during a war without fighting hand to hand. Here are the German troops, armed with their Mausers, their MG 34s and their mortars, with their officers barking orders. They smile and nod to the British as they form up. The pantomime of chivalry continues as the German column, interspersed with British units, heads to the gate. A military red cap holds up the traffic and waves the German column toward its lines. A group of young women wave goodbye; they are probably from the nearby villages, Mike thinks. One of them, realising she is being filmed by Bill, turns and screws up her face at him.

The two army medical corps working at the camp are joined by German nurses and a Red Cross medical team as evacuation of the camp gets underway. It seems to Mike that the German nurses work all hours, as if they are trying to pay penance for the terrible atrocities committed here by their countrymen and women. The internees are being triaged now. Those too weak to move are removed from their huts by men of 11th Light Field Ambulance, who wear protective clothing, and then stretchered in ambulances to the 'human laundry' to be washed and deloused. Wrapped in clean blankets, they are taken to a hospital that has been set up in the German barracks. Early one morning, four Luftwaffe fighters sweep very low overhead and bomb and strafe the hospital; the ambulance drivers bear the brunt. Mike thinks this must have been deliberate, given the many large Red Cross signs everywhere.

A special feeding mix used for famine victims, Bengal famine mix, has also been brought in to help to stabilise those suffering starvation, but people are still dying and the dead are still in need

of burial. It is an unremitting task, as more skeletal corpses are dropped into the pits every day to become part of the unbearable tangle of bodies. The German guards, men and women both, are still collecting the dead and taking them to the pits, but not fast enough; the bodies are everywhere around the camp, decomposing, and the guards are becoming exhausted. They trail the legs of the corpses through the loose dirt as they drag them to the pits, leaving a snaking imprint of their last journey, which Mike captures on film.

Finally those organising the relief effort decide to use bulldozers to push the bodies into the pits. If Mike and his fellow cameramen thought the careless handling of the dead had been bad so far, this is far worse. It is obscene and disturbing to watch these emaciated forms tumble and roll over one another as they are pushed toward the pit, and Mike thinks that this is one time the lens does not remove him enough. Sometimes the blade of the bulldozer does not catch the bodies cleanly, and they split open. He gets as close as he can to the bulldozer, letting the camera pan with the blade as it shovels the bodies into the pit. Then Mike asks the driver, Wrinn, who is part of the Allied relief team, to let him perch on the bulldozer for his next run. He soaks a handkerchief in petrol to put over his mouth. He starts in close up on Wrinn's face, panning to follow the rolling bodies to the huge grave-pit. The petrol is vile, and Mike does not know whether to put up with it or take off his mask and bear the smell of death.

Mike is grateful for the burial services that are held after the pits are covered over. They are a chance to pull back from the overwhelming scale of the calamity, the huge numbers of dead and

the desecration of human remains. He films a quiet and sombre moment of contemplation when Father Michael Morrison, a British Army chaplain, and Father Stanisław Kadziołka, a Polish Catholic priest and former prisoner, perform a service at a mass grave. It suddenly comes to him as he is looking at the dismal scene that a spade sticking up out of the dirt looks like a cross on a burial mound. He frames the padres in profile with the mound of dirt and the spade in the foreground. He wonders if those who view it later will see it the same way.

After days and days of vileness, Mike is glad to recognise that some hints of normal life are returning. Engineers have rigged up showers with hot water, and women are washing themselves and shampooing their hair with obvious delight. They stand naked under the showers and do not seem embarrassed by the cameramen who film them or an NCO who steps in to adjust the showerhead for one. Mike films some women sitting around a tent with washing hanging on the barbed wire next to them; other women are shaking blankets and washing clothes. Men polish shoes and shave. These are ordinary, everyday tasks, signs of dignity returning, small moments of hope in the hopeless bleakness that is Belsen.

German officials are brought in from the nearby town of Celle to witness one of the mass burials, and Mike and Bill cover it between them, catching each other occasionally in frame and noting it on their dope sheets. Mike gets in close to the faces of the guards and the officials from Celle. It is as if he wants to interrogate them with his camera; to ask them why, why did they do nothing? He wants to capture their reaction to the scene before

them, but they have none, or none that shows. He lingers on their faces, waiting for a reaction, but they stand there impassive.

After ten days of filming and photographing in the camp, the four cameramen are relieved. Another AFPU team will continue coverage. One of the last rolls of film Mike takes is of Belsen village. He writes on his dope sheet:

> Almost adjoining some parts of the concentration camp is Belsen village. This roll is devoted entirely to it. The contrast between the village and the conditions in the camp is as striking as Life is against Death.

Mike is glad to leave the camp at last, and glad in a way that the war is still going on and that there will be other assignments to help drive Belsen from his mind. It is not just the thousands of dead or the appalling conditions of the camp; Mike does not want to think about the survivors either. They walked around so apathetically for the most part. It was hard to gauge their attitudes, their beliefs, their feeling. They had lost so much and been through so many horrors. Mike could not speak to them—not just because of the language problem, but because what does one say to people who have been to hell and back? Even though they have survived that hell, it will still continue in some way, be there with them in their painful memories.

Mike feels something change for him after Belsen. He has to think hard about how it happened. Who were the people who ordered it, who allowed it, who carried through the inhumane orders and treated people in this barbarous way. Then it comes upon him, in a chilling moment of realisation, that the

perpetrators he saw were shatteringly ordinary. Yes, that was the chilling part—they were not monsters but ordinary people, the kind you might pass on the street, the kind who worked with you, lived next door to you. They were ordinary people who, once they got started, were extraordinarily vindictive and pitiless.

•

A wet and windswept morning develops slowly out of the predawn darkness as I lie wakeful, waiting until it is time to rise and make ready for my trip to the Gedenkstätte Bergen-Belsen, the memorial museum at the site of the concentration camp. I will not go straight there, because I have an appointment to tour the British garrison at Hohne. It is a former Wehrmacht training facility and has been in British hands since 1945. Part of it was used to house survivors from Bergen-Belsen after the camp's liberation.

I am collected at the gate and driven around the facility, which is huge—a small town, really. Apart from the living quarters for the families of British forces stationed there, the garrison has several schools and shops, swimming pools, medical and dental centres, even a small but well-endowed military museum. Within the Hohne training area, there are also fourteen mass graves that I am told contain the bodies of Soviet prisoners of war who died there between 1941 and 1942. Terrible treatment was meted out to them by their captors, foreshadowing what was to come at Bergen-Belsen.

At the end of my tour, my guide offers to drive me the short distance to the Gedenkstätte. He points out the farmhouse where BBC broadcaster Richard Dimbleby, who made one of the first

reports from Belsen, stayed. Dimbleby's report was so graphic that at first the BBC refused to broadcast it. I wonder whether this is the same farmhouse where the AFPU had their headquarters. A short distance further on, we pass the old entrance to the camp. There is nothing much to see now except a low metal barrier; the grassed area beyond opens out into a wedge shape between deciduous forests—birch trees mostly, as far as I can see.

The British army took over the camp at Bergen-Belsen under a curious truce that saw the war flow on around the camp even as the survivors were being tended to and the dead were being buried. Most of the German troops there were allowed to return to their lines, and only a small contingent of Waffen-SS troops, including some women and Hungarian guards, remained behind. The truce began on 12 April, but it was not until 15 April 1945 that the British 11th Armoured Division arrived. At the Imperial War Museum, I found a sequence of film taken by AFPU cameraman Sergeant Grant that appears to show the gates of Belsen. German and Hungarian soldiers are watching the British armour go by, toward the front, I suppose. The soldiers salute one of their officers, and when he turns to the cameras I see that it is Kramer, the commandant of Belsen. He is smoking, still neatly turned out in full uniform, not yet arrested and manacled. He appears relaxed and is perhaps waiting for the British to arrive. You cannot really see much beyond the gates except buildings and barbed wire.

Among the dope sheets in the Imperial War Museum, I found several typed foolscap pages listing 'Concentration Camp Material'—materials shot at Belsen and at many other camps too. The list gives each item a serial number and title, and includes

the location of the camp, the name of the film's creator and the approximate footage. There are over forty separate locations on one page. Together the pages read like an inventory of the concentration camps, of the atrocities committed in them, and they help me to situate Belsen within the wider calamity of the Holocaust. Belsen was just one of thousands of camps liberated by the Allies as they continued their advance into Germany and beyond. The camps ostensibly served different purposes—exchange camps, labour camps, transit camps, extermination camps—but whatever their official designation, most of their inmates would ultimately die. There were millions of deaths: mostly Jews, but also Roma and Sinti, homosexuals, Slavs, socialists and Jehovah's Witnesses; in fact anyone deemed undesirable by the National Socialist regime.

After being used to house Russian prisoners of war, Bergen-Belsen became an exchange camp, where Jews thought to be of 'value' were held hostage, with a view to exchanging them for Germans held by the Allies. In reality, only a few were ever exchanged or released, and the population expanded as further groups were transported there from places such as Salonika in northern Greece, the Netherlands and Hungary. The internees were held segregated within the main Belsen compound.

In December 1944, Belsen had received a new commandant, Josef Kramer, formerly commandant of the Auschwitz extermination camp. The already harsh conditions deteriorated drastically and were made worse as the population of the camp swelled from fifteen thousand to sixty thousand with the influx of prisoners who were moved there beyond the reach of the advancing Red Army. Belsen had not been set up for mass killings and cremations like

the extermination camps at Treblinka, Auschwitz and Birkenau, but it became a death camp through disease and starvation, cruelty and murder, and indifference.

I say goodbye to my guide at the entrance to the Gedenkstätte documentation and information centre. The centre was opened in 2007 as part of the more recent evolution of memorialisation and remembrance at this site. The impressive brutalist architecture of this new building seems to fit its grim task, and it sits just outside the grounds of the old camp with a seven-metre extension jutting out over the former camp grounds. A large window allows those inside to look out into the grounds. The exhibition is well thought out, sensitive; there are many firsthand testimonies. I spend my first day in the centre researching and reading primary source documents and newspaper cuttings. I am really testing to see if any of it contradicts the history of Belsen I have come to know. I am not yet ready to enter the grounds.

That evening I try to pull together my thoughts on Belsen, to give Belsen some coherence or framework, but the place defies reason. So many of the firsthand accounts written in the early days after the liberation of the camp begin by expressing the author's inability to properly describe what it was like in those first few weeks, and many question whether they would be believed even if they could. That is Belsen—it slips between understanding and incomprehension, between knowledge and disbelief, that such a place could have been allowed. I think about Harry Oakes bringing out his bundle of photographs, and my brother asking why anyone would keep such horrific mementos. Clearly neither my father nor Harry needed reminding; the experience of Belsen was burned

into their memories as indelibly as it was on the film they used to capture it. I doubt that my father ever looked at the images he kept again, except when he was asked to for an interview.

I see Harry Oakes again, bringing out the photographs for my brother and me, and then suddenly I realise that it was not just a bundle of memories Harry brought out for us to look at, but a bundle of evidence, proof. Proof against the time when someone might say you exaggerated—that it was not that bad, or that it did not happen that way, or at all. Proof against a time when memory might fail or be doubted. He kept them ... just in case. Like Alan taking a photograph of everything he painted, he was retaining evidence of events that would defy description and representation and belief.

For Mike, it would have been impractical to copy and keep the hundreds of feet of film he took, even if he had wanted to. He would have needed some kind of projector to see them again anyway. Instead he kept stills taken by fellow cameramen who were there with him, whose images reflected the essence of what he had witnessed and captured on film. I begin to see something more, something new, in the images that Mike kept. I am seeing them for the first time not merely as embodiments of horrors, but as pieces of a story he had to tell about what he witnessed. Tomorrow I will walk the grounds.

Reading horror

A laneway formed by part of the Gedenkstätte building and an imposingly high concrete wall channels me into the grounds of Bergen-Belsen. Nothing of the old camp structure remains except a few foundations and the grave mounds. The buildings were burned after everyone was evacuated from the camp to stop the spread of disease, and over time the remaining evidence of fences and watchtowers has been pulled down. The camp which once covered fifty-five hectares is now a kind of wild parkland around the mass graves.

A sign carved into a wall of stone blocks declares: *Bergen-Belsen, 1940 bis 1945*. Visitors have placed pebbles on top of it and around the bas relief of the letters and numbers, and tucked in small pieces of hawthorn, bright with red berries, picked from a nearby tree. It feels like each token is some kind of prayer or affirmation of remembrance.

Paths circulate out past the grave mounds with their anonymous statistics of death also carved into block stone, and other memorials punctuate the green. It is cold and a sharp breeze carrying fine drops of rain whips my cheeks. I stop here and there;

reading plaques and signs, making notes. My head begins to ache.

The film I have seen again, just recently in London, of what it was like in Belsen, of what lies beneath those mounds and beneath the grass, is fresh in my mind. I circle back toward the camp's old entrance. Explanatory panels tell me that here stood the two-and-a-half-metre-high barbed wire fence that ran nearly four kilometres. Over there a nine-metre-high watchtower, patrolled below by guards with dogs. Here was a square where rolls were called twice a day or more, in all weathers and sometimes for hours; a form of physical abuse. There was the water reservoir, the foetid pool the cameramen saw. Here were the administration buildings. I arrive back at the old entrance, where I started. I turn and look back into the camp, back into the past, where Mike and his team are driving through the gates for the very first time, and where, amid the desperate wretchedness, Olga is making up her mind to live.

I walk back past the grave mounds again toward a modern-looking structure that I saw off to the side among the birch trees—the 'House of Silence'. Inside, the walls rise at oblique angles to a soaring glass roof through which the rain-blown sky can be seen. Simple, single-seat benches face three huge triangular stacked slabs, an altar of sorts. It is covered in small pebbles and slips of paper. They are notes, prayers, letters, memories, fragments. I sit on one of the benches, soothed for a moment by the ascetic serenity of the space; it seems to lighten my spirits a little. I wonder what my pilgrimage here has achieved: how it has changed or illumined Belsen for me; what I have learned from this place where there is nothing to see except the grave mounds.

By the time I get back to my room at the guesthouse, my headache is worsening. I feel nauseated too. I run a hot bath and lie in it sipping mineral water, enjoying the steam and heat, letting go of the tensions of the day; of being here, finally; of grappling for my own fragmented understanding of Belsen and of the images I found as a child.

Perhaps it is hard to imagine, looking back from our image-suffused age, where technology has made the camera omnipresent, but when the film and photographs of Belsen were first broadcast and published no one had seen anything like them, and certainly not on the scale found at Belsen. Abram Games, the war artist whom Mike used to visit, wrote to him after the *Images of War* documentary was broadcast in 1981, remembering their impact at the time:

> Bill Stirling head of processing came to my room and said that I must see something, still wet that he was putting through the editing box at that moment ... Never will I forget what you photographed that same day.

Like everyone else who visited during those first few weeks, the cameramen were not prepared for Belsen—let alone for filming there. Trained in combat work, they had to find a new visual language to describe what they were seeing. Bill Lawrie hints at this in one of his dope sheets, where he wrote, 'The atmosphere about the whole camp makes the job extremely difficult—it is hoped that some of the atmosphere has got into the pictures.'

At Belsen the cameramen were ordered to confront and record physical evidence of human savagery at its worst—a huge demand

on them both as professionals and human beings. They had to identify the 'telling image' from amid the chaos. They made explicit choices about what to record and how, requiring a set of visual judgments that were new to them. There were technical considerations, too. Having decided what they would cover, the cameramen had to use their training to make decisions about the best way to film what they were seeing, given the limitations of their cameras and film.

At the same time, they also had to manage their personal responses to the enormity of the situation and still make a functional record, balancing journalism, record-making and bearing witness. This is demonstrated on their dope sheets, which not only record the time and place but also other information that provides context and explanation—provenance.

Their first dope sheets for Belsen share a characteristic lengthy, scene-setting statement before any shots or sequences are listed. As you read them, you can feel the cameramen struggling to find a way of framing in words what they are recording.

Lieutenant Wilson wrote, 'Roll 1, 1: Here is the foul smelling foetid water pool the only source available'; Captain Malindine, 'Weak and dying they carry their dead to the heap past many who have gone to the heap to die. To save their ... camrades carrying [them]'; Mike, 'The degradation of men and women for years and in spite of this, they still have a spark of decency which asserts itself to wash and clean their bodies and clothes.'

Alan Moore faced similar conceptual difficulties in his work at Belsen. He too wanted to make a record, so he sketched and took photographs. In a letter to Treloar, Alan urged that the Belsen

paintings be hung properly and viewed a few times before a decision was made about them, because, as he said:

> ... after numerous visits they [viewers] begin to understand to look a little deeper into the artists thoughts, it is this work, that lives not the work of the surface value which leaves no room for intellectual effort or stimulated imagination on the part of the viewer.

Like Mike, who wondered if viewers would recognise the symbolic spade cross in his film, Alan wanted others to read the aesthetics of his work.

In 1984, when Robert Penfold interviewed my father about filming at Belsen for the Australian program *A Current Affair*, he asked, 'In some funny way, I suppose, did you see it as an artistic piece as well, despite all the horror of it?' At the time it made me wince; to associate artistry with such horror seemed blundering. Now I think perhaps he was just trying to articulate a vague notion he had about the film's aesthetic qualities, about an aesthetic of horror. My father's response to Penfold's question was, 'I don't think I was thinking of artistry. I think I was trying to show it the way it happened, the way it was.' That may have been true, but his training—as an artist and screen journalist—meant that he was not just making *a* record, he was making *his* record. The same was true for Alan Moore.

The bath has done its work and relieved my aching head, and the lassitude that seemed to have attached to me in the grounds of Belsen has lifted. I wrap a robe around me and sit down at my computer to bring up digital copies of the Belsen images my father

kept. There are eleven in total—six small ones in the war diary and the five large-format ones that I found as a child.

The images in the diary are arranged symmetrically on the left-hand side of opposing pages. Running the length of the second page next to the photographs is a typed panel describing the camp's liberation under the truce; nothing new there. The images are all uncaptioned, except the last one in the diary. Perhaps this was because there was little that could be added. On one of his first dope sheets for Belsen, Mike wrote, 'It is regretted that separate shots could not be mentioned in writing but so much was happening and so quickly that it was decided to dispense with the captioning of separate shots especially as the material was self-explanatory.'

I arrange the photographs according to their presentation in the diary and slot the five separate images in where they seem to fit in the timeline of events I have come to know. I wonder if the separation of the five photographs from the others in the diary, and even their unusually large size, reflects Mike's wrestling with the place of Belsen in his war experiences. The Belsen images are both inside the narrative of the war and outside it; part of the war, the small images in the diary, and yet something quite apart, the five huge images in the envelope. It is a paradox that has been noted by some historians of the Holocaust that the two conjoined events of the war and the Holocaust are often treated as separate events, the vastness and complexity of both demanding their own historiography.

As I toggle between the images, I see now how well they stand in for the film Mike took. I am beginning to see also the story within the frame. The image I have placed first is one of the

large-format images I found as a child. Captain Malindine took it on 17 or 18 April 1945, the third or fourth day after the British assumed control. It is a scene-setting image and gives an idea of the scale of the catastrophe and what conditions were like in the early days of the relief effort.

A vast area of the camp is shown. In the distance can be seen the fence and two of the nine watchtowers. There are also some buildings and what look like tents visible through a haze of smoke. People are walking too, going who knows where or why in the squalor of that desolate landscape. In the foreground water pours from a standpipe into a bucket; women are gathered round it collecting water and washing items, surrounded by appalling grime and mud. There had been no water to the camp for four days when the British arrived, but they managed to reconnect it fairly quickly. Malindine's caption reads, 'A general view of the filth of the camp where women had to wash.'

In 1984, Mike told journalist Philip Castle from the *Canberra Times* about climbing to the top of the watchtower to look down on Belsen. 'It just looked like a huge sanitation tip,' he said. 'The people did not even have the dignity of going to an area to clear their bowels.'

The second Belsen image—the first in the diary—is of uniformed SS guards loading bodies onto a wagon for transport to a burial site. It is taken from a high angle, which suggests that the cameraman was standing on the truck, looking down. The SS are heavily guarded by British troops, who have formed an almost solid line, guns held ready. Tension emanates from the soldiers' stance, though you cannot see their faces. The bodies being loaded onto the wagon are so impossibly thin they look barely human. There are bodies too at the top right of frame; then to the left I see a familiar profile I have never noticed before. I enlarge the image and, yes, it is Mike, standing there with his camera, either preparing to film or having just done so.

There were other occasions, too, when the cameramen filmed each other or recorded their presence at Belsen. Bill Lawrie wrote on his dope sheet for 23 April:

> In one of these shots can been seen Sgt Lewis of the Army Film and Photo Section who has been in this camp since the first day of our occupation and its liberation, collecting photographic evidence of the Nazi brutality for all the world to see. The atmosphere of a place like this is ghastly to say the least, but nothing has deterred this photographer from watching in his lens scenes such as never the wildest and most morbid mind could imagine.

Scholar Toby Haggith thinks that the cameramen might have been deliberately verifying each other's presence at Belsen for the record.

I cannot find an attribution for the image but am pretty sure it was taken by Harry Oakes, as it fits in sequence with another taken by him, probably just before this one.

Harry and Lieutenant Wilson both noted on their dope sheets for 18 April that the SS were being put to work. Lieutenant Wilson said it had been decided to take them as 'legitimate prisoners', something the SS guards may not have expected under the terms of the truce. Harry wrote: 'Today burying of the dead continued.

A Bulldozer was put to work to make a grave whilst SS men and women collected the corpses.'

I move on now to the third image, another of the large-format ones and the one that connected me to Alan. It is a striking image. At almost a right angle to the frame, a dead man lies with his arms outstretched, his head tilted backwards. His body, like those being collected by the SS in the previous image, is emaciated, but we are closer to this man. His ribs form a defined barrel beneath his skin, his abdomen is concave, and the blades of his hipbones are visible.

The way the light plays on his stretched skin gives him a strange translucence. One wrist seems to be bound, and another man lies against him at a right angle. The legs of a third victim are evident in the top right-hand corner. The man's outstretched arms seem to suggest a crucifix, with its connotations of innocence and terrible pain and suffering, except that he is not framed face on. A rotation to the right and he might be.

The heads of the two men are almost touching. Death has rendered them curiously twin-like, with their sunken eyes and cheeks and their open mouths and bristle of beard and hair. It is a powerful image with its classical allegorical references, but it also has its own narrative, personalising suffering in a place where the sheer numbers of dead overwhelmed the personal tragedy.

For Mike, the image also referenced a sequence he shot on 16 April showing another victim similarly splayed, and then dozens of such men, so that the splayed form, barrel of ribs and open-mouthed death stare became some kind of horrific leitmotif. In the notes I made while watching this footage, I recorded that I thought I recognised the man from the still by his tethered wrist.

The fourth and fifth images are also large-format ones and are of the camp guards collecting the dead. They were taken by Sergeant Midgley. The guards have dispensed with their jackets now and have clearly been working hard. In the fourth image the guards carry the corpses from the pile by their arms and legs and walk toward the camera under the gaze of their British guards. The victims appear to be women. To the right of the frame there is a woman who looks like a nurse, though it is hard to tell what she is doing. Camp buildings can be seen in the background, and

some internees are watching their former captors do the work that they had been made to do by the same camp guards. Mike wrote on his dope sheet for 16 or 17 April that he was told that the women 'could only get their very meagre portion of food if they carried away at least one dead body a day'.

In the fifth image two men carry a body toward the back of a truck watched by soldiers and internees, and a nurse, blurred by her movement, runs from the left-hand corner of the frame. Both Mike and Harry noted on their dope sheets that some of the internees became quite emotional while watching this activity; some clapped and cheered, some shouted abuse, some just cried. The running nurse seems to illustrate another point that Mike made: that the German nurses and doctors worked 'like hell'

alongside their British Army colleagues. In 1984, he told journalist Marsali Mackinnon in the *Weekend Australian*: 'My impression was they were doing this as if they were grasping at the opportunity to pay penance for the terrible things that had happened—I was amazed at the hours they put in.'

The images, like the film, repeatedly return to the collection and burying of the dead, because it was such an endless process in those first two weeks before conditions in the camp were stabilised. It reflects the huge numbers who needed burying and the numbers who continued to die every day. On 17 April, Sergeant Morris wrote, 'Bodies of women who die in the huts are carried outside by their fellow prisoners and left because they have insufficient strength to carry them further.' On 18 April, Harry wrote, 'Still hundreds continue to die every day … It seems that there

must be as many dead as alive.' On 23 April, Bill wrote, 'In spite of all possible medical attention, many in this camp will undoubtedly die as they are beyond aid … Such men and women are seen in this reel—their days are numbered.'

The sixth photograph is from the diary and is of the naked corpse of a woman, partially covered by a blanket. Her eyes are half open; her crown of dark wavy hair can just be seen, but how long it is we cannot tell because it is hidden by the blankets and what appears to be a scarf. Her mouth is open, but not in a death rictus, and her body, though thin, is not quite as emaciated as some. The photograph is one of a series taken by Sergeant Oakes on 18 April, showing people bringing out those who have just died and putting

their bodies on the pile. The pictures of the dead include this one, and another of two small children. The woman's image is particularly poignant when you understand that she is the mother of the dead children.

If Mike had any remaining belief in the chivalry of soldiers toward civilians, this would have destroyed it. The dead in these images were not soldiers killed in battle but women and children, who might have been expected to be spared, to be put first.

In the seventh image, a large-format one taken by Captain Malindine, we see the ultimate destination of the bodies we have seen in the earlier images. It shows part of a burial pit with an immense tangle of corpses, emaciated and naked for the most part,

their clothes taken by either their captors or other internees as fuel for fires. The cameramen found that the Germans had stockpiled clothes, shoes, watches and other belongings collected from their prisoners.

The framing of the photograph means you are not quite sure how big this pit is, how long, and its depth is completely confounded by the pile of bodies. It was one of thirteen mass graves dug at Belsen to take the thousands of dead the British found there when they arrived and the thousands who continued to die in the first few weeks. This pit was where bodies were taken by the guards who had been put to work, and the casual tumbling of the bodies into the pits was a scene captured over and over again by the cameramen. This pit, or one like it, was where the young mother and her children were bound.

But now comes the final desecration. The eighth image, this time one from the diary, is of the bulldozer being used to push the bodies into the grave. It was probably taken on 19 April by Sergeant Oakes, at the same time Mike filmed his bulldozer sequence with Wrinn. By this time the British had been in the camp for five days, and the warm spring weather was speeding up the decay of the bodies, until it was no longer possible to pick them up. The bulldozing of human bodies like so much detritus is probably some of the most notorious and disturbing of the Belsen footage, and the moving image particularly so, as you see the corpses tumble over each other. The still freezes the moment in time, the bodies poised in rolling toward the viewer. The gore and stench are suggested by the handkerchief covering the driver's nose and mouth, and we can be thankful that the images are black and white.

There are only two portraits of survivors, and these are the ninth and tenth images, both from the diary. Perhaps this is because so much of what Mike and his team filmed in those first two weeks concerned the disposal of the dead. Both images were taken by Harry Oakes. The ninth is of a man peering out from behind barbed wire. It is typical of the framing used by both cine and stills cameramen when filming survivors at Belsen, showing us what the cameramen found there when they arrived and also what had been done to the internees. This man does not look overjoyed to see his liberators—perhaps he does not quite believe that is what they are. His wizened face looks out suspiciously, despairingly—expectant, perhaps, not of something good, but further brutalisation.

The tenth image is of a woman inside one of the huts. The women were crammed in, as many as five hundred in a space suitable for about thirty. Sometimes the women were crowded in so tight that they had to sit with their knees up under their chins, but usually this did not last long—as inmates died, their bodies were removed by those who still had the strength. The caption sheet says that the woman depicted is suffering from typhus. She is so gaunt that it is impossible to gauge how old she is. The wall of the hut is visible behind her; others lie along it, looking out from under piles of rags. She still has the strength at least to sit up, but I wonder whether she had the strength to survive.

Mike and his team would have seen some signs of improvement in the internees before they left; there was food for those who could eat, medical treatment for those too sick to help themselves, and showers and fresh clothes for those strong enough to make use of them. On 24 April, Mike filmed some of the surviving children being pushed on swings by British soldiers. But it was the next AFPU team who covered the emptying of the camp and the final burials. On his dope sheet for 1 May, Sergeant Parkinson wrote, 'Stark horror having been pretty well covered the story now goes on to progression.'

The eleventh and the last photograph in the diary was taken by AFPU Sergeant Hewitt. It is an image of a hut being burned. It is the only one of the sequence with a caption in the diary, and

it reads: 'Pictured on the left is the burning of the camp on the completion of its evacuation.' In fact the huts were burned progressively as they were cleared to prevent the spread of disease, but the final destruction was probably on or around 29 May, at which point a 'ceremonial' burning of the last hut was carried out. The film sequence shows the hut, adorned with a swastika and a picture of Hitler, being hit by a flamethrower. After this, the AFPU left the camp and moved on to cover the evacuees living at the barracks, and this continued into June 1945.

Back at the beginning, I scroll through the images again; they are overlaid now by their history and the history of the cameramen

who captured them. I stop at the image of the splayed man, the one that connected me to Alan Moore and the unexpected discovery that he had photographed Mike at Belsen. Since I first opened the suitcase and saw this photograph again, it has gathered so many added layers of meaning. Even after my meeting with Alan I have learned more.

When I reviewed his works at the Australian War Memorial, I noticed that he had incorporated this image into his study for *Blind Man in Belsen*, and then in the painting itself. I have a digital copy of the study on my laptop, and I look at it again now. The splayed man appears in the bottom right-hand corner.

The pen and ink study has a dark, intense complexion, with its obvious signs of death and degradation surrounding the central figure, a blind man in prison camp pyjamas. He dominates the

foreground and leans toward us as if about to step out of the frame. The unseeing dead are strewn everywhere, while the faces of the living are in shadow. The blind man, one arm in a sling and the other holding a stick, picks his way among the dead. The study shares many pictorial elements with another of the photographs from my father's war diary: the image of the Belsen landscape taken by Captain Malindine. There is the watchtower, and the fence; the people moving here and there; the ruin and squalor.

I think of Alan's injunction to look a little deeper into the artist's thoughts, and I do—I try to see what he wanted me to see. I realise that the events at Belsen and elsewhere were only possible because of a kind of blindness—it is a powerful metaphor. There is the blindness of the perpetrators to the suffering of their victims, the blindness of the living internees to the dead in the camp as they struggled to survive, the blindness of the civilian population to the barbarism happening in the camps, even a kind of blindness on the part of the Allies who were unwilling to publicly acknowledge or act upon the early reports of these atrocities. Finally there is the blindness and perhaps hubris of McCubbin and Dargie, who in looking only to be horrified, and perhaps thinking of photographs they had seen, saw only the 'surface value' of Alan's work and missed what else it had to say. I think of my own blindness to the images too, born out of a childish fear that froze me in some way, rendering my adult self incapable of confronting and dealing with this history and its place in my father's life.

I see now that these images can be useful sources of information, both evidentiary and illustrative, if we know how to read them, if we do not redact from them their creators and context,

if we do not 'shoot the messenger' and in our horror blame the cameramen for the awful scenes they have put before us. Film taken during the liberation and relief of Bergen-Belsen was used as evidence during the Belsen war crimes trial at Lüneburg, which began on 17 September 1945. It was the first use of film as corroboratory evidence, and a compilation of AFPU footage, supported by a joint affidavit made by Mike and Sergeants Lawrie and Haywood, was screened for the court.

Yet for all that these images can be, they can only provide part of the story of Belsen, even with their history and context. My father said that no film he ever saw conveyed the despair and horror of Belsen. In an interview for the *Age* in 1984, he told journalist Fia Cummins: 'I remember seeing all the raw unedited film when I was demobbed in London, and I was amazed by one thing that film never does, can never show it the same way. You are removed from it, aren't you? It doesn't show the smell of death, which was awful.'

When I was younger, I was somewhat bemused that my father bore so little animosity toward the Germans, but he maintained that any nation could do what the Germans did once it allowed itself to fall into unreasonable hate. He told journalist Marsali Mackinnon that people should not think it only happened to Jews. 'People who think "Well I am not Jewish, it won't happen to me" are deceiving themselves.'

I know that he questioned whether the Germans alone were to blame. It was, he said, 'death by administration'. The scale and industrialised nature of the killing required a large, organised, modern administration that planned and worked for the mass

transportation of people by rail to the death camps. He wondered why the railways had not been bombed by the Allies, and why the religious institutions of the world had not acted. 'They knew what was going on,' he said. 'We had heard rumours, we had known. And surely these people would have known better than us ordinary people. And they had been silent.'

He said that what happened was a warning against all prejudice. He told Fia Cummins: 'If people hate it will destroy them in the end because nature takes a kind of revenge, it becomes sick with it. It sounds fantastic but if you had seen the camp lots of things would have occurred to you. I don't go around making a campaign of it but I try to see that people are valuable in themselves.'

My father said that he did not believe in showing horror pictures but thought they should be shown if they could warn people what happens when the restraints of civilisation are removed.

Sitting in the guesthouse in Bergen, I wonder what he would have thought of the fact that the Imperial War Museum is restoring the film *Memory of the Camps*. It will be screened under its original title, *German Concentration Camps Factual Survey*. I wonder how the film will stand the test of time.

•

I am on the plane travelling home, twelve hours out from Sydney and feeling a desperate need to be at my cabin in the bush, to feel grounded again after my visit to the Gedenkstätte Bergen-Belsen. I have poured so much of myself into apprehending the moment of Belsen that I feel stretched thin, but I am relieved, too. Something has shifted in me. I am still afraid of the darkness that this history

holds, but I know now I can go into it and come out again.

We try to piece together knowledge of the historical events at Belsen from the records left behind—we try to imagine, to know, in a sense to become witnesses—but our seeing is more than this. Our seeing is also an act of remembrance. Because the Belsen dead, without families left to mourn them and mark their passing, and stripped of their names and identities in anonymous graves, have only these photographs, shocking as they are, to mark that they existed at all.

Liberation

The Allies are advancing further into Germany now, and Mike is again teamed with stills cameraman George Laws and Blondy the driver. They are to go in with the crossing of the Elbe at Artlenburg, about fifty-five miles north-east of Belsen. They are assigned to a flying column of Churchill tanks, infantry and ancillary units. This column will strike swiftly across northern Germany into Denmark. Though he is happy to be leaving Belsen, Mike is not so sure about travelling with the column through enemy-held territory without flank protection.

'You know the other name of the Churchill, don't you, Blondy,' says Mike.

'Er, no,' says Blondy, a bit unsure where this is going.

Before Mike can enlighten him, George steals his thunder. 'Ronson Lighters—you know, 'cause they go up so easily.'

The operation begins with a softening-up artillery bombardment. Then, in the early hours of 29 April, under cover of a smokescreen, the assault begins. Elements of the 15th Scottish Division cross the river in boats, supported by the endearingly nicknamed Donald Ducks, floating Sherman tanks. As soon as

the first assault has got across, work begins on building a pontoon bridge. The troops are bothered for a while by Luftwaffe, and Mike captures men streaking for cover during the shelling, but their own aircraft soon put an end to that trouble.

They follow the advance of the 2nd Battalion Wiltshire Regiment. Their advance is rapid, covering nearly twenty-five miles in one day. By 2 May, they are nearing Lübeck, a northern German port. At a crossroads they are surprised to meet a contingent of German military cars coming from the east. The Germans are equally surprised, though not at all displeased to see the British. Mike supposes they are running from the Red Army, and that from their point of view they have reached safety. The occupants of the cars seem to be high-ranking officers—generals, perhaps, Mike thinks—and there are women with them too. The cars are so stuffed and weighed down with loot that it is a wonder they can move at all.

With the capture of Lübeck on 3 May, there is a mass surrender of Wehrmacht troops led, in many cases, by their own officers. Mike films prisoners marching through an ancient Gothic gateway that he is told is called the Burgtor. He also takes footage of girls and boys watching the prisoners being marched through. On his dope sheet that night he writes, 'Will the boys when they grow up remember this defeat?'

The flying column moves on toward Kiel, liberating some British prisoners of war who have been languishing in Germany since Dunkirk, in 1940. Mike thinks that even their uniforms look outdated; they have been prisoners so long. The men are jubilant at being rescued. It is a wonderful moment for them, and they hug

their liberators fiercely, almost crying with relief. George captures the moment, yelling out to Mike, 'I think I got you too—well, at least your legs!' There is a growing confidence that the end of the war is close.

On 4 May, they enter the city of Kiel, where a few nights before the RAF did its work. Mike films wrecked buildings and a destroyed merchant ship at the docks. He films a house blasted through. In the foreground is a stairway leading to a bath and nothing else; beyond it a ship lists at the dockside. The devastation in Kiel is phenomenal, buildings completely turned into rubble. The main railway station is just a shell of arches now. For a short time, Mike and George and Blondy are joined by another AFPU team, Sergeants Grant and Jones and Captain Evans, who have also been assigned to cover Kiel.

When they reach the Kiel Canal and start to cross the bridge, a small farce unfolds. At the far end there is a sentry box with a young German soldier on duty. As the column rumbles toward him, he suddenly steps out into the middle of the road, holds up his rifle and says, 'Halt.' There is some shouting at him to 'bloody well' get out of the way, but he stands there defiantly. Mike and George chuckle at the absurdity of the situation as the young man faces down the entire armoured column alone. It is quite embarrassing, really—nobody seems to know quite what to do with him.

'The BF,' says Mike, 'it's too silly for words.' Finally a German-speaking officer persuades him to stand aside, and the column resumes its progress.

They are headed for Flensburg now, on the German–Danish border. The Germans are surrendering piecemeal. They have discarded their metal helmets and weapons, which lie in piles. Italy has already been liberated, and that day they hear that Montgomery has accepted the surrender of the forces in their area of operation, in Germany. Along the way they pass what seems to be a convalescent home for injured German officers, judging by how most of the inmates are dressed. The patients stare out at the British column in amazement, not quite believing their eyes. One officer in military dress with a high-peaked cap sports a monocle, like a character from a film. He is goggle-eyed with fury and disgust at the sight of them passing, and Mike sees him pop his monocle out and plug it back in again in a gesture of barely controlled rage.

German troops are streaming out of Denmark toward home. Some are so exhausted that they rest by the side of the road, sleeping against their packs with their boots off, enjoying the warm spring weather, and the relief, Mike is sure, of being out of it.

As they cross the border into Denmark, it seems to Mike that something miraculous occurs, and he knows that he will remember this moment for the rest of his life. It is as if he has been travelling in the dark for years, and suddenly the sun has come out. Behind them are smashed cities and towns and all the misery, grief, pain and death of the war; before them are intact houses and buildings, cultivated fields and well-dressed, properly nourished people. Crowds line the roads, welcoming them exuberantly as their cavalcade rolls by.

The German troops are still moving in the opposite direction, travelling by any means they can: even carthorses have been co-opted. Along the way, Mike films Captain Jensen, a Dane who trained as a paratrooper in England and dropped with five others to work with the resistance in Jutland. They are travelling through Aabenraa now and cross to the island of Funen, where they take a ferry to Zealand and start to make their way toward the capital, Copenhagen.

There is a relaxed air all along the convoy, and it is decided, as they have been travelling for many hours, that they should stop for a tea-break. Men gather round tommy cookers to mash up all along the wide grass verge. Mike, George and Blondy join the

picnic. As they sit together on the grass in the sunshine, Mike and George agree that this is a moment of bliss. There is no hurry, no looming battle. Life is good, thinks Mike. No—at this moment, life is marvellous.

Then, in the distance, they see bicycles coming toward them ridden by young men and women. The spokes of their wheels flash with colour and, when they reach the convoy and stop, Mike can see that they have been woven with red, white and blue streamers. The young Danes stare at the men in some bemusement and ask in hesitant English, 'Why have you stopped? Copenhagen is waiting for you.'

When it is politely explained that the column has stopped for a tea-break, and that 'we'll be along soon', the young Danes are delighted. Everything they have heard about the British and their tea-drinking is true.

On 5 May, the column enters Copenhagen, and if they thought their welcome had been warm so far, it was nothing compared to the thousands of people hanging from windows and doorways and thronging the squares. Excited, the crowds wave, cheer and throw flowers, notes and invitations. Girls jump up to kiss them, and people run after them asking for autographs—George captures Mike signing his name. They are heroes, and their armoured thrust has become a victory parade. They are travelling slowly now, because of the crowds, and Mike asks Blondy to stop momentarily so he can get a shot. As soon as the vehicle halts, they are hit by a wave of people clambering aboard. The whole jeep sags down until the springs give out. Mike is nearly swamped—but, oh, it is lovely being a hero.

The crowds continue to follow them on bikes and on foot, trying to scramble onto their vehicles, and it seems as if the whole of Copenhagen is celebrating. A young man invites Mike and the others to join him and his friends at a party. There will be good music, he tells them. At the party there is a trio modelled on the Andrews Sisters, and one of the girls, Lis Varnaae, is mesmerising. Mike thinks she is more beautiful than Ingrid Bergman. He introduces himself using his bad army German, knowing immediately that he must see her again. Fortunately for him, she seems to feel the same.

On 8 May, victory in Europe is officially declared. The next day the Danish parliament reopens, and Mike is sent to cover it; there is still work to do in spite of the festival air. In between, there is also time to see Lis. Some of the last film he takes before he is recalled is of Monty, Field Marshal Montgomery, driving through Copenhagen amid cheering crowds.

Mike's few weeks in Copenhagen have been like a dream after the years and years of war. Has it been five years or six? He is not sure anymore. It feels like he was born into war and has never known anything else except an uncertain future. Now all that is past and he has to constantly remind himself of peace to grasp the new reality. He cannot seem to feel the exulting joy of the celebrating crowds. The war has squeezed all colour from his feelings and he is enveloped by a sad loneliness—a stranger now in a strangely peaceful world. But there is the possibility of a new adventure; there is Lis and the start of a new life. Yes, he feels a sudden surprising desire to have children, to bring new lives into a world at peace. Before he leaves Copenhagen, he arranges to have a single red rose sent to Lis every day until his first letter will arrive. He tells her he will come back when he is demobbed to see if they still feel the same way.

Back at headquarters in Lüneburg, Germany, he hears that some of his Belsen footage is to be used in a Ministry of Information film about the concentration camps. Sidney Bernstein is producing it, and he has Alfred Hitchcock, famous for his thrillers, on the team as treatment adviser. Rumour has it that when Hitchcock, the master of horror, first viewed the raw footage, particularly that from Bergen-Belsen, he was so disturbed that he had to take leave for a few weeks. Some of the film is also being compiled for use at the war crimes trial of the camp commandant, Josef Kramer, and forty-four other accused.

The war is not yet over in the Pacific, and Mike receives a wholly unexpected blow when he is assigned to an airborne assault on Singapore and sent on embarkation leave in July. He is shocked;

others with fewer operations under their belts are already being demobbed. The orders fill him with gloom in a way that no other mission has before. He has come through so much, but now—when he was so close to being free of it, when there is Lis and all the possibility of a future—somehow he feels he will not survive another campaign.

Mike is not given to superstition, but the feeling is so strong and so overwhelming that he decides to talk to his commanding officer, Hugh Stewart. He is not sure that it will do any good, but he feels he has to try. He explains as best he can how he feels that his luck, which has held up so far, will not last through another operation. He is surprised when Stewart sends him to see an army psychiatrist, a major. Mike tells the major that although he knows it is quite irrational, he cannot get it out of his head that he will not come back from another operation.

To his amazement, without any argument or cross-examination, the major says, 'Look, sergeant, what I'll do is regrade you.' Mike is posted back to London to work on *Soldier* magazine.

Constant witness

Is this where the story ends? The *Images of War* documentary casts it as a fairytale ending in Denmark. The narrator says, 'It was a dream end ... and a dream beginning, for it was in Denmark that Mike Lewis met the girl he was to marry, and with whom he was to live happily ever after.' Maybe it ends with the army psychiatrist regrading Mike and sending him back to London, or maybe it ends where all war stories end if they do not end in death—in the return to civilian life. Then I realise that it does not end there either for those who survived; for them the story of war continues in memory, always.

Mike's archive might suggest that nothing much happened during his thirty years with the BBC news service and the pioneering days of television news, even though he went on to cover other wars and was wounded for a third time in 1973, during the Yom Kippur War, when Egypt and Syria joined forces against Israel.

He was offered other jobs, too, and tried working as a producer for a while, but he could not settle at a 'desk job' and went back to camera work. His working life after the war seems to have had

much in common with that of a combat cameraman, though of course it was not always dangerous. In between civil unrest, riots and wars, there were visiting dignitaries, celebrities and art shows, but he was always on the move, always in different situations and locations day to day, always chasing the clock to meet deadlines.

What his archive does show is that Bergen-Belsen was a constant in his life. Though he never wanted to relive those memories, there is evidence that he did so on many occasions—for journalists and filmmakers, for Holocaust commemorations, for anyone who had interest. He did what he had to do, what his nature and conscience compelled him to do, in spite of his reluctance to relive it all again. He bore witness to the horror he saw in Belsen and to the suffering of its victims who had no voice.

In 1984, after Robert Penfold's interview was aired on *A Current Affair*, two sisters, Ms Bruell and Ms Peer, survivors of Bergen-Belsen, wrote to him.

> Dear Mr Lewis,
> Watching your documentary on the liberation of Bergen-Belsen on the Mike Willesee program brought back painful memories for us as well. I was there with my sister when you took those shots. Watching horror-stricken we dreaded the thought that we may soon recognise ourselves among the camp inmates. Your film accurately conveyed the horror of the place called hell. We both survived, not through hope because in a place like that you had none— but through sheer luck and the liberation of the British Army. We thank you for showing the world and telling

about the real truth (albeit 40 years later, why? why?) You have condemned those who say it was all lies. You and we have proved that the unbelievable did happen in a civilized country. It must never be allowed to happen again.

I think it must have been a wonderful letter to receive. The sisters dreaded that they might recognise themselves, yet were thankful the images were shown. They understood my father's distress and wrapped him in the embrace of shared witnessing. They acknowledged that his film was a faithful record, and that he was a reluctant but constant witness to a moment in history.

I think that when he asked me, 'Why do I have to keep telling this over and over again? Isn't it enough I took the film?' he already knew the answer was no—that the film and photographs he and the other cameramen took provided only a trace of what the place was like. Perhaps his question was really a cry of pain at the business of remembering; toward the end of his interview with Robert Penfold he said that he had not seen the film again because he did not want to be reminded. He said that if you tried to carry the memories with you, to remember it all in detail, you'd be locked up. 'You have to put it away. You just can't go on feeling like that.'

Olga Horak said: 'The past lives in me.' It lived in my father too, and it lives on in the photographs and film of the horrors and barbarity that he and others captured, and in his memories, and now in me. Though a lifetime may pass, though you may spend your whole career recording stories, there is only one story that remains at the end: it is the war, and Bergen-Belsen. In 1985, less than a year before his death, Mike wrote:

For two weeks I filmed the horror of Belsen. When I left I thought that time and the war, which was still on, would make me forget. I wanted to forget. After forty years, I know now I will never forget. That the hell I saw in Belsen will never leave me. Down the years the dead still cry out to us. Remember us. Each of us like you had loves, ambitions and hopes for the future. Now, no more.

•

In 2014, I am invited to the Australian premiere of *German Concentration Camps Factual Survey* at the Melbourne International Film Festival. Restoration director Toby Haggith of the Imperial War Museum introduces the film and explains that in restoring the film they went back to the original nitrate negatives and completed the sixth reel according to the production notes and a finalised script that had been held in the museum's archive since the war. The film was originally intended to be screened in German cinemas after the war, but by September 1945 British priorities for Germany had shifted from de-Nazification to reconstruction, and the film was never finished. The film includes footage shot at ten camps and four sites of atrocity discovered in Germany, Austria and Poland, including scenes at Bergen-Belsen, Dachau, Buchenwald, Auschwitz and Majdanek. Haggith encourages members of the audience to stay for a 'debriefing' session at the end, and also to leave, at any time, if they find the images too confronting.

Before seeing the restored film, I worried about the wisdom of bringing it back to life, but all my doubts and concerns are

swept away when I see the finished work. It is a masterful piece of restoration and a remarkable documentary: unflinching but empathetic, leaving spaces in the narration for silence and contemplation. The restoration and digitisation of the film removes the smog of time and gives the images a crisp immediacy that is even more confronting, if that is possible; and though I have seen the images from Bergen-Belsen many times now, their horror never seems to diminish. The linking of Bergen-Belsen with other camps and sites of atrocity makes this a remorseless viewing experience, and some of the last scenes, shot in a warehouse stacked high with bales of human hair, bring home the scale of this catastrophe.

Afterwards, I am introduced to an elderly woman, bent with age, a Belsen survivor. She asks me whether my father is still alive. When I tell her no, that he died some years ago, she clasps my hand in hers, looks into my eyes and says: 'Well, I will just have to thank you for him.'

•

I am sitting at my desk in the stone cabin looking out at Egan Peaks, misty blue against a grey sky. I am at the end of Mike's story and must bring it to a close, but this is difficult to do. It has become my story too: so many years have passed in pursuit of it. I know I need to 'put it away' now and resume a life without the horror and the awfulness that has been ever present in my thoughts and dreams, without the obsessive checking of details and dates and sources. I have to accept now that I have done my best to tell Mike's story the way he might have if he had the thought to write it down himself. I have to accept that there will always be gaps

and uncertainties, that what I have recovered and reconstructed is only a trace of his history. I need to let go of all this and be in my garden, propagating, planting and tending living things. But letting go will mean letting go of Mike, of my father. It will be like having him die again, and I know I will miss him and his sympathetic and compassionate eye, his irreverent sense of humour.

At times during my research and writing, I wondered what was driving me, what it was I was searching for in his history. It started in such a small way, as a desire to know more about what my father experienced in the war, and especially at Belsen, and perhaps a desire to make up for all the years I had deliberately avoided the dreadful historical truth of what he had seen, but it grew to be more than that. It became about who my father was as a young man, what shaped him and his visual language, and it became about the ethics and aesthetics of images of atrocity, about whether we should look at them at all, and if we do, how we can really see them. I came to realise that, sometimes, in the face of the great human capacity to commit extraordinarily barbaric crimes, there is nothing a person can do but bear witness, report back, bring evidence; that maybe it is all a person can do in such circumstances.

I pondered too the images of the people responsible for the atrocities at Belsen, the 'shatteringly ordinary people' my father described, and realised the truth of what he said about them. We might look at those people and think, 'That could never be me—I could never do those things.' Perhaps it is true that we would not be capable of such brutality, but would we let others perpetrate such brutalities on our behalf? Would we be complicit

in some way, by looking away, by not speaking out? Are we?

While a victim may shrink inside all of us, a perpetrator lurks there too. We must be watchful of slipping into generalisations. *You people. Those people. Their type.* We must be watchful of slipping into hurtful slurs and slanders, of labelling people who live differently from us, who believe differently from us, who are not of our tribe, because this is the way that hate begins, this is the way that persecution begins, and this is the way to Belsen, or some place like it.

Acknowledgments

Many people provided inspiration, insight and support on the path to completing this book. Some whom I met fleetingly—at conferences, in archives and on my research travels—provided vital moments of revelation and affirmation. Others with whom I had more regular exchanges over many years greatly enriched and informed my thinking, particularly in regard to the Belsen images. I am sorry I cannot mention everyone by name, but you all contributed greatly to my knowledge and understanding of the images and the events they portrayed. Thank you for that and your friendship.

A special thanks is due to the institutions who gave me access to their archives and the archivists who advised and guided me in the use of their collections: the Imperial War Museum, London; the Australian War Memorial, Canberra; the Gedenkstätte Bergen-Belsen; the Parachute Regiment and Airborne Forces Museum, Duxford (formerly of Browning Barracks, Aldershot); and the British Garrison at Hohne.

In particular, I would like to thank Dr Suzanne Bardgett of the Imperial War Museum for the opportunity of the Research Associate position; Kay Gladstone, Curator of Acquisitions and Documentation in the Film and Video Archive, Imperial War Museum, for having the foresight to initiate the oral history recording with my father and other AFPU cameramen; Dr Toby Haggith, Senior Curator, Department of Research, Imperial War Museum, for sharing his research and insights on the Belsen archive; James Barker, a researcher on the *Images of War*

documentary, for sharing his memories of my father; and Michael Loebenstein, formerly of the National Film and Sound Archive of Australia (now Director of the Austrian Film Museum), for inviting me to the premiere screening of *German Concentration Camps Factual Survey* in Australia.

Thanks are also due to Dr Robert Voskuil, Friend of the Airborne Museum Hartenstein, who opened up the Arnhem archive for me with his moving 'photographic battle tour'; Earle Hoffman of the National Jewish Memorial Centre, Canberra, who provided information about my father's activities in relation to the Belsen archive after he moved to Australia; and Philip Moss, who gave vital feedback on the manuscript, especially on military matters.

I am also deeply indebted to those people who shared their memories with me, many of which were extremely painful: Harry Oakes, Alan Moore, Peter Norris, Olga Horak and Mania Salinger.

Of course there would have been no thesis and no book had it not been for Professor Deborah Lipstadt, Emory University. Her book *History on Trial: My Day in Court with David Irving* and her exposure of the practices of the denialist launched my inquiry.

I was blessed with a marvellously perspicacious supervisor for my doctorate in Professor Paula Hamilton at the University of Technology Sydney, and I thank her for challenging me to dig deep and helping me hone my thinking on questions of memory and representation.

My initial research would not have been nearly so productive without the work of David Reid, a fine photographer, who undertook the initial digitisation of the Mike Lewis archive for me;

and Ian Affleck of the Australian War Memorial, who made the important connection between Alan Moore's Belsen photograph and the one in my father's archive. Thank you both.

For unflagging support, encouragement and helping me shape the narrative, I thank Fred Mitchell, who heroically read and critiqued every draft (and there were a lot of them), and also author Frank Moorhouse, who steadfastly discussed the darkest topics, permitted my obsessive discussions and reviewed my final draft with great acuity.

Turning a doctoral thesis into a book is a challenging task, and I am very grateful to Elizabeth Cowell, my editor at Text, for guiding me through this process and having faith that I could pull it off; and to my agent, Grace Heifetz at Curtis Brown, for steadying my nerves from time to time.

Thanks go to family and friends who have lived with me and with this topic for so many years, but kept on supporting me just the same and had faith in me and the story. I am pleased to say there are many of you.

I thank Susie Levy for always being there to talk, Deirdre McGuire for her unwavering support, Susan Douglas for always reminding me to breathe, Elizabeth Henderson for wise counsel, Ellen Shipley for her wicked sense of humour, Hilary Hudson for not letting me slip into self-doubt, Kathleen Warner for putting up with my erratic work availability, and all of you for the special gift of your friendship.

To my brother, Jeff, and my sister, Caroline, who also remember finding the Belsen images, I give my love and thanks for your continuing support over many years.

Images

The images in this book come mostly from my father's war diary; where possible, I have credited the photographer in the text. Others are family photographs. The few exceptions were supplied by the Australian War Memorial and Britain's Imperial War Museum.

Still from film taken by Sergeant Mike Lewis, No. 5 Army, Film & Photographic Unit, page 31: Women inmates of the German concentration camp at Bergen-Belsen wave through the wire to liberating British soldiers (including the cameraman Mike Lewis), © Imperial War Museum (collection reference no. FLM 3762).

Photograph taken by Sergeant Christie, No. 2 Army, Film & Photographic Unit, page 146: Sgt M Lewis of the 2nd Parachute Battalion examines a memorial to the 1st Parachute Brigade on the Nefza-Sedjenane road in the Tamara Valley, 14 October 1943, © Imperial War Museum (collection reference no. NA 7679).

Photograph taken by Alan Moore, page 234: British combat cameraman, Sergeant (Sgt) Colman Michael (Mike) Lewis, Army Film Unit, uses a De Vry camera to film a group of women at Belsen, Australian War Memorial (collection reference no. P03007.011).

Study for *Blind Man in Belsen* by Alan Moore, page 291, © Australian War Memorial (collection reference no. ART25014).

Sources

When I began work on turning my doctoral thesis into a book, I took a decision to use dramatic reconstruction for parts of my father's story, drawing heavily on the primary resources available to me, and using secondary sources to provide the historical context.

Readers who are interested in sources and the academic argument can find an electronic version of my thesis in the UTS library: http://hdl.handle.net/10453/36977.

Below is a small but important selection of secondary sources.

Battlefield: The Battles for Tunisia, 2001, television program, Cromwell Productions, London.

Brown, Harry, 1945, *Poems*, publisher unlisted, London.

Cherry, Niall, 2011, *Tunisian Tales: The 1st Parachute Brigade in North Africa 1942–43*, Helion & Company Limited, Solihull.

Dargie, William, quoted in Bevan, Scott, 2004, *Battle Lines: Australian Artists at War*, Random House, Sydney.

Dawidowicz, Lucy S., 1975, *The War against the Jews, 1933–1945*, Holt, Rinehart and Winston, New York.

German Concentration Camps Factual Survey, 1945/2014, documentary film, British Ministry of Information/Imperial War Museum, London.

Gladstone, Kay, 2002, 'The AFPU: The Origins of British Army Combat Filming during the Second World War', *Film History*, vol. 14, no. 3/4, pp. 316–31.

Golden, Lewis, 1984, *Echoes from Arnhem*, William Kimber, London.

Haggith, Toby, 2002, 'D-Day Filming: For Real. A Comparison

of "Truth" and "Reality" in *Saving Private Ryan* and *Combat Film by the British Army's Film and Photographic Unit*', *Film History*, vol. 14, no. 3/4, pp. 332–53.

——, 2006, 'The Filming of the Liberation of Bergen-Belsen and Its Impact on the Understanding of the Holocaust', in S. Bardgett and D. Cesarani (eds), *Belsen 1945: New Historical Perspectives*, Vallentine Mitchell in association with IWM, Portland & London, pp. 89–122.

Harclerode, Peter, 1992, *Para! Fifty Years of the Parachute Regiment*, BCA, London.

Heller, Joseph, 1955 (1970 edn), *Catch-22*, Corgi Books, London.

Horak, Olga, 2000, *From Auschwitz to Australia: A Holocaust Survivor's Memoir*, Kangaroo Press, Sydney.

Lindsay, Jack, 1942, *Into Action: The Battle of Dieppe*, Andrew Dakers Limited, London.

Lipstadt, Deborah E., 1994, *Denying the Holocaust: The Growing Assault on Truth and Memory*, Plume, New York.

——, 2005, *History on Trial: My Day in Court with David Irving*, HarperCollins, New York.

Marr, David, 2005, 'The Truth on Trial', *Sydney Morning Herald*, Spectrum (Books & Ideas), 9 July, pp. 17–18.

McGlade, Fred, 2011, *The History of the British Army Film and Photographic Unit in the Second World War*, Helion & Company Limited, Solihull.

Pegasus, undated, *Parachutist*, Jarrolds, London.

Ryan, Cornelius, 1974, *A Bridge Too Far*, Simon & Schuster, New York.

Saunders, Hilary St George, 1950, *The Red Beret: The Story of the Parachute Regiment at War, 1940–45*, Michael Joseph, London.

Spender, Richard, 1944, *Collected Poems*, Sidgwick & Jackson, London.

Uncredited, 1945, *Arnhem Lift: Diary of a Glider Pilot*, Pilot Press, London.

Voskuil, Robert, 2004, 'Identification of the Location Where Sergeant Mike Lewis Took the Famous Photo of a British Patrol', *Newsletter of the Society of Friends of the Airborne Museum Hartenstein*.

The World at War, 1973–74, television series, Thames Television, London.